KT-211-203

MARCEL DUCHAMP

in Perspective

Edited by

JOSEPH MASHECK

DA CAPO PRESS

For H.-R. H.

Copyright © 1975 by Joseph Masheck
New introduction copyright © 2002 by Joseph Masheck

All rights reserved. No part of this publication may be reproduced, stored in a retrieval system, or transmitted, in any form or by any means, electronic, mechanical, photocopying, recording, or otherwise, without the prior written permission of the publisher. Printed in the United States of America.

Cataloging-in-Publication data for this book is available from the Library of Congress.

First Da Capo Press edition 2002
This Da Capo paperback edition of *Marcel Duchamp in Perspective* is an updated republication of the English-language edition first published in 1975 by Prentice-Hall, Inc. It is reprinted by arrangement with the author.
ISBN 0–306–81057–3

Published by Da Capo Press
A Member of the Perseus Books Group
http://www.dacapopress.com

Da Capo Press books are available at special discounts for bulk purchases in the U.S. by corporations, institutions, and other organizations. For more information, please contact the Special Markets Department at the Perseus Books Group, 11 Cambridge Center, Cambridge, MA 02142, or call (800) 255-1514 or (617) 252-5298, or e-mail j.mccrary@perseusbooks.com.

1 2 3 4 5 6 7 8 9—06 05 04 03 02

CONTENTS

vii

PREFACE

This volume samples much of the best thinking that has been applied to Duchamp and his work. some of it far from worshipful. Many other essays had claims to be chosen, but these, taken together, should constitute a firm basis for further study and reflection. My introduction is intended to acquaint the reader with the broad outline of Duchamp's art, its major watersheds, and the problems that attach to it. In a few places this gives me the chance to put my two cents in. The readings fall into rather indistinct classes: texts dealing with the artist and his work in general, analyses and reflections on individual works and clusters of them, negative criticisms of Duchamp, and writings that evidence his importance to other and younger artists. Further suggestions for reading can be found in the bibliography, but the reader is advised that over the past generation, the Duchamp literature has burgeoned.

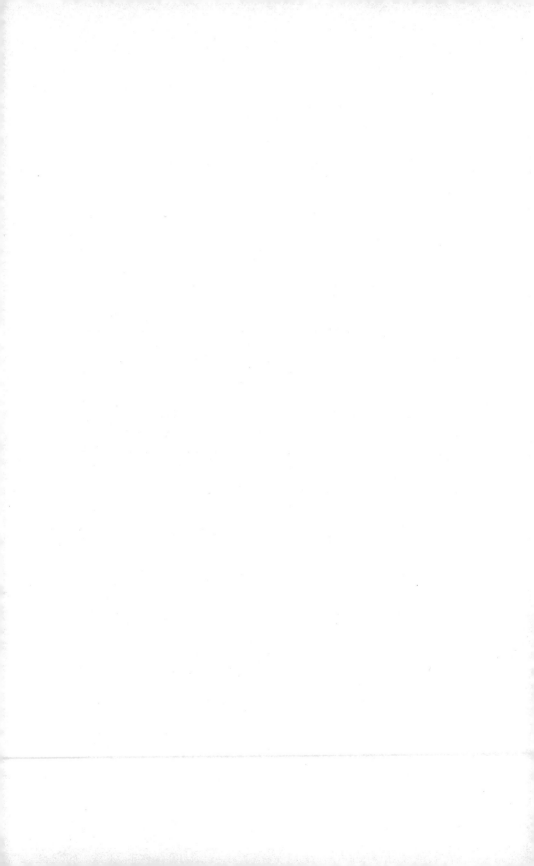

INTRODUCTION TO THE
DA CAPO EDITION: WHERE WERE WE?

Something has happened, and it is partly the fault of Marcel Duchamp and not all to the good! It's not just that twenty-five years ago, not so many people were interested in Duchamp; nor that many of us were becoming more 'theoretically' interested in art. Actually, though general interest in art had then yet to peak, ever since the prevailing obsession with money-making over all else began in the 1980s there has been if anything a glaring decline in the proportion of the educated population seriously interested in art at all, let alone modern art—possibly even in anything 'in itself.' Not that anybody will be prepared to argue that a general slump in artistic morale might have been stemmed had Duchamp only lived on! No; stagnation has set in, and he is in some measure responsible for it, because—face it—he fathered the notion that any sort of statement not ironic must be totally uncool (perhaps he slipped away just in time). At least Andy Warhol, come to think of it, used to say too many indiscriminately *affirmative* things.

It is not for his intellectualizing effect that Duchamp can be faulted: it does seem amazing today that artists used to get away with behaving as though they deserved to be paid for their feelings. His art managed to be both hermetic and surprisingly approachable: just bring your intelligence and a toothbrush! But his so-called 'anti-art' position only makes sense if you know and care about art as such, and twenty-five years ago more of the people who were interested in his work were prepared to wonder, say, where *The Large Glass* might leave medieval painting or the work of the Mannerists or Cézanne. But thanks largely to Duchamp's iconoclastic negation-of-art-that-still-counts-as-art, a loophole appeared, of which too many lazy art students (not all are) and too many pseudo-radical scholars (not all are) availed themselves: it was no secret that now all you really had to worry about was Marcel Duchamp and Andy Warhol, the latter as his anointed *nipote* overseeing more or less the same turf.

That Duchamp himself deserves better is the best reason for re-issuing this book, which notwithstanding an immense volume of discourse on the artist since its appearance in 1975 still constitutes a useful 'kit' of important

basic and classic texts which has itself had some influence—including the introductory essay, to judge by the cropping up, subsequently, of oblique references taking the form "as has been said" (most attentively of course where the subject matter tends toward the lurid, notably with my original reading of the *Sad Young Man on a Train*). Expanding the roster at this stage would have meant replacing this book with another. Yet in twenty-five years of genteelly unhurried thinking about Duchamp, sometimes in conversation with my students at Columbia, Harvard and Hofstra, I do have a few further thoughts to mention (unfortunately I have repeatedly failed to trace a fascinating connection with Walter Lippmann once made by a student of mine); so I must appeal to the reader's forbearance as I range rather unevenly over some points. The following 'Miscellanea Duchampiana'— observations, ideas, suggestions—are arranged as far as practicable in respect to the works to which they pertain, followed at the end by a few special recommendations from the vast newer literature on Duchamp.

STUFF-IN-ITSELF

Readymade Bore, by now one could almost think; yet one is always provoked, especially in face-to-face encounter with one of Duchamp's actual 'readymades'—those manufactured objects insinuated under the purview of the fine arts—to think of something else again. First, the most general of all possible points, as background to the readymade as a willfully arbitrary disruption of signification: the readymade highlights the notion that signification, far from being a natural condition, is indeed 'arbitrarily' conferred by linguistic fiat. But this idea that meanings, even the meanings of basic words, have no innate relation to things but must somehow be ordained, began much earlier in modern culture than even modernists, let alone postmodernists, tend to assume. Already in *A New Theory of Vision* (1709; 1732) Bishop Berkeley says that "the words of any language are in their own nature indifferent to signify this or that thing or nothing at all' (§ 64, ed. M. R. Ayers ; cf. §§ 77); further, that "words" are "not . . . regarded in their own nature, or otherwise than as they are marks of things" (§ 140); again, that (rather unlike "visible figures") words are "arbitrary signs" (§ 141; cf. § 143); and indeed, that "the signification of . . . ideas by words . . . is . . . depend[ent] altogether on . . . arbitrary appointment" (§ 152). Among any number of later exemplars, still prior to the ever-quoted Ferdinand de Saussure (c. 1900), are the Irish logician George Boole, in *An Introduction into the Laws of Thought* (1854): "A sign is an arbitrary mark . . . " (ii.2); and F. H. Bradley, who in his *Principles of Logic* (1883) remarks that "a sign" is "[o]riginally imposed as an arbitrary mark" in a "process . . . which makes it a sign and associates it firmly with the thing it signifies" (§ 17; ed. J. A. Allard and G. Stock).

Besides, the notion that everything in the world, as is, might somehow be at least potentially beautiful enough to be considered tantamount to art, if only we could appreciate it, etc., etc., was important in the whole discovery of the subjective component of art in early eighteenth-century aesthetics. Francis Hutcheson remarks at several points in the section 'Of the Universality of the Sense of Beauty Among Men' in 'An Inquiry Concerning Beauty, Order, Harmony, Design' (1725; 1738) on both randomness and the relativity of beauty not only to character of stimulus but also to receptiveness in a more or less sophisticated perceiver: "[T]here is no form which seems necessarily disagreeable of itself, . . . no composition of objects which give not unpleasant simple ideas, [that should] seem positively unpleasant or painful of itself, had we never observed anything better of the kind. . . . [B]ad music pleases rustics who never heard any better, and the finest ear is not offended with tuning of instruments if it be not too tedious, where no harmony is expected; and yet much smaller dissonancy shall offend amidst the performance, where harmony is expected. A rude heap of stones is in no way offensive to one who shall be displeased with irregularity in architecture, where beauty was expected" (sect. vi; ed. R. S. Downie). This is not exactly Duchamp, to be sure, but it is, in retrospect, part of the prehistory of what he would be up to.

Winckelmann, keeper of the classical law, picked up on the differently naturalistic sense of a connectedness between natural and artistic form as in a sense reciprocal, in Bernini's view: For Bernini "was . . . of the opinion that nature was capable of bestowing on all its parts the necessary amount of beauty, and that the . . . art consisted in finding it. He prided himself in having to overcome his earlier prejudice concerning the charms of the Medicean Venus, since, after painstaking study, he had been able to perceive these very charms in nature" (*Reflections on the Imitation of Greek Works in Painting and Sculpture* (1755; trans. E. Heyer and R. C. Norton).

We might do well to begin again with Kant, but not with Kant as figurehead of a later, all too teleological yet anti-historical 'Greenbergian' formalism. By sharpening the old distinction between useful and 'fine' arts, Kant's sense of nature as purposive, with the special beauty of art held to be a *Zweckmässigkeit ohne Zweck* (purposiveness without purpose), becomes with Duchamp the perfect set-up for a joke of and about brainy uselessness: the genteel genius goes on vacation from producing at least the usual, specialized, high-class art commodity—on what, however, turns out to be a busman's holiday. One reason why, then, the *Bicycle Wheel* or the *Bottle Rack*, or for that matter *Fountain*, should qualify as a work of art is that, naughty or nice, it takes advantage of an idealist loophole: like an over-zealous convert from the world of ineligibly useful practical objects, it wears on its sleeve a privileged disfunctionality as totally *ohne Zweck*. Disinterestness? *You asked for it!* Outrageously enough, Duchamp's once utilitarian object proves capable of going further, and in such a dandyishly easy way, than any

aesthetically workaday representational transposition, especially of already presumptuously lovely 'nature.' We were so concerned about art versus nature, and here this unambiguously *un*-natural *thing* comes in the back door.

One might go so far as to say that only in a state of ignorance can the I'm-Overlooking-a-Four-Leafed-Clover aspect of the readymade even seem radical (and how American, that!). A comment of Coleridge in *Biographia Literaria* is telling for the crypto-authorial subjectivity usually glossed over with the readymade (ch. vii): "the will itself by confining and intensifying the attention may arbitrarily give vividness or distinctness to any object whatsoever . . ." Certain remarks of Carlyle, who would be respected as a kindred spirit in *symboliste* art circles at the turn of the century, also pertain, such as the statement in *Sartor Resartus* (1831), "Rightly viewed no meanest object is insignificant; all objects are as windows, through which the philosophic eye looks into Infinitude itself" (I.xi), but also, apropos of Dante, in 'The Hero as Poet' (1840), in *On Heroes, Hero-Worship and the Heroic in History*, Carlyle's claim that *any* face, in particular, has more "significance" than is renderable: "To the mean eye all things are trivial, as certainly as to the jaundiced they are yellow. . . . No most gifted eye can exhaust the significance of any object. In the commonest human face there lies more than Raphael will take-away with him." The formalist theoretician Konrad Fiedler already writes in *On Judging Works of Art* (1876) that "art has nothing to do with forms that are found readymade prior to its activity and independent of it" (iii.6; trans. H. Schaefer-Simmern and F. Mood); and while no form of *fertig* ("ready") occurs in the original, there is a sense of that which is *vorfindet*, which does, as that which is met with or come upon.

The English usage, as Carlyle would have appreciated, is more simply derived from the notion of 'ready-made' clothing as 'off-the-rack'—the opposite of made-to-order or 'bespoke' (though conceptually, of course, one size fits all). In France there was the kindred but broader concept of 'le tout fait,' of the already made up. Delacroix points in the opposite, more traditionally Aristotelian, direction where he remarks that the trouble with Ernest Meissonier's wretchedly detailed pictures is that they lack that which makes of some "odious object" an "object of art" (*Journal*, 5 March 1849); but among potentially relevant texts employing the term *le tout fait* in the sense of that which is ready-made can be mentioned not only Baudelaire's essay 'Sur le peinture' (1855) but an important passage in his life of Delacroix (1863) regarding *"des tableaux tout faits"* (ready-made pictures). Also worthy of note are Edmond Duranty's impressionist exhibition review 'La Nouvelle Peinture' (1876); Joachim Gasquet's speaking in his *Cézanne* memoir of Courbet's having "had the image in his eye, ready-made" (trans. C. Pemberton); and the 'Letter to Daniel Halévy' prefacing Georges Sorel's *Reflections on Violence* (first edition,1908; English trans., 1914).

Perhaps more than any other nineteenth-century text however, there deserves to be invoked for the prehistory of the readymade a famous passage in Friedrich Engels' *Ludwig Feuerbach and the End of Classical German Philosophy* (1886), in which there is "freed" from idealism Hegel's insight into the importance of historical process as governing mere things, the "great basic thought" being that "the world is not to be comprehended as a complex of ready-made *things*, but as a complex of *processes*, in which the things apparently stable no less than their mind images in our heads, the concepts, go through an uninterrupted change of coming into being and passing away, in which, in spite of all seeming accidentality and of all temporal regression, a progressive development asserts itself in the end . . . " (pt. IV; italics in source). Needless to say, the anything but political Duchamp would have preferred to do without the progressivist editorializing, but the passage is difficult to truncate partly because it leads into something more broadly relevant to him: "But to acknowledge this fundamental thought in words and to apply it in reality . . . are two different things. . . . one is always conscious of the necessary limitation of all acquired knowledge, of the fact that it is conditioned by the circumstances in which it was acquired. . . . One knows that what is maintained to be necessary is composed of sheer accidents and that the so-called accidental is the form behind which necessity hides itself—and so on." In the original the crucial phrase "a complex of ready-made *things*" reads "*ein Komplex von fertigen Dingen*," and the standard German dictionaries do give for *Fertigware*[n], 'readymade article' or 'ready-made goods.'

His dandyism was more (*Sorry!*) inhibited than Oscar Wilde's (Duchamp was simply not 'Edwardian,' but he does sometimes come close to striking a note of Edwardian neo-Georgian *taste*); nevertheless, it is easy to imagine our progenitor of the readymade delighting in a passage from Wilde's 'Lecture to Art Students,' given at the Royal Academy Club, London, in 1883: "I believe that in every twenty-four hours what is beautiful looks ugly, and what is beautiful looks ugly, once. And the commonplace character of so much of . . . English painting seems to me due to the fact that so many . . . young artists look merely at what we may call [N. B.] 'ready-made beauty,' whereas you exist as artists not to copy beauty but to create it in your art, to wait and watch for it in nature. . . . [O]f the young artist who paints nothing but beautiful things, I say he misses one half of the world."

Sometimes, even if one cannot be sure of just how much philological credence to allow to such a crucial translated term as 'readymade,' attention to context secures a reasonable equivalency of conceptual entailments. Thus where a whole section (xi) of the Russian novelist Tolstoy's aesthetic treatise *What Is Art?* (1898) sets out to tackle the problem of large-scale latterday displacement of authentic art by "simulacra of art" and "counterfeits of art," there is opportunity to ascertain what Tolstoy despises in the glib detachment from values fostered by the academy; for once someone has learned

the how-to-do-it part (especially how to render the figure), "he can cease-lessly paint one painting after . . . another, choosing . . . mythological, reli-gious, fantastic or symbolic subjects, or portraying what is written about in the newspapers—a coronation, a strike, the Graeco-Turkish War, the disas-ters of famine; or most commonly, portraying all that seems beautiful, from naked women to copper basins." By the end of the same section it becomes a safe surmise that "ready-made" is probably not so farfetched in the state-ment that "in all areas of art, counterfeit works are produced by a ready-made, worked-out recipe, which our upper-class public takes for genuine art" (trans. R. Pevear and L. Volokhonsky).

The readymades point up with amusing concision the idealist require-ment that art be 'purposeless,' notwithstanding the immediately material form which Duchamp's statement takes—in such an unrepentantly prosaic manner. Since the net effect is amusingly iconoclastic, it is hardly surprising that an important early occurrence of the word 'readymade' should have been discovered in the 1911 (i.e., first) English translation of Henri Bergson's 1900 essay on comedy, *Le Rire: Essaie sur la significance du comique*: "The vice capable of making us comic . . . is that which is brought from without, like a readymade frame in which we are to step . . . " (as quot-ed by I. Davies, *Art History* 2, 1979). A year earlier, however, Frank Lloyd Wright had already published in the prefatory essay to the great album of his early work put out in Berlin in 1910, the remark that in America "'Readymade' architecture directly transplanted" (from European tradition) had been "too successful" (Wright's *Writings and Buildings*, ed. E. Kaufmann and B. Raeburn). Bernard Bosanquet, the British aesthetician, makes an interesting point that Duchamp could well have appreciated, speaking of language as cultural medium in a 1914 lecture published in the following year: how pronouncing "a phrase so commonplace in itself as 'Rule, Britannia!'" carries so much entailed signification that "Up to a cer-tain point, *language is poetry ready-made* for us" (*Three Lectures on Aesthetic*, 1915). While Duchamp's premier readymade, the *Bicycle Wheel*, was (first) 'executed' (!) in Paris in 1913, Duchamp only adopted the *term* 'readymade' after coming to America in 1915. In the same moment, the Russian modernist painter Olga Rozanova said in a statement for the impor-tant '0.10' exhibition in Saint Petersburg in 1915–16 (reprinted posthu-mously in the catalogue of the 'Tenth State Exhibition: Nonobjective Creation and Suprematism,' 1919), "We propose to liberate painting from its subservience to the ready-made forms of reality and to make it first and foremost a creative, not a reproductive, art" (trans. J. E. Bowlt). Contemporaneously, in *Reconstruction in Philosophy* (1920) John Dewey—for whom "fixed, ready-made, static" were kindred pejorative terms (ch. vi)—sees philosophy turning from "ready-made" realist or idealist-rational-ist conceptions, both too like "a spectator viewing a finished picture," to a more operational sense of "the artist producing the painting" (ch. v).

One hesitates to be a party-pooper, but a certain problem with the readymade has long been swept under the carpet, no doubt as an embarrassment to modernism, namely, the readymade's dependence on more or less the very notion of authorial intention called into question by the famous essay of the aesthetician Monroe Beardsley and the literary critic W. K. Wimsatt, Jr., 'The Intentional Fallacy' (1946). Undeniably there is hearty truth in the modern view that, face to face with any artistic production standing on its own, it must hardly matter what its perpetrator (who might anyway have been honestly deluded) may have *thought* he or she *meant* to accomplish in bringing it about—certainly not to whatever extent 'meant' means *intended but failed to effect*. Of that problem Duchamp's readymades have presumably stood safely clear, probably mainly because in their inertness they count as art without making representational claims. Conveniently, then, as well as understandably, aestheticians and theorists have concerned themselves with how the art-status of a readymade (or any other work of art) is a function of a discourse in which it participates, which is certainly true in its thrust. Meanwhile, however, but for some modicum of old-fashioned authorial intention a Duchamp *Bottlerack* could never even qualify as anything but an ordinary bottle-rack. As exciting as it has always seemed to applaud the readymade as art (especially if it was to be embraced as radically authorless art), the fact may have been overlooked that when Duchamp cleverly proposed ordinary objects for naturalization as art-works, they perhaps only validly qualified because they were properly sponsored—*intentionally* sponsored—by him as artist. If true, this means that the readymades unfortunately do lack that self-sufficient 'intentionality' which is more reliably imputed to other works of art, many of them no less conventional. Fans of Duchamp will generally not want to hear this (and nobody else will care), but there the implication is. An outside limit of the problem is, why it should matter so much, or just how it should matter, that the professed artist decided to christen certain anonymously produced things as artworks of art by simple fiat of declaring the intention to have it so, and how that *worked*. As if seconding the Duchampian 'motion,' in the context of 1980s 'appropriation' art Mike Bidlo and Sherrie Levine did various 're-dos' of Duchamp readymades: now what the re-do was a reiteration *of* could only be that most unusual of presumably common and anonymous things, 'a Duchamp,'—'Duchamps' in this sense being *nothing but* art objects, however naughty, at least in a default sense of things that only make sense, even iconoclastic sense, when taken as such.

This is quite apart from any political objections which might be lodged, such as Carl Andre's, in a statement 'Against Duchamp,' delivered in a symposium at Oberlin College on 'The Role of the Artist in Today's Society,' in 1973, in which the Minimalist sculptor accuses Duchamp's readymades of being pseudo-radically corrupt: "The bread on the tables of the capitalist is the prototype of all readymades. It is thought to have been

rescued from the state of nature by capitalist cunning and dedicated to capitalist consumption by divine right" (*Praxis* [Berkeley] 1/1 [Spring 1975]). Considering the cynicism the readymades have lately proved so readily to feed and even to warrant by *historical* appeal (one sees Duchamp grinning), Andre had a point. Their aging historicity is not amusing, though amusingly enough the readymades still manage to pick up meaning, including stray iconography of traditional sort, like lint. Take the *Comb*, of 1916: it happens that a large-toothed metal comb, such as was used by carters of wool, is a symbolic attribute of Saint Blaise, physician and bishop, martyred c. 320. That language (and art) may implicate meanings unintended by or even unknown to the speaker (or artist) is an interesting aspect of the semiotic game. It is not that *Comb* is necessarily about Saint Blaise, though with Uncle Marcel it just might be, should its entailments suffice; but the intention might well matter.

FOUNTAIN AND SUCH

Fountain, the urinal declared a readymade in 1917, is really the arch-readymade: more is written about it than on all other readymades combined, and often as the basis of generalizations. Clearly, the main reason why this should be so is the piece's scandalous genito-urinary implications, often extended by induction to the scatological as automatically scandalous, even though the distinction by which it could count as male (and American) equivalent to a bidet—which manufacturers were then actually trying to sell Americans on, so that every bathroom would need one more thing—might have been more interesting to pursue. I myself have argued (in a lecture on 'Materiality and Constructive Tradition,' at the Museum of Modern Art, in November of 1985) that one referent of *Fountain*, however inadvertent, may well be the water vessel with rather penile spigot of Chardin's *La Fontaine de cuivre* (c. 1734; Louvre), possibly as mitigated by the similar but more innocent as well as more modern-cubistic form of Malevich's *Samovar* (c. 1913; New York, Museum of Modern Art).

But no, to all the world *Fountain* is tantamount to a toilet, and thus all too close to 'doo-doo.' Perish the thought: Baudelaire had mentioned chamber-pots along with skeletons as unpleasantly given facts of the real world ('Salon of 1859'); Zola complained famously in a letter to Cézanne (25 March 1860) that realists such as Courbet "brag that they paint only subjects stripped of poetry (*dénués de poésie*) . . . [b]ut everything has its own poetry, manure (*le fumier*) as well as flowers"; and Gavarni, the caricaturist, said that Delacroix's painting looked like toilet paper (quoted in Paul Signac's *D'Eugène Delacroix au néo-impressionisme*, 1899). In a famous remark whose pointed anti-positivism however is more often than not elim-

inated in quotation, Karl Kraus famously wrote (apparently in 1930) of Adolf Loos, the modernist architect in early twentieth-century Vienna: "All that Adolf Loos and I did—he literally, I linguistically—was to show that there is a difference between an urn and a chamberpot, and that in this difference there is leeway for culture. But the others, the 'positive ones,' are divided into those who use the urn as a chamberpot and those who use the chamberpot as an urn" (trans. H. Zohn in his *Karl Kraus*, 1971).

To about 1900, actually, there dates a *topos* of Good Plumbing as the Best America Can Do. In the unsigned notice of 'The Richard Mutt Case,' in the second number of New York Dada magazine *The Blind Man* (May 1917), there occurs a famous statement, often mistakenly assumed to be by Duchamp, which would be hardly original even if he himself had pronounced it *ex cathedra*. Here one of the hypothesized reasons why Duchamp's readymade urinal *Fountain* had just been excluded from the supposedly unjuried 1917 New York Independents exhibition is the two-pronged claim: "it was a plagiarism," just "a plain piece of plumbing," with this countered by the familiar riposte: "The only works of art America has given are her plumbing and her bridges." Duchamp might have been amused by the idea of accusing an anonymous manufactured object of plagiarism. In actual fact, a review of Philip Johnson's 'Machine Art' exhibition at the Museum of Modern Art in 1934, offering that "the machine," as against handicraft, "implies . . . reproducability," and aware that the predicate 'ready-made' derives from the clothing manufacture, instead of allowing that some art exists in multiple originals (e. g., all coins and most prints), does call the machine-made goods we settle for, including clothes, "reproductions" (C. Bauer, 'Machine-Made,' *American Magazine of Art*, May 1934).

But the cultural superiority of American plumbing was apparently quite a patronizing European canard at the turn of the century. In his early essay on 'Plumbing' (1898) the Viennese modernist architect Adolf Loos not only shames Austria, compared with America, on plumbing, but, all the more remarkably in view of its ornamentation, supports his case with an illustration of a 'Grecian Vase Toilet' made by the J. L. Mott Iron Works, of New York—the supposedly elusive manufacturers of the urinal which became Duchamp's *Fountain* (in Loos's *Spoken into the Void*, trans. J. Ockman Newman and J. H. Smith). I say supposedly elusive because any New Yorkers who have spilled ink over the affair should have known that near the Triborough Bridge, in the very neighborhood still called Mott Haven, in the Bronx, was all along built into the very brickwork of one of the buildings (1828–1906) of the firm in question, the inscription "J L MOTT IRON WORKS" (illus., A. I. A. *Guide to New York City*, ed. Willensky and White, 3rd ed., 1988). Much the same note is struck in a straightforward discussion of 1900 by a European assessing "American Architecture from a Foreign Point of View: New York City," and especially admiring the "bath-

rooms, . . . hot-and-cold water and everything that has to do with plumbing" (Jean Schopfer, 'American Architecture from a Foreign Point of View: New York City,' *The Architectural Review* 7, 1900).

PAINTINGS OF SORTS

It is sometimes noticed that the hinged mount by which Duchamp's thus moveable semi-circular painting of sorts on glass, the *Glider Containing a Water Mill in Neighboring Metals*, 1913–15, is attached to the wall of the Philadelphia Museum of Art, recalls a practice still seen in some European paintings collections—but also in Victorian households—of hinging a framed painting or drawing near a window, so as to make it possible to shift it for seeing in better light. For Duchamp, this adds to the Glider an amusingly old-masterish touch of old-fashioned, institutional 'fine art.' Without contradiction however, it is possible to appreciate the same idea in the context of Herman Melville's novel of the declining fortune of an aging bohemian writer, *Pierre; or, The Ambiguities* (1852), where, as if for a painful note of contrast, there is hung in just this way "a fine joyous painting in the goodfellow Flemish style" (I.vi).

THE LARGE GLASS AGAIN. More promisingly curious in respect to *The Large Glass* than ever more tedious art-historical speculations on so-called 'fourth-dimensional' images—one of the more desperate ways of clinging to an unreformed sense of art as necessarily 'representing' phenomena, or even (if you're really good at it, to paraphrase Mae West) *noumena*—is a classic diagram purportedly known as 'The Chair of the Bride' in Hindu geometry since the ninth century (though not as yet by any mathematician known to the present writer). With two squares, one above the other, the upper pivoting left and the lower, right, from a common corner, and both squares subdivided equivalently into polygons, this diagram said to show "equidecomposability" between "corresponding triangles and quadrangles of like orientation , . . . even associated by parallel displacement," was added in Paul Bernays' supplements to the modern mathematician David Hilbert's *Foundations of Geometry* (1899; ed. P. Bernays, trans. L Unger).

Apropos of the 'sieves' of the *Glass* as sexual motif: an ancient joke, uncannily (or cannily?) derives from Lucian's *Demonax*, in the second century A. D.: "On seeing two philosophers very ignorantly debating a given subject, one asking silly questions and the other giving answers that were not at all to the point, he [Demonax] said: 'Doesn't it seem to you, friends, that one of these fellows is milking a he-goat and the other is holding a sieve for him!'" (§ 28; trans. A. M. Harmon). Edgar Wind traces its retelling through, among others, Erasmus, Sir Richard Steele, David Hume, Kant (in the *Critique of Pure Reason*) and Doctor Johnson ('Johnson and Demonax' [revision of 'Milking the Bull and the He-Goat,' 1943], in his *Hume and the Heroic Portrait: Studies in Eighteenth-Century Imagery*, ed. J. Anderson).

Also as to sex in this painting-construction formally called *The Bride Stripped Bare by Her Bachelors, Even*: in a section on 'The Mechanism of Fore-Pleasure' in 'The Transformations of Puberty,' the last of Freud's *Three Lectures on the Theory of Sexuality* (1905), we read: "the erotogenic zones . . . are all used to provide a certain amount of pleasure by being stimulated in the way appropriate to them. . . . [F]rom the pleasure yielded by . . . excitation the motor energy is obtained, . . . by a reflex path, which brings about the discharge of the sexual substances" (trans. J. Strachey). I realize that I risk redundancy here, with a passage likely to have been cited many times by others, but perhaps not with the full sense that it reflects upon *The Large Glass* the dubious honor of illustrating Freud's notion of all art as (for better or worse) tantamount to endless foreplay.

Apropos of the motif(s) of the 'uniforms and liveries' in the *Glass*: Kandinsky had written in an essay 'On the Question of Form,' "[o]ne should not make a uniform out of the form. Works of art are not soldiers"; W. Kandinsky and F. Marc, eds., *The Blaue Reiter Almanac* (1912; ed. K. Lankeit, trans. H. Falkenstein et al.). As to the chance-determination of positions of elements by firing matchsticks dipped in paint: the art dealer Ambrose Vollard wrote in his study *Cézanne*, published in 1914 (ch. ii), "The prevailing opinion in critical circles about Cézanne's method was that he simply aimed a pistol loaded to the muzzle with variegated colors at a blank canvas. Thus his manner came to be dubbed 'pistol-painting'" (2nd ed., trans. H. L. Van Doren).

Man Ray's 1920 *Dust Breeding* photograph of *The Large Glass* seems almost arguably at the back of the mind of Herbert Read in his essay on Ezra Pound in *The Tenth Muse: Essays in Criticism* (1957), if not of Pound himself for that matter. This once transatlantically famous modernist of literature and art alike is concentrating at this point on an image of Pound's own in *The Cantos*, namely, "the image of the magnet and the iron filings." But the Duchampian hint, incipient in the statement of the poet (bespeaking the 'imagist' literary image)—"The *forma*, the immortal concetto, the concept, the dynamic form which is like the rose-pattern driven into the dead iron filings by the magnet . . . Cut off by a layer of glass, the dust and filings rise and spring into order"—seems only the more plausible in reiteration by the critic: "The dust and filings—these are the detritus of a civilization in decay, in dissolution. The Cantos must be conceived as a massive attack on this civilization, and exposure of its rottenness and active corruption. . . . Corruption is traced to its source in usury, and those who have opposed usury and tried to eradicate it—Malatesta and Jefferson, for example—are treated as heroes in this epic. Against this corruption is set the harmony and ethical rectitude of Confucius."

AUTOMOBILINE EROTICISM. Perhaps not until *The Large Glass* was finished, but at least quick in its wake, a popular black blues song famously sung by Ethel Waters included a figure motif of a 'love gasoline' of volatile erotic stimulation, as Duchamp thought of it apropos of the *Glass* in his

notes. The song 'Go Back Where You Stayed Last Night,' by Sidney Easton and Waters, includes the quatrain: "I' been a chump long enough, / From now on I'm gonna be mean: / So find another station / To get your supply of gasoline" (from a recording made 28 July 1925; thanks to Tom Nozkowski for this report). Also, in *Kasimir und Karoline* (finished 1931), by the Hungarian writer Ödön von Horváth, an ex-chauffeur elaborates farcically on a wife's anatomy in terms of an automobile with gasoline for blood and a heart-magneto that causes misfires if its sparks are insufficient (scene 110).

READYMADE ROSE

One of the most curious of Duchamp's casual moves must be his assuming as nom de plume and alter ego the 'first' or 'Christian' name Rose, later Rrose, even more than the mock 'last' or 'family' name Sélavy (*c'est la vie,* of course), and thereby as self-affiliating with a permanent aesthetic cliché, the supposedly guaranteed beauty of roses—all actual roses but even mere mentions of the bloom. People who fantasize about changing their names usually seek a new identity, distinctive in some conventional way perhaps, but surely not more eccentric than what they already have. With the name Rose Sélavy, as of 1920, there was obviously an element of invented identity; yet by virtue of sheer ridiculousness this particular nom de plume could only remind everyone of who was 'behind' it, which is also to say that assuming it involved a certain self-acceptance of an identity already to some extent established, 'given,' on the artist's part. The fact is that the name 'Rose,' simple as it is, comes with certain, shall we say, ready-made ideas attached.

'Rose' in particular certainly sounds ordinary and *given* enough, even fairly square. Well, O.K., except for a man! Yet this was not just another name, except precisely insofar as it was probably *the perfect* just-another, or any-old, name, above all the perfect choice for an all too assumedly pretty name—with beauty, like art to contentedly boorish Americans, assumedly feminine. At the end of his life, Duchamp told Pierre Cabanne that his first idea had been to take a Jewish name: "I was a Catholic, and it was a change to go from one religion to another! I didn't find a Jewish name that I especially liked, or that tempted me, and suddenly I had an idea: why not change sex? It was much simpler"; besides, Rose "was an awful name in 1920." Actually, the Jewish idea may not have dissipated, not only because Rose is indeed often enough a Jewish name but also in that this allowed of an implicit 'Rose Duchamp' or 'Rose du Champ,' tantamount to a French 'Rosen-Feld,' as in the name of Paul Rosenfeld, an important critical defender of modern art in New York early in the century—not to mention that full-time all-American, Theodore *Roosevelt* (d. 1919).

Above all, however, even above the question of gender—because if Duchamp had been born a girl and named Rose and suddenly wanted to

change her name to Marcel (or a feminine cognate) it would be most obvi-ous—is an implied antiromanticism, in the case of Rose Sélavy by the sheer sarcasm of the proposed name as a whole. A few observations are in order concerning the romantic rose motif of conventional discourse on beauty as implicated in Duchamp's assumption of the name Rose, and then, too, his doubling of the initial 'R.'

Wincklemann, again, compares ancient Greek with modern European *bodies* as more or less worthy *models* in the real world for max-imum leaps into the ideal in art. According to him, a likely "young sybarite of our own time . . . would be a Theseus fed on roses" in comparison with a tougher "Theseus fed on flesh, to borrow the terms used by a Greek painter . . ." (namely Euphranor, D. Irwin has pointed out). Schlegel reworks the figure and makes it integrally his own, in a comment, tellingly, on a markedly Christian-heroic figure, the saint in Sebastiano del Piombo's *Martyrdom of St. Agatha* (1520; Pitti Palace), whose "body possesses hero-ic virginal beauty and strength," glowing "not with the colors of lilies and roses, but with the flush of ruddy good health" ('Second Supplement of Old Paintings,' 1804).

Papa Kant must be in some measure responsible for the aesthetic cliché of the all too reliably beautiful rose. His contribution to the prehistory of the readymade is his early sense of the fetish as ordinary concrete object idolized for a magically conferred sign value; thus, "A bird feather, a cow's horn, a conch shell, or any other common object, as soon as it becomes con-secrated by a few words, is an object of veneration . . ." (*Observations on the Feeling of the Beautiful and Sublime*, 1764; iv; trans. Goldthwait). In the *Critique of Pure Reason*, roses seem quite hypothetical, whether "a" rose (A29/B45; trans. Smith), or "the" rose or "the rose *in itself*" (B70 n.), and likewise the thought in the *Critique of Judgment* of "compar[ing] many sin-gular roses and so arriv[ing] at the judgment, Roses in general are beauti-ful" (§ 8, trans. Pluhar). Kant obviously speaks as if roses are beautiful by common consent (as Dewey claims of the Parthenon), though when the clock had barely struck 1800 the beauty of the rose was the most cloying of commonplaces. In the universe of Romantic rose metaphors one of the most remarkable must be a figure in the opening lecture of Baron Cuvier's anatomy course—in a sentence whose operatic sweep, all the more amazing for maintaining an upright restraint, one hesitates to bruise by translation—of "cheeks tinted by roses of voluptuousness (*joues teintes des roses de la volupté*)" on a female body "in the state of youth and health" (*Leçons d'anatomie comparée*, 1805). On the other hand, there is distinctly intellec-tual, even *logical* delight, in the remark of Schopenhauer: "We can never construct a rose from its perfume . . ." (*On the Fourfold Root of the Principle of Sufficient Reason*, 1813, 1847; § 21; trans. E. F. J. Payne).

Indeed, a certain counter-romantic, almost anti-rose motif appeared in attempts to strand the worn-out rose, with, as it were, hardly any metaphoric capacity left in it, as something like an exact opposite of the

readymade, a cliché wrongly stamped as artistic. But the rose of conventional high art, poetry, definitive beauty of whatever sort, not to mention valentines, begins to wither in the icy irony of a significant passage in Baudelaire's early 'Salon of 1846,' addressed provocatively 'To the Bourgeois.' There the thoroughly antidemocratic section 'On Schools and Journeymen' opens with the thought of a policeman beating a leftist, and the *bon-mot* aesthete responding: "Thump on, thump a little harder, thump again, cop after my own heart!" For, "The man whom thou thumpest is an enemy of roses and perfumes, and a fanatic for utensils; he is the enemy of Watteau, the enemy of Raphael, the bitter enemy of luxury, of the fine arts and of literature, a sworn iconoclast and butcher of Venus and Apollo! He is no longer willing to work on public roses and perfumes as a humble and anonymous journeyman. He wants to be free, poor fool . . ." This Baudelaire was, after all, the early modernist poet and art critic who, as it struck Walter Benjamin, "went so far as to proclaim as his goal 'the creation of a cliché'" ('Some Motifs in Baudelaire,' 1939).

Zola, the great Continental naturalist and smasher of systems, ordains in his exhibition art review 'Les Réalistes du Salon' (11 May 1866), "Paint roses, but paint them lively (*vivantes*) if you're going to call yourself a realist." *Jivey* roses, that's what he means by wild roses, only correspondingly square ones, so to speak, being so ruthlessly ruled out. Unless this hearty *"vivante"* in rose-painting can be made to carry considerably more than naturalistic weight—as with Courbet, after whom Duchamp would make 'Selected Details'—Zola's rose pales before a braver rose of Nietzsche in *The Birth of Tragedy* (1872), one that almost becomes a kind of military decoration indicating authentic beauty hard-won over and against the brutal realities of the too-romanticized natural state: "out of the original Titanic divine order of terror, the Olympian divine order of joy gradually evolved through the Apollonian impulse toward beauty, just as roses burst from thorny bushes" (§ 3; trans. Kaufmann, modified).

Without discounting foundational nineteenth-century anti-romanticism, in the decade before Duchamp took on the name Rose there were significant new developments within the American modernism with which he was then affiliating himself. As I have already observed elsewhere, it was in 1913, the very year of the first readymade, that Gertrude Stein, who would have known Emerson's example, wrote the line "A rose is a rose is a rose" into her play *Sister Emily* (in *Geography and Plays*, 1922). That most celebrated item itself recalls an important passage by Friedrich Engels, dealing with dialectical versus simplistic negation, a text that André Breton would one day resuscitate: "I negate the sentence, the rose is a rose, when I say: the rose is not a rose; and what do I get if I then negate the negation and say: but after all the rose is a rose?" (*Anti-Dühring: Herr Eugen Dühring's Revolution in Science*, 1878, trans. E. Burns).

It would surely have interested Stein (who had studied psychology under William James) that in the same year of 1913 Vernon Lee (nom de

plume of Violet Paget) wrote rather quasi-cubistically in Chapter III, 'Aspects versus Things,' of her essay on *The Beautiful: An Introduction to Psychological Aesthetics*, "A rose, for instance, is not merely a certain assemblage of curves and straight lines and colours, seen as the painter sees it, at a certain angle, petals masking part of stem, leaf protruding above bud: it is the possibility of other combinations of shapes, including those seen when the rose (or the person looking) is placed head downwards. . . . if , on trial, any of these grouped possibilities disappoint us, we decide that this is not a real rose, but a paper rose, or a painted one, or no rose at all, but some *other thing*." Rather more romantically, the American emigrée Imagist poet H. D. (full pen name of Hilda Doolittle) can be found riffing on the phrase "Little, but all roses" in an undated essay on Sappho's love of beauty, intellectual as well as physical, in women ('The Wise Sappho'; she also published a book of poems under the title *Red Roses for Bronze*, 1929).

Basically, and for better or worse, the rose had been an emblem of the aesthetic in the old-fashioned sense. Already in Clive Bell's *Art*, however, a 'rose' point concerns Cézanne's sense of formal reality as against all remnant romanticism and realism. While the preface is dated November 1913, in a preface to the second edition (dated October 1948) Bell claims that the book "records what I thought and felt in 1911 and 1912." *Art*, which was published in New York as well as London in 1914, is critical for modernist rose-revisionism: "The instinct of a Romantic invited to say what he felt about anything was to recall its associations. . . . A rose touched life at a hundred pretty points. A rose was interesting because it had a past. 'Bosh,' said the Realist, 'I will tell you what a rose is; that is to say, I will give you a detailed account of the properties of *Rosa setigera*, not forgetting to mention the urn-shaped calyx-tube, the five lubricated lobes, or the open corolla of five obovate petals. To a Cézanne one account would appear as irrelevant as the other, since both omit the thing that matters . . . "For after all, what is a rose? What is a tree, a dog, a wall, a boat? What is the particular significance of anything?" (IV.i). Also from 1914 comes an iconoclastic text that Duchamp himself would one day suggest be included in a proto-Dada section of Robert Motherwell's anthology *The Dada Painters and Poets* (1951), by Arthur Cravan (of whom, more shortly): "Maurice Denis ought to paint in heaven for he never heard of dinner-jackets and smelly feet. Not that I find it very bold to paint an acrobat or a man shitting; on the contrary, a rose executed with novelty seems much more demoniacal" ('Exhibition at the Independents,' trans. R. Mannheim).

In a symbolist-influenced essay written in the heyday of Duchamp's classic readymades, the painter Max Liebermann opposes the rose to a vegetable, the latter as categorically *un*beautiful, to downplay the artist's motif as beholden to the ordinary world, and to affirm instead the independence of art: "A bunch of asparagus, a bouquet of roses, an ugly girl or a beautiful girl, an Apollo or a deformed dwarf is enough for a masterpiece: it is possible to create a masterpiece from everything, of course with a sufficient

amount of fantasy," for ". . . the value of a painting is absolutely independent of its subject" (*Die Phantasie in der Malerei*, 1916). Quoting these words, the Prague linguist Jan Mukařovský recalls the claim of the aesthetician Max Dessoir "that an aesthetics could be written without the word 'art' even being used" ('The Place of the Aesthetic Function Among the Other Functions,' 1942; 1966; trans. J. Burbank and P. Steiner). Liebermann's bunch of asparagus as realist, categorically unpretty counter to a bunch of roses, meaning, of course, utterly vegetable asparagus, stripped of its ferny floristic tulle, alludes to a particular painting, or actually two paintings, by Manet. As Liebermann would certainly have been aware, because he in fact owned the *Bunch of Asparagus* in question, a friend of Proust's had paid Manet so generously for his still life that the painter surprised him with the extra, single-stalk *Asparagus*, 1880, a work that, to Bataille, in turn, showed "the full depth of Manet's indifference to the subject" (*Manet*, 1955)—though of course by the same token it had allowed of an absorption in pure painting. A scholar who tells the friend, the two still lifes and Proust's own *aestheticization* of asparagus comments, "some of Proust's poetry is sublimated gastronomy" (J. Cocking, 'Proust and Painting,' in U. Finke, ed., *French 19th-Century Painting and Literature*, 1972)—which would certainly have amused Duchamp, with his cerebrally cultivated opposition to what he despised as the 'culinary' aesthetic of eye-pleasing art.

In 1921 Marcel's 'Rose' became 'Rrose,' instigated by Francis Picabia's phonetic signature as "Pis qu'habilla" on a painting of sorts, *Cacodylatic Eye*, which quite a few artists inscribed (including Duchamp's sister and her husband). Duchamp came up with the semi-opaque "en 6 qu'habillarrose Selavy," involving the rather Joycean pun 'éros, c'est la vie' (and less obviously, 'arroser la vie,' i. e., to water or hose down life, to make it thrive; so Barbara Lekatsas tells me). An unremarked reverberation however is a revision noticed by the literary critic Unterecker and corroborated by the semiotician Jakobson, whereby in 1925 William Butler Yeats introduced into his poem 'The Sorrow of Love' (1892), at the start of the second stanza, the phrase "A girl arose," echoed at the start of the third by "Arose . . . ," making for "a double vision of 'a girl arose' and 'a girl, a rose'" (R. Jakobson and S. Rudy, 'Yeats' "Sorrow of Love" Through the Years,' 1977; in Jakobson's *Language in Literature*, 1987).

As far as the doubling of the 'R' is concerned, it should not be disregarded that a doubling of consonants had quite swept Duchamp's family, what with both his brothers' name-changes embracing the doubled 'l' of Villon, and his sister, who already had a doubled 'n' in her Christian name Suzanne, acquired another double consonant with her married name, Crotti. Then too, we dare not forget the already willfully chosen doubled 't' of Mutt!

But if 'Rose' was to begin with a virtually ready-made name, one particular 'corrected readymade' by Duchamp relates particularly to his doubling of the initial 'R' as 'Rrose.' Before Duchamp doubled this 'R' he had already *singled*, so to speak, the double 'l' of a significant contemporary

French name in the work whose title is a prominent part of its image: *Apolinère Enameled*, made in New York in 1916–17. This piece consists of a thin sheet-metal advertisement for Sapolin enamel, with the lettering (and small bureau-mirror image) modified by Duchamp to refer to the poet and art critic Guillaume Apollinaire (and plausibly, Paul Signac's proto-abstract portrait of an important critic of the previous generation, *Against the* [N. B.] *Enamel of a Background Rhythmic with Beats and Angles, Tones and Colors: Portrait of M. Félix Fénéon in 1890: Opus 217*). Obviously, the single 'I' was *given*, even quite literally embossed, as such, with the trade name Sapolin; but it might have been adjusted, since one letter was suppressed and five were in fact added (flat) anyway. For one thing, anyone still newly surrounded by English print might well have been struck by the peculiar orthographic tolerance of just such spellings as 'enameled' and 'enamelled,' thanks partly to turn-of-the-century, so-called 'progressive' spelling reform in the United States. Then why not try out even the likes of 'Gui*l*aume Apo*l*inaire'? Furthermore, there is not only the fact of the kitschy American custom of rendering both men's and women's given names all too cutely unique by 'customizing' modification, but also the quite opposite possibility of Anglophiliac affectation, in analogy with the initially double-consonanted name 'ffrench' as rubbed-in *Norman* (so Marjorie Welish suggests).

Moreover (if not without risk of tedium): Duchamp is known to have been particularly amused with the initially double-consonanted English name 'Lloyd.' With 'Rrose,' could he even have been stimulated by thought of one particular Lloyd who had *dropped* just that as his real family name? There was reason for him to be talked about in the Dada orbit: Arthur Cravan, both boxer (sometime light-heavyweight champion of France) and Dadaist, born Fabian Avenarius Lloyd, had disappeared in 1917, only months after marrying the poet Mina Loy—who thus when styling herself Mrs. Lloyd would have bracketed, as if quoting, her own maiden name ('L-loy-d').

Whatever the provocations for the change from Rose to Rrose, the extended modernist aesthetic currency of the critical, 'counter-rose' motif continued through the 1920s. In an essay that Clive Bell published in 1922, 'The Artistic Problem,' the counter-rose becomes affirmative of the modernist self-sufficiency of the artwork, yet also of that self-sufficiency as so vitally cognitive as to owe nothing to beauty in the unreformed sense in which the rose had long seemed akin to art just because it was thought categorically beautiful: "We all agree now—by 'we' I mean intelligent people under sixty—that a work of art is like a rose. A rose is not beautiful because it is like something else. Neither is a work of art. Roses and works of art are beautiful in themselves." But while "a rose is the visible result of an infinitude of complicated goings on in the bosom of the earth and in the air above," with the implication that tracking them all would be futile, and unnecessary in the face of the "finished product," works of art are so innately cognitive that their very pleasurableness entails understanding why and

how they were brought about: "Personally, I am so conscious of these insistent questions that, at the risk of some misunderstanding, I habitually describe works of art as 'significant' rather than 'beautiful' forms. For works of art, unlike roses, are the creations and expressions of conscious minds" (collected in *Since Cézanne*, 1928). Once Roger Fry, the other great British formalist, was assailed by T. E. Hulme for acquiescing in the old all-roses-are-beautiful premise: "When Mr. Roger Fry . . . talks, as he did lately, of 'machinery being as beautiful as a rose' he demonstrates . . . that he . . . is in fact a mere verbose sentimentalist" ('Modern Art and Its Philosophy,' collected in his posthumous *Speculations*, 1924).

By the time André Breton paraphrases "Engels' classic example once again," from *Anti-Dühring*, in the 'Second Manifesto of Surrealism' (1930), it is clear that there are roses and counter-roses, and one wonders if a 'rrose' might be a neutralized form or rather a strengthened one, perhaps like the philosophers' 'iff' (= 'if and only if'): "'The rose is a rose. The rose is not a rose. And yet the rose is a rose . . . '" With the help of Engels, Breton is distinguishing dialectical, post-idealistic materialism, "which is the negation of a negation, . . . not the simple restoration of the former materialism," which was the gross, inert materialism that the old idealism had opposed (what he says has analogical bearing as a justification for the special form of representation found in surrealist art as no mere retreat from idealistic abstraction). Well, then, maybe by the doubling of its initial consonant the name of Rose, too, with its inevitable connotation, even in negation, of ideal beauty, was somehow renewed and refreshed, the induction of 'Rrose' at least offering respite from cliché—that, after all, being one of the stronger drives of early modernity.

MONSIEUR 'W. C.': AN INSIDE JOKE?

A peculiarly interesting problem of influence concerns Charles Demuth's important American modernist painting *I Saw the Figure 5 in Gold*, of 1928 (New York, Metropolitan Museum of Art), which has always been known to involve the poet William Carlos Williams, whose epiphany of a fire engine on Ninth Avenue in New York led to a poem, 'The Great Figure,' published in 1921, known to have stimulated Demuth. With *I Saw the Figure 5 in Gold* the painter celebrates his poet friend with graphically inscribed "BILL," "CARLOS" in lights on a building and the initials "W. C. W." as not only equated along with Demuth's own "C. D." signature at bottom left, but centered, while the painter's initials as much as step aside (with the further inscription "ART CO." appearing on a wall or the side of a truck). Is it possible that Duchamp, who was known to Williams, in the orbit of Walter Arensberg, from his earliest days in New York, played a cameo role in this famous American modernist duet between poetry and painting?

The question of influence begins on the poetry side, in that the painting is known to have been inspired by Williams' 'The Great Figure'—though as Gail Levin has noted, there is a precedent in a poetic text by a modernist painter, Kandinsky's *Klänge* (Sounds), of 1912, where the section titled 'Different' opens: "It was a big 3—white on dark brown" (trans. P. Vergo). Still further beyond, however, as Williams surely knew, was the celebrated 'Song of Myself' (1855) part of *Leaves of Grass* where Walt Whitman not only mentions "the sign painter . . . lettering with red and gold" (sect. 15), but also toasts some firemen: "Lads ahold of fire-engines and hook and ladder ropes no less to me than the Gods of the antique wars . . ." (sect. 41). Otherwise: Dickran Tashjian has noticed ('Seeing Through Williams: The Opacity of Duchamp's Readymades,' in D. Oliphant and T. Zigal, eds., *WCW & Others*, 1985) that in the prologue to Williams' *Kora in Hell*, which was originally dated 1 September 1918 (published in parts in 1919; as a book, 1920), and which also mentions *The Large Glass* of Duchamp, Williams calls Duchamp's *Fountain*, the notorious readymade urinal of 1917, "a representative piece of American sculpture" (with what an odd twist on 'representative'). Still, one might not start to wonder about a possible friendly inside 'bathroom' art joke playing on Williams' first two initials—'W. C.'—if it were not for a curious detail in Amédée Ozenfant's *Foundations of Modern Art*, originally entitled *Art* (1928): in an amusing double-page chart titled 'Literature in its Lyrical Aspects,' the works of seventeen modern French poets are pseudo-scientifically tabulated as to incidences of recurrent motifs under categories of weather, heavenly bodies, colors and "modes of transport." Under the last, two motifs are instanced as significant in the work of the poet Paul Morand (b. 1888): "A Locomotive all in Gold" and "The W. C. in the Orient Express."

Ozenfant's "Locomotive all in gold" and railroad "W. C." are all the more interesting in view of the fact that below the chart the translator of the 1931 English edition, John Rodker, would add the note: "The reader may find it an entertaining pastime to adapt this table to selected English and American Poets"—as perhaps, in effect, an American painter had already done? It is known that Demuth was working on *I Saw the Figure 5 in Gold* in May of 1928 and finished it in August. The original preface to *Art* is dated 1927–28. Now let's see, Who could possibly have had a copy of the French edition of that new book *Art* in New York?

GREEN BOX NO. '0'?

After the *Box* of 1914, with self-reproductions, Duchamp produced the documentary *Green Box* of private notes in facsimile (1934), and later the *Box in a Valise* (1941) and *À l'Infinitif* (1967), the latter also known as 'The White Box.'

It was in a volume of the nice old-fashioned pasted-in albums comprising the catalogue of the National Library of Ireland that I discovered several 1779 Dublin editions alone of an eighteenth-century curiosity, *The Green Box of Monsieur de Sartine, Found at Mademoiselle du Thé's Lodgings*, a (Butterfield) purporting to be an English translation of *La Cassette verte de Monsieur de Sartine, trouvée chez Mademoiselle du Thé*, but a political-pamphlet spoof apparently by one Richard Tickell mocking French sympathy for American independence. The box in question is taken as standard for diplomatic papers, here espied and pilfered from a distinctly erotic setting and concerning art: "Mademoiselle *Du Thé's* . . . femme de chambre, a little arch brunette, whose eyes seemed to require absolution, having opened the door, engaged the attention of my companion; so that without any inquiries from the maid, I slipped up stairs to be of equal service to the mistress. The toilet door being open, I walked in, in hopes of finding her there, but I soon saw my mistake; for upon one of the sophas I discovered a chapeau de bras and sword; which exciting my curiosity, I examined the room more closely, and, behind the veil of the glass (*sous le voile qui couvroit le miroir* [Fr. 2]), to my great delight, I perceived a *Green box*"(1–2). Secret memoranda inside the box concern how to distract Louis XVI with a mistress but also with the flattery of art: "Sometimes to . . . surpass, if possible, the flattering pencil of Le Brun—now to represent in allegory his protection of America under the form of a fountain with thirteen spouts watering (*fertilisant* [Fr. 9]) thirteen laurels—Invention must be wracked for new designs in medals; for example, His Majesty binding thirteen fagots—His Majesty a colossus, one foot at Paris, the other at Philadelphia. The misfortune is, it will be almost impossible to invent novelties: for, while Louis the XIV was at war with the Hollanders, he had almost as many medals in honour of his love of liberty, as he suffer'd defeats, for actually combatting against it (9). (Dublin: Printed by James Byrn and Son for the Company of Booksellers, 1779; French citations from *La Cassette verte de Monsieur de Sartine, trouvée chez Mademoiselle du Thé*, The Hague: La Veuve Whiskerfield [sic!], 1779).

APROPOS OF *ETANT DONNÉS*

ESPECIALLY THE WATERFALL ('*1ᵉ la chute d'eau*'). In the notorious treatise *Degeneration* (1893) Max Nordau insults Baudelaire for the love of the artificial, the sheerly unnatural, betrayed in his poetry: "Such is the world he represents to himself, and which fills him with enthusiasm: not an 'irregular' plant, no sun, no stars, no movement, no noise, nothing but metal and glass, i. e., something like a thin landscape from Nuremberg, only larger and of more costly material, a plaything for the child of an American millionaire suffering from the wealth-madness of parvenus, with a little electric lamp in

the interior, and a mechanism which slowly turns the glass cascades, and makes the glass sheet of water slide. Such must necessarily be the aspect of the ego-maniac's ideal world" (III.ii; 2nd ed., 1912). Not quite so close to Duchamp's piece but at least from a modernist is another dismissal of the very idea of the pseudo-aesthetic, hypernaturalistic artificial waterfall: Roger Fry, annotating the *Discourses on Art* of Reynolds, the great Neoclassicist theoretician, says in his introduction to Discourse XIII (1786), that in his day, at the opening of the twentieth century, one can no longer appeal to the theater in the matter of artistic deviation from nature as given because of excessive naturalism on the stage, the "introduction of a real hansom cab, a real waterfall, or what not," being considered "the proof of scenic completeness"; Roger Fry, ed., *The Discourses Delivered to the Students of the Royal Academy by Sir Joshua Reynolds, Kt.* (1905).

OVER AND OUT

There has been such an enormous proliferation of writing on Duchamp since this book first appeared in 1975 that a responsibly augmented bibliography wold be a major project in its own right. At least and at last it is possible for us all to refer to Arturo Schwarz, *The Complete Works of Marcel Duchamp*, 3rd edition, 2 volumes (New York: Delano Greenidge, 1997), with, besides a bibliography of works cited in this great catalogue raisonné itself, a bibliography of new writings published between 1969 and 1995, in supplementation of Schwarz's first (1969) and second (1970) editions, and also an exhaustive listing of exhibitions.

Although it did not in the end prove possible to produce an expanded new edition, it is at least possible to mention, for their intrinsic worth and interest and also out of gratitude toward their authors for cordially entertaining my propositions, several very different texts from which, had expansion been feasible, I was especially keen to include selections: Craig Adcock, *Marcel Duchamp's Notes from the Large Glass: An N-Dimensional Analysis* (Ann Arbor: U. M. I. Research Press, 1983); Paul Crowther, *The Language of Twentieth-Century Art: A Conceptual History* (New Haven: Yale University Press, 1997); Thierry de Duve, *Kant After Duchamp* (Cambridge, Mass.: M. I. T. Press, 1996); Amelia Jones, *Postmodernism and the En-Gendering of Marcel Duchamp* (Cambridge: Cambridge University Press, 1994). Also one particular article from among the many 'applications' of Duchamp to contemporary art: Barbara Maria Stafford, 'Coldness: Renoir / Duchamp / Gober,' *Art + Issues*, March-April 1988. And I can note two texts of my own: 'Two Blasts from the Past in Picasso (and Yes, Marcel, You Too)' (1985), in my *Modernities: Art-Matters in the Present* (University Park: Pennsylvania State University Press, 1993), and an extensive reconsideration of Duchamp's never really broken connections with the realm of

abstract painting: 'Duchamp in the Abstract,' *Art Press* (Paris) no. 178 (March 1993), international edition, with translation by Frank Straschitz as 'Duchamp dans l'abstraction.'

At the end of the first preface I originally thanked my since deceased friend Bjørn Robinson Rye, writer and artist, for helping me with something else while I was working on this project: a *dacha* in the Catskill Mountains in which I did some of the writing for this book and that now, twenty-five years later, still stands,—though on its last legs, so that a perhaps somewhat more abiding monument to his blessed memory can be the hereby augmented re-publication.

<div style="text-align: right">

Joseph Masheck
New York
28 July 2000
Duchamp's Birthday

</div>

INTRODUCTION: CHANCE IS ZEE FOOL'S NAME FOR FAIT

Joseph Masheck

BORN TO ART

Normally we assume that revolution occurs quickly and disruptively, whereas evolution is gradual and painless. Marcel Duchamp was not a revolutionary artist in the sense of swiftly and radically changing the course of the mainstream of art, in the manner of Picasso. However, there is a sense in which revolution seems historically inevitable, while evolution demands creative guile.

An evolutionary sequence is really a network of catastrophes: development occurs through an irregularity that escapes a general peril. Evolution moves by collisions, weaknesses, failures, accidents; it only looks tidy and teleological after the fact, and to an outsider. Similarly, Duchamp's career has its stalls, lurches, and burn-outs, with development evidencing itself only after mutations and adjustments have occurred. Hence, if we simply lined up the few most significant of all Duchamp's works and characterized them, it would be impossible to locate all the lesser works accurately on the curve thus plotted. It is not that Duchamp was doing too many things, often at the same time, to jell as an artistic personality. It is that his work always took place in a context, and contexts change: he was fond of the notion of *delay*. For Darwin, changing circumstances were the very causes of the catastrophes that produce evolution.

Marcel Duchamp was born in France, near Blainville (Calvados) on July 28, 1887, the son of a provincial lawyer. Rouen was his first metropolis—the Rouen to which Madame Bovary slipped off in Flaubert's novel, subtitled *Patterns of Provincial Life*. It was Flaubert, in fact, who wrote "Quelle lourde machine à construire qu'un livre, et compliquée surtout," a sentiment that has its counterpart in the com-

1

plexities and mock-machinery of Duchamp's masterpiece, *The Bride Stripped Bare by Her Bachelors, Even* (alias, the *Large Glass*) (Fig. 17). In *Madame Bovary* the house of the notary—or lawyer—was the epitome of provincial bourgeois accomplishment and taste; the pharmacist personified the unchallenged, pseudo-rationalist country intellectual, in a little town called Yonville-l'Abbaye, 20 miles from Rouen. Duchamp, the lawyer's son, made a ready-made in Rouen in 1914, *Pharmacy*, consisting of a cheap commercial print—what passes for art in the provinces—"corrected" by the addition of two small marks, one red and the other green—like the red and green fluids in jars displayed by pharmacists.

The economic situation of the Duchamp family, so far as it affected Marcel, both established a plane of security and encouraged self-sufficiency and living economically. Not having to live by his wits at first, he had the chance to learn to live by his wit. For Duchamp's father did support him when he decided to become an artist, but with the provision that the funds supplied would be deducted from his inheritance. Duchamp also began life with another kind of limited capital: he was always considered noticeably handsome. Even late in his life Duchamp's striking "Continental" profile added to his charm. Thus capital allowed for an investment in artistic confidence (covered by progressive frugality), while comeliness compounded a beneficial grace and charm. There is no reason to exaggerate these circumstances, but without them as *givens* Duchamp would not have been the Duchamp we know.

The career begins with some undistinguished landscapes painted in his hometown just after the turn of the century. Unremarkably competent, they are hardly as promising as the early landscapes of country churches by Delaunay and Mondrian, with which Duchamp's *Church at Blainville* (1902) can be compared. Throughout the rest of the first decade Duchamp also drew journalistic illustrations, but they would be of only period interest if they weren't by him. In 1910 the young artist was painting in a hipper, more Fauve mode, especially nudes, and in the same year he painted some portraits, one of which —*Artist's Father, Seated* (Fig. 1)—recalls Cézanne's portraits of his father in a rather conservative way.

Chess Game (alias *Chess Players*), painted in August 1910, is a portrait of Duchamp's two artist brothers, Jacques Villon (born Gaston Duchamp) and Raymond Duchamp-Villon, playing chess while their wives rest and wait. It has overtones similar to those of *Artist's Father, Seated*; here there is the resemblance of the two brothers arched over the game table to the various *Card-Players* of Cézanne, and also perhaps the suggestion of a resemblance between either of the bearded brothers and Cézanne himself. Artistically this has little to do with

Cézanne. Like most of Duchamp's works of the time, it uses pasty, pastel-like patches of paint to fill in the figures. Perhaps in retrospect the feature most charactristic of Duchamp is the cross-pairing of figures and objects: a high, dark table (with husbands) *versus* a low, light table (with wives); the males in a tight, concentrated downward arc, the females in a loose, relaxed, open, upward arc; alternate pairing of males and females; and an analogy between the two visible chairs (one a man's, the other a woman's), with the respective men's and women's tables. This interest in permutative moves held in static check may seem to adumbrate Duchamp's mature art, just as his artistic interest in the family chess game looks forward to his legendary reversion to the game of chess in its own right.

In 1911 a number of Duchamp's paintings show Symbolist overtones, but more along stylistic lines than in terms of heavy mythopoeticism. Indeed, a work such as *The Thicket* (Fig. 2), begun just before the New Year, suggests pictures in a similar vein by Arthur B. Davies in America, almost as though Duchamp were preparing himself for integration into the American scene.

The influence of Cubism also made itself felt in 1911, as in such still symbolistic pictures as *Spring* (alias *Young Man and Girl in Spring*), and more thoroughly and consistently in *Sonata* (Fig. 3)—a group portrait of Duchamp's mother and sisters playing music—and *Portrait*—which shows the same sitter in five positions at different moments in time and which evokes the water color technique of Cézanne. Most of these works are not impressively beautiful, an exception being the (also symbolistic) *Yvonne and Magdeleine Torn Up* (Fig. 4). Like many fine cubist paintings, they are dim in color; but they are not ingeniously put together. Robert Lebel has tended to overestimate their accomplishment in order to lend Duchamp's turn away from Cubism an heroic or at least cavalier character. But it is possible to recognize their inferiority and then consider that Duchamp himself may well have understood that they did not measure up to the masterpieces of Analytical Cubism already accumulating in Paris. Together with Duchamp's participation with his older brothers Jacques and Raymond in the Section d'Or, this points in the direction of another explanation.

In brief, the Section d'Or (Golden Section), whose name was probably coined by Jacques Villon, was a circle of Cubist painters who met, especially in 1910 and 1911, in the studios of Jacques and Raymond at Puteaux, a suburb of Paris. The participants included the three Duchamps, Delaunay, Gleizes, La Fresnaye, and Metzinger, as well as Léger and Picabia. The Section d'Or is part of the history of Cubism, and yet there was a certain strain between it and the definitive Cubists, Picasso and Braque, who declined to exhibit with the

group's Salon in 1912. The Puteaux painters were more conservatively interested in what were really post-Impressionist ideas, and they were more involved with geometry, as the title—which is also lightly evocative of the Symbolists' Salon de la Rose+Croix—hints. If the group's ideas would have struck Picasso and Braque as overly theoretical, conservative or distracting, it nevertheless held within it—in Duchamp and Picabia and to some extent Léger—seeds of Dadaism, which before very long was to assault the old-masterly trappings of even superior Cubist painting. Similarly, Duchamp's own painting *Yvonne and Magdeleine Torn Up* is both symbolistic in style in proto-Dadaistic in implication, for its title suggests a mockery of Cubist fragmentation and the institution of a much more direct iconoclastic kind of formal disassembly.

Duchamp was cerebral. In a sense he was a mute critic and aesthetician whose works were plastic rather than verbal: although he is commonly thought of as a conceptual plastic artist, much of his work is really reflection concretized. It is easy to imagine the young Duchamp in a frame of mind like that of the dialogues in *Intentions: Essays* (1905) where Oscar Wilde maintained that criticism is at least as creative as art and even more necessary to culture, and that art except for criticism may be running out of steam anyway.[1] In any case, no one as sensitive and intelligent as Duchamp could have overlooked the aesthetic limitations of his own competent but undistinguished art up to that point. He must have seen that he could not go much further as a painter pure and simple. That, in turn, may well have reflected on the future of painting in relation to critical activity. His first great work—still an easel painting—emerged in this context of shy but maverick Cubism, reflections, and doubt: the *Nude Descending a Staircase* (Fig. 8).

THE NUDE DESCENDS

Nothing did more to establish Duchamp's reputation in the United States as an exponent of artistic modernity than the exhibition of his *Nude Descending a Staircase, No. 2* (1912) at the Armory Show in New York in 1913, where it was mocked in a cartoon ("The Rude Descending a Staircase") in the New York *Sun*, called an "explosion in a shingle factory" by Julian Street, and discussed more intelligently

[1] See especially "The Critic as Artist; with Some Remarks upon the Importance of Doing Nothing" and "The Critic as Artist; with Some Remarks upon the Importance of Discussing Everything." In Oscar Wilde, *Intentions* (New York, 1912), pp. 93–217.

by Theodore Roosevelt.[2] The Cubistic qualities of the work have often
been commented upon. However, it is symptomatic of Duchamp's
position in French art at the time that before its appearance in
America the picture had already been withdrawn from the 1912 Salon
des Indépendents on the objection of more orthodox Cubists. It got
shown in a Cubist exhibition in Barcelona before finally being exhibit-
ed under the auspices of the rather suburban Parisian Section d'Or.

Certainty and contradiction invade one another in sequences of
works as well as in individual works by Marcel Duchamp. Even the
art-historical facts of the development of the *Nude Descending a
Staircase* suffer infiltration by impossibility, unlikelihood, and irony.
It is as if there were a subversive magnetic field around the object,
capable of undermining facticity in circumstances of undeniable
concreteness.

On paper the sequence of studies for the *Nude* looks clear. Sup-
ported by remarks of the artist, the origins of the *Nude* are estab-
lished as follows. In November of 1911 Duchamp made a pencil
sketch (Fig. 6) based on a poem by Jules Laforgue called "Encore à
cet astre" ("Once More to This Star"). In December he painted two
pictures, the *Nude Descending a Staircase, No. 1* (Fig. 7) and *Sad
Young Man on a Train*. From "Encore à cet astre"—the drawing—
comes the basic motif of the figure on a staircase, although in the
drawing the figure is ascending rather than descending.

The *Sad Young Man on a Train*, a male counterpart to the female
standing figure of the *Nude*, is a highly problematic work. On the back
of the canvas, along with the title and signature, Duchamp made the
notation "Marcel Duchamp nu (esquisse)" ("Marcel Duchamp nude
[sketch]"). The autobiographical overtones of the picture are acknowl-
edged, but not the fact that the young man may well be mastur-
bating: his penis occupies a prominent place in the center of this
scene on a jouncing train; it bends slightly upward on its downward-
angled axis and an arc of dots trails down from the organ. (This is
similar to arcs of dots in the *Nude*, which have been traced to chrono-
photographic sources). A genital reading of the young man has im-
portance for the later work of Duchamp as well as for the autobio-
graphical content of the picture. For instance, it relates to the ready-
made urinal exhibited by Duchamp as *Fountain* in 1917, to the sexual
content of the *Large Glass* ("The bachelor grinds his chocolate him-
self"), and to the erotic sculptures that he made late in life. Similarly,
the pictorial interchangeability of the young man with the female nude

[2] See Joseph Masheck, "Teddy's Taste; Theodore Roosevelt and the Armory Show,"
Artforum, IX, No. 3 (November, 1970), 70–73, with editorial correction, IX, No.
4 (December, 1970), 8.

relates closely to Duchamp's androgynous postures, such as his adoption of the pseudonym Rose (later Rrose) Sélavy ("arrose, c'est la vie") in 1920 and his drag self-portrait on a perfume bottle label, *Belle Haleine, Eau de Voilette* (1921).[3]

In the *Nude . . . No. 1* a joggling, semiabstract figure steps down a literally rendered staircase with spiralling banister. In the *Sad Young Man* the figure is more radically decomposed into its purely plastic aspects, and there is no reassuringly nonabstract setting. The severe lurching of the young man and his consequently more obscured legibility have to do with the narrative content of the picture —the violent, almost audible jouncing and rattling of the train, and perhaps the act of masturbation in human analogy with it—just as the increase in both legibility and abstraction in the *Nude . . . No. 2* derives from and depends upon scientific studies of the human body photographed in steady, regular movement.

The definitive (but not final) version of the *Nude Descending a Staircase*, the version identified as *No. 2*, was executed in the following month, in January of 1912. Or so the story goes. This is the version that was rejected by the official cubists and whose Cubist and quasi-futuristic stylistic features have been discussed ever since. The forms of the figure in *Nude . . . No. 2* have over the years taken on a similarity to the time-yellowed, now opaque, celluloid forms of early Constructivist sculpture—which, like Futurism, was another international derivation out of Cubist impulses. This is the painting that had made such an impact in France and then here, that when Duchamp first arrived in New York in 1915 he was already considered an important and radically modern artist.

When the *Nude . . . No. 2* was sold at the Armory Show to another collector, Walter Arensberg regretted not having been the one to buy it. Duchamp obliged with a full-sized facsimile, a photograph doctored with watercolor, ink, pencil, and pastel, which thus became the *Nude Descending a Staircase, No. 3* (Fig. 21), in 1916.

[3] The rose is a recurrent motif in the literature of early twentieth-century art. Besides possibly recalling the mystical *Rose+Croix* Duchamp's *nom-de-plume* is reminiscent of Gertrude Stein, who wrote the line "A rose is a rose is a rose" into her play *Sister Emily* in 1913 (pub. in *Geography and Plays,* 1922). Clive Bell, in formulating the notion of significant form, asked the question, "For, after all, what is a rose? What is a tree, a dog, a wall, a boat?" in *Art* (1913), and in *Since Cézanne* (1922) Bell compared a work of art to a rose as being "the result of a string of causes." By 1920 Marcel was the last Duchamp to alter his name, even Suzanne having automatically done so by marrying Jean Crotti. Marcel remained a bachelor until the age of forty, and there may be the idea of marriage to his art attached to his name Rose. The switch from Rose to Rrose, involving amusement at the Anglo name "Lloyd," was also stimulated by a pun Duchamp contributed to a work Picabia was making in Paris: "En 6 qu'habillarrose Selavy."

Typical of Duchamp is this work's self-illustrative and self-reproductive function, as well as the fact that as an actual photograph it returns to one of the technical sources of the "original" painting. But the last *Nude Descending a Staircase*—except for those reproduced in Duchamp's boxes of reproductions (Should they be counted or not? How could we decide?)—is the *Nude . . . No. 4.* This is a miniature drawing in ink and pencil made by the artist for the dollhouse of Carrie Stettheimer in 1918, thus returning the sequence to its ultimate origins in a small sketch.

In this account all the works until the colored photographic version (*No. 3*) were made at Neuilly, outside Paris; the last two were done in New York. The dates seem firmly established, even though key individual pieces carry incorrect dates: *Encore à cet astre* (1911) (Fig. 6) is signed 1912, with an inscription dated 1913; *Nude . . . No. 1* (1911) does carry the date 1911, but the *Sad Young Man on a Train* (1911) is signed 1912. Duchamp himself, toward the end of his life, showed a lofty and playful carelessness about the dating of these works. In an interview with Pierre Cabanne he said, "When you compare the dates, you say 'that's impossible.' An amusing mess." [4]

This seems all the more curious because there is an uncanny relation between "*Encore à cet astre*"—the preliminary sketch—and a famous American painting of the eighteenth century which hangs in the Philadelphia Museum of Art, along with Walter Arensberg's splendid collection of Duchamp's works, including here all but the *Sad Young Man* (Venice, coll. Peggy Guggenheim) and the *Nude . . . No. 4* (Museum of the City of New York). A main feature of Charles Willson Peale's *Staircase Group: Raphaelle and Titian Ramsay Peale* (1795) (Fig. 5) is the extreme, quasi-Dadaistic, illusionism by which the imaginative space of the picture invades the real space of the gallery: a real wooden step (now reconstructed, but originally planned) extends out from the bottom of the canvas, becoming the bottom step of the illusionistic staircase which the Peale boys mount.

To compare "*Encore à cet astre*" with the old American painting by Peale would seem altogether fortuitous if certain analogies were not so insistent. Duchamp's drawing is remarkably close to Peale's *Staircase Group,* in the poses and in the fact that the primary figure in Peale's picture is ascending, as in the drawing (and, before it, Laforge's poem) but not as in the *Nude.* Even the legs of the two figures in the drawing resemble the tight eighteenth-century knickers of the Peale boys. When "*Encore à cet astre*" is juxtaposed with the American painting, the two seemingly nonreferential patches of hatching at the

[4] Pierre Cabanne, *Dialogues with Marcel Duchamp,* trans. Ron Padgett (*The Documents of 20th Century Art*) (New York, 1971), p. 46.

upper right appear to take on a highly literal descriptive function, indicating the planes of the walls—and even the wallpaper—in the enclosed Philadelphia-type stairwell of Peale's painting. Can we ever understand the uncanny relation of the two works?

The fact that the subjects in Peale's double portrait are both young men also calls into play an association with the *Sad Young Man on a Train* and his place in the development of the *Nude Descending a Staircase*. Duchamp had not yet been to America when he drew *"Encore à cet astre,"* unless all three of its dates (1911, the signature date 1912, and the inscription date 1913) could conceivably be wrong. It is possible that Duchamp could have seen a reproduction of *The Staircase Group* in France, perhaps in investigating the art history of the country which he was to make his second home.[5] Also, Thomas Eakins, another Philadelphia painter, had practiced chronophotography long before Duchamp's involvement, and Eakins (d.1916) was still alive. Furthermore, in Duchamp's mind-boggling door closing on three rooms—*Door 11 rue Larrey, Paris* (1927)—there was a step flush up against the jamb of the bathroom, like the second step in Peale's *Staircase Group*.

Perhaps these speculations are as overly complicated as they are enticing. As such, they surely demonstrate the capacity of Duchamp's works to center attention on the almost frustrating actuality of the object itself, and to subvert the elusive and sometimes fantastic relations between it and other things. Behind Duchamp's severe distrust of fact is a core of common sense; or else, the two attitudes succeed one another like the layers of an onion. One kind of factuality is undermined in favor of another.

Duchamp was not the only French artist excited by the transatlantic potential of the Armory Show. Delaunay, who had anticipated the painting-in of the title onto the canvas of the *Nude Descending a Staircase* with his first *Eiffel Tower* of 1909, manifested his Franco-American optimism in the sign lettered "New York-Paris" in the *Third Version* of *Cardiff Team* (1913). Delaunay shared this transatlanticism with Duchamp and with such men of letters as Apollinaire and the poet Blaise Cendrars—who came to describe Dada as a "people rejoice star" that was "hurled upon the Cubist tinkle-dance." Duchamp knew Delaunay from the Section d'Or, and Apollinaire remembered the two discussing the idea of simultaneity with others in 1913. The *Large Glass*, Duchamp's masterpiece, can even be related in a conceptual way to the important *Windows* series which Delaunay began in 1912. In Delaunay's *The Cardiff Team* of 1912–13, the prominent

[5] Duchamp might have reversed Stein's "America is my country and Paris is my home town": France was his country and New York was his home town.

word "ASTRA" on a billboard may suggest *"Encore à cet astre"*; with more formal significance, the interrupted form of a ferris wheel and superimposed biplane in the same work compares with the watermill on glider in the *Large Glass.*

The reputation of the *Nude Descending a Staircase,* like its own development, is unexpectedly complicated, mostly because it is so difficult to separate the *Nude's* notoriety from its status as an admired work of art. We might suppose the notoriety derived exclusively from mistaken opposition to the picture in 1913 as being ugly or iconoclastic. The difficulty is that the idea of unacceptability held a certain positive appeal in the art world. If the middle classes like it, something must be wrong with it. To really succeed one had first to attain rejection. In such circumstances admiration and condemnation become ironically confused.

Only this can account for the fact that more than one advocate of progressive art later found himself talking seriously about the *Nude Descending a Staircase* in the same breath as Paul Chabas' well-known shivering female nude, *September Morn* (1912). Chabas' notorious barroom Venus taking a sponge bath by the water's edge is famous both as artistically reactionary and also as scandalously lewd—as though lewdness equalled modernity (on grounds of bohemianism). Oliver Sayler, in his *Revolt in the Arts* (1930), spoke of painters and sculptors as having been "long-suffering victims of specious curiosity ever since Duchamp's 'Nude Descending a Staircase,' Chabas' 'September Morn,' and Brancusi's 'Bird in Space.' . . ." That seems like an improbable sorority until we realize that it was purely the notoriety of the Brancusi sculpture—the blocking by U.S. Customs of its admission as a work of art—that it had in common with the works of Chabas and Duchamp.

Similarly, in an unpublished lecture called "And the Nude Has Descended the Staircase," delivered at the Museum of Modern Art, Marsden Hartley discussed *The Nude Descending a Staircase*:

> . . . the picture which was the butt of ridicule for the now so famous Armory show here in New York, and like the other picture that bothered so many people, Paul Chabas' "September Morn," which now of course no one thinks of, and you may find it in life size form in stained glass in a certain villa in Mexico City in the house of a mestizo of course, and while we are thinking of this the "Nude Descending" would be fine put in stained glass also, and who knows perhaps this will yet happen, as there are always or every now and then, epidemics of something or other.[6]

[6] Marsden Hartley, "And the Nude Has Descended the Staircase," in his *The Spangle of Existence; Casual Dissertations,* unpublished typescript in the library of the Museum of Modern Art, p. 108. Quotation by the kind permission of Miss Norma Bergen.

As we follow Hartley's remarks we cannot but think of the relation of the *Nude* to *The Bride Stripped Bare by Her Bachelors, Even* (the *Large Glass*) of 1915–23. Nevertheless, Sayler and Hartley were at least as struck by the simple fact that Duchamp had bucked the establishment as by the content of his art or the form that it took. Except that it also deals with a standing female nude, only the moral offensiveness of Chabas' painting allowed it to be categorically compared with Duchamp's on grounds of modernity.

From the *Nude Descending a Staircase*, with its wittily mechanistic presentation of the lurching human figure, Duchamp developed the biomechanical figure further, into an entity at once figural yet mechanical (like a suit of armor or a robot), man-made yet pseudo-organic (like chemical equipment or artificial vital organs). Works of this kind include the painting *King and Queen Surrounded by Swift Nudes,* drawings of the *Virgin,* and paintings of *The Passage from the Virgin to the Bride,* all from 1912. They contribute at a very early time to a critical suspicion of biomechanistic ideas later formulated by Karel Čapek's play *R.U.R.* (Rossum's Universal Robots) of 1921.[7] Also, from Duchamp's biomechanistic figures of 1912 ultimately derived Jean Tinguely's monumental "self-constructing and self-destroying work" *Homage to New York,* complete with Duchampian bicycle wheels, which wrecked itself according to plan in the garden of the Museum of Modern Art in March 1960.

READY-MADES

The *Nude Descending a Staircase* may have announced Duchamp's modernity, but his most original contribution to the history of art was the ready-made. A ready-made is an ordinary manufactured object singled out and exhibited as art. The fundamental idea that value can be gleaned from unpromising sources was far from new (Shakespeare: "All places that the eye of heaven visits/Are to a wise man ports and happy havens," *Richard II,* I.iii.275–76). What was new was having nonaesthetic sources rise to the nobility of art with practically no artistic intervention. Duchamp's common objects selected from the real world vivified certain Cubist ideas about the reality of the art object. The wit was in making a common object as remarkable as an art object and making a work of art as real as an ordinary thing at the same time.

Essential Cubist notions of the objective reality of a painting de-

[7] Biology itself was under the influence of mechanical metaphor around 1912. See, for example, Félix LeDantec, *La "Mécanique" de la vie* (Paris, 1913).

rived ultimately from post-Impressionism. Highly conceptual Cubism focused on these issues more urgently and, especially towards 1912, in a more critical way. Then in May of 1912 Picasso made the first collage, the rope-framed *Still Life with Chair Caning*, attaching to the canvas a piece of real oilcloth, yet one which, by a nearly Duchampian irony, actually *represented* chair caning. If Picasso, who had the benefit of Braque's moves in the direction of collage shortly before, had entitled the picture *Still Life with Oilcloth*, it could almost have been the first ready-made as well as the first collage. Although Cubism had showed the capability of painting to *pre*sent reality as well as *re*present it, the concept of the ready-made allowed Duchamp to introduce maximum *pre*sentation and to reduce representation to the amusing redundancy of each object fully, accurately, and effortlessly representing itself both as a unique entity and as representative of some class of objects. This move involved an outwitting of Cubism in a chess-like way, where Duchamp had not done terribly well in the earlier stage of the painters' game. And it involved still more wit by overthrowing representation without resorting to abstraction, which in 1913 was coming into its own.

If a ready-made is an amusingly self-representational sculpture, trivial in its motif, it is still sculpture nevertheless. Too much attention has been paid to the question of whether the ready-made asserts or denies art, of whether it is in itself an art-object or a counter-art-object. To deal with the ready-made as sculpture is a more subtle problem, even if its sculpturality seems absurd.

As soon as we admit Duchamp's ready-mades to the history of sculpture other insights emerge. It was Rodin who in the early years of modernism had developed the idea that practically every model is potentially beautiful as subject matter for sculpture. For Rodin beauty became virtually coextensive with the whole of life. Of course Rodin still assumed figuration, but his point was taken in opposition to the pseudo-classical tradition of a small number of subjects of implicit and guaranteed aesthetic value. In other words, Rodin's radically inclusive attitude toward the subject matter of sculpture opened the door through which the ready-mades eventually passed.[8]

In one case a ready-made abstractly resembles a sculpture by Rodin himself. Duchamp's *With Hidden Noise*—in French, *À Bruit secret*—(1916) is an "assisted ready-made" consisting of a ball of twine clamped by bolts between brass plates, with a mysterious object in-

[8] Rodin himself, speaking of his deliberate violation of academic poses in his *Walking Man* or *St John the Baptist*, said, "I only copied the model whom chance had sent me." Albert Elsen, ed., *Auguste Rodin: Readings on His Life and Work* (Englewood Cliffs, N. J., 1965), p. 166.

serted by Walter Arensberg to rattle inside. As a cylindrical form tightly clasped by a pair of embracing elements it compares with Rodin's *The Secret* (Fig. 19), of 1910, where a geometrical, piston-like cylinder is firmly enclosed by a pair of hands. If Rodin's sculpture seems to differ too extremely in kind and form from Duchamp's, both are nevertheless very much involved with the sculptural idea of *clasping* a cylinder and with secrecy. Duchamp himself produced an etching of Rodin's *The Kiss*, modified and entitled *Selected Details After Rodin* (1968).

There are also certain surprising affinities between Duchamp and Brancusi, the prince of modernist abstract sculptors. Both sent exhibits to the Armory Show in 1913. (Stieglitz had a Brancusi show in his Photo-Secession Gallery in New York in the next year.) When the first sale of the John Quinn collection took place in Paris in 1926, Duchamp was invited to go to New York to arrange a Brancusi exhibition of works he had helped to purchase in Paris; he arranged another Brancusi show, again at the Brummer Gallery, in 1933.

Duchamp's difficulties with his *Fountain* (1917), the famous ready-made urinal (signed "R. Mutt") which was rejected by the hanging committee of the New York Independents,[9] have a parallel in the rejection as obscene of Brancusi's *Princess X* (1916)—abstract, but quite as genito-urinary in form—in Paris. When U.S. Customs maintained that Brancusi's works were not art, Marcel Duchamp carried fifteen of the sculptor's works back on board ship to take them back to France and then on to an exhibition in Berlin. The New York *Times,* in its account of February 27, 1927, spoke of the sculptures Duchamp carried as being by "his friend Constantin Brancusi."

Brancusi's *The Kiss* (1908), in the Arensberg Collection, is one of the pieces whose acquisition at the Quinn sale Duchamp arranged. Thematically it relates to Duchamp's ink and charcoal *Study for Chess Players* (1911), which simultaneously represents two figures playing and two faces kissing, although the kiss motif was in wide currency from the turn of the century. In our own day, when Claes Oldenburg parodied Brancusi's *Kiss* in his print *Proposal for a Colossal Structure in the Form of a Clothespin—Compared to Brancusi's* KISS (1972) he used, in combination with a photograph of Brancusi's sculpture, a clothespin whose form is much like the figure identified by Duchamp as the "cuirassier" in his first *Cemetery of Uniforms and Liveries* (1913) study (Fig. 12) for the *Large Glass.*

Duchamp began making ready-mades in Paris in 1913, coined

[9] Richard Hamilton has pointed out that it was *present* at the exhibition, but behind a partition. See his entry in the Arts Council of Great Britain exhibition catalogue, *The Almost Complete Works of Marcel Duchamp,* 2nd ed. (London, 1966), cat. no. 126.

the term "ready-made" in New York in 1915—for *In Advance of the Broken Arm*, a snow-shovel—and first exhibited the works as such at the Bourgeois Gallery (!) in New York in 1916, in a climate that for its own American reasons was already attuned to the idea of iconoclastic or anti-aesthetic subject matter in art. At the time of the Armory Show Robert Henri, for instance, had been advocating a radically inclusive attitude toward the subject matter admissible to painting. Stuart Davis noticed that for many painters of the time radicalism of subject matter actually became a distraction from abstract values, so that this otherwise progressive tendency had an ironic cut. Thus the ready-mades of Duchamp shared in a crucial dilemma of American art at the very time at which they joined it.

Actually, the ready-mades seem much more American than European, and Americans have probably had an easier time with them than Europeans. When Yeats saw the premiere of Alfred Jarry's proto-Dada play *Ubu Roi* in 1896 (for which Duchamp designed a bookbinding in 1935), he was bothered by the fact that the King's sceptor was "a brush of the kind that we use to clean a closet." [10] Even as late as 1960, the director of the Kunstgewerbemuseum, Zurich—which normally exhibits applied art and design rather than art—could experience unaccustomed "laughs and smiles, little shocks and large wonders" on unpacking Duchamp's ready-mades. No doubt a people used to lawn planters made from tires, chandeliers from wagon wheels, and barstools from milk cans, is more predisposed to the ready-made idea than one dominated by conventional artistic taste: both approval and rejection can become wittily reversed and intensified. Duchamp's affection for America could sometimes be patronizing, but it was real.

The essential commonness of the objects selected as ready mades was also related to the everyday working aesthetics of the Ash Can School of painting in New York. Those painters of the grubby actuality of city life acquired their collective tag in the very month in which Duchamp unveiled his ready-made art in New York, April, 1916. In the same year Hugo Münsterberg used the actual word "ready-made" in connection with the convincing representation of real life in the cinema. In his essay *The Photoplay; a Psychological Study* (1916) Münsterberg hailed the freedom from theatrical artificiality of the new art of film: if the producer "needs the fat bartender with his smug smile, or the humble Jewish peddler, or the Italian organ grinder, he

10 Quoted in Edgar Wind, *Art and Anarchy*, rev. ed. (New York, 1969), p. 113 n. 16. Yeats's remark has a scatological implication if he meant a *water*-closet brush, which is possible: Jarry had been quite struck by such brushes on latrine duty in the French Army; see Anthony Powell, "Proust as Soldier," in Peter Quennell, ed., *Marcel Proust 1871–1922: A Centennial Volume* (New York, 1971), p. 151.

does not rely on wigs and paint; he finds them all ready-made on the East Side." [11] It is not so far from the Ash Can attitude to the exhibition of a sanitary appliance as sculpture, especially when we note that —as with "dustbin" in Britain—"ash can" is a euphemism for a messier *garbage* can.

In one of his notes Duchamp proposes a "reciprocal ready-made": use a painting by Rembrandt as an ironing board. This unexecuted project has many implications. It obviously relates to the "corrected ready-made" *L.H.O.O.Q.* (1919), an ordinary photographic print of Leonardo's *Mona Lisa* with moustache and goatee added, whose title pronounced is, loosely, "She has a hot piece of tail" (also a late revision, without whiskers, *L.H.O.O.Q., Shaved* [1964]). There is a loss of confidence in the glory of painting, generating a hip iconoclasm in compensation for square idolatry. There is an assault on the detached, bourgeois idealization of reality, of which the use of art as a pseudo-spiritual escape from the world of business, and the abuse of the artist as an estranged oddball, are merely aspects. A stretched, thickly coated canvas could certainly be used as an ironing board if anyone wanted to be utilitarian in the extreme. The only obstacles would be expense and the hilariously ironic fact that Rembrandt's *painterliness* (normally of purely visual concern) would make it bumpy.

It is important that Duchamp mentioned Rembrandt in particular for this projected idea. Surely Rembrandt is the greatest exception to classical theories of selectivity and to modern theories of pure form. For instance, Sir Joshua Reynolds, in his sixth *Discourse* (1774), encouraged young art students by saying that it is sometimes possible to produce great work despite inadequacies in theory or method, using Rembrandt's very indiscriminateness of subject as an example: if one "makes no selection of objects, but takes individual nature as he finds it, he is like Rembrandt." The ready-mades are also about taking reality as one finds it, although the reality in question is the landscape/still life of man-made objects, from which some are borrowed like anonymous "portraits." In the time of Rembrandt painting still had a preservative function, later subsumed by photography. The ready-mades show us that representation is normally a redundancy, and to that degree they share in more conventionally modernist trends in

[11] Hugo Münsterberg, *The Film; a Psychological Study; the Silent Photoplay in 1916* (New York, 1970), p. 50. William James, also at Harvard, had used the adjective to describe spiritualistic believers: "They simply find various characters ready-made in the mental life, and these they clap into the Soul. . . . The soul invoked, far from making the phenomena more intelligible, can only be made intelligible itself by borrowing their form. . . ." William James, *The Principles of Psychology*, I (1890; Reprint. New York, 1950), p. 347.

painting and sculpture. Where they differ from abstract art, however, is in their fully prosaic gratification of the desire for recognizable form at the very moment when it is finally abolished for aesthetic purposes.

With Duchamp the selection process was evidently not governed by an "artistic" standard, but instead by a more practical sense of both typicality and careful randomness—like the accurate tables used in applied mathematics to insure that one is working with truly random numbers. The ready-mades are philosophically *realistic*: they imply that objects like bottle-racks or urinals are categorically interchangeable and hence, that reality is connected and continuous. Yet they are also philosophically *nominalistic* because they undermine the possibility that any two objects might be fully identical. The paradox is not futile but fecund. It refuses to dissolve into absurdity because it sustains thought, common sense, and even a kind of intellectual good taste. Duchamp envisioned the range of the ready-mades as gradually expanding until coextensive with the whole galaxy of objects surrounding us. But the initial instances had to be chosen with consideration, and their number controlled, so that the wider implications would not be spent prematurely. The result was careful chance.

TOWARD THE *LARGE GLASS*

The ready-mades were an open-ended sequence of works begun after the *Nude Descending a Staircase* (Fig. 8) and concurrent with *The Bride Stripped Bare by Her Bachelors, Even* (1915–23) (Fig. 17). They can be associated conceptually with the *Nude* and with such succeeding works as *The Passage from the Virgin to the Bride* (1912) (Fig. 9) and even the *Large Glass* (Fig. 17) itself. One connection is the theme of marriage and generalized female nudity, with a corollary involving the representative particularity of dressed males who are as identifiable by their work as the figures in Courbet's *Burial at Ornans* (1849–50)—the "malic molds" of the *Large Glass*. From this viewpoint, the ready-made is an object *divorced* from utility, which plays not only on the idea of divorce from a spouse but also on the idea of the unique but general bride as against the various but specific and typical potential husbands. Also, the ready-mades appeared as Duchamp the artist divorced himself from painting and began to present himself to his muse in various guises—thinker, worker in glass, chess player.

The "nine malic molds" of the *Large Glass* and the studies for them, beginning with the (eight) figures in uniform of *Cemetery of Uniforms and Liveries, No. 1* (1913) (Fig. 12), relate to the ready-

mades because a man in uniform is a figure abstracted, an interchangeable representative of a type, a man with a ready-made identity. (The fundamental meaning of "ready-made" in English pertains to off-the-rack clothing.) In *Cemetery . . . No. 1* the uniforms are identified as those of a priest, a department-store delivery boy (the ready-made *Bottle Rack* [Fig. 16] was to be selected in a department store the following year), a gendarme, a cuirassier, a policeman, an undertaker, a "flunkey," and a bell-boy. Similarly, the selection of a ready-made raises one bottle rack to a kind of peerage, both as *above* unrecognized bottle racks and *on a plane of equality with* other ready-mades. The ironic relation of "peer" in the sense of social superior to "peer" in the sense of social equal seems distinctly available in Duchamp's ready-mades, which really developed after his arrival in America.

The *Three Standard Stoppages* (Fig. 13), of 1913–14, is a monument in Duchamp's development of an aesthetic of chance. More crafted than most ready-mades but conceptually similar, the piece ironically gave birth to his only thoroughly abstract painting, the *Network of Stoppages* (1914) (Fig. 15). *Three Standard Stoppages* is a related group of concrete objects resulting from a pseudo-scientific but genuinely artistic experiment in aleatory creation that suggests the chance-determined compositional experiments of Jean Arp. To make the "stoppages" Duchamp dropped three strings, each a meter long, onto a canvas plane one meter below. The way the strings randomly turned in falling determined "a new form of the unit of length," and the actual strings, in their fallen state, were attached to the canvas and then cut into separate strips and glued onto glass plates. For practical use as templates of irregularity each of the three lines was also copied onto a wooden ruler and cut out. The two sets of three stoppages each were then fitted into a croquet box for safe keeping. The three fixed standards of accident are similar to the ready-mades in that they comprise a small, representative group of forms selected without the application of visual judgement from a countless number of possible alternatives; that these forms are also *pure line* is like the almost sarcastically abstract aspect of the ready-mades.

Perhaps the most masterful implication of the *Three Standard Stoppages* is that Duchamp uncovered an affectation of precision in measurement that physics has since attempted to come to terms with (he said he wanted to "stretch the laws of physics just a little.") When he made his set of wavering linear templates—like draftsmen's "French curves" pushed to an extreme—the world still trusted the absolutist accuracy of the "standard meter," a platinum-iradium prototype enshrined like a talisman of rationalism by the French Government. Not so since 1960, when the Conférence Générale des Poids et Mesures

decided that one exact meter is defined in the following way: "1,650,760.73 wave lengths *in vacuo* of the radiation corresponding to the transition between the levels $2p_{10}$ and $5d_5$ of the atom krypton-86." How amusing Duchamp must have found the officially redefined meter after accomplishing for his idiosyncratic meters a so much more assuring tangibility.

The painting *Network of Stoppages* uses each of the stoppages three times to describe the nine channel-like lines which touch and join together into a flat pattern suggestive of circuitry. That it contains nine stoppages evokes the "nine malic molds" of the *Large Glass,* which is reinforced by virtue of the *Network's* own perspectival projection (as the "capillary tubes") onto the nine molds in the *Large Glass* and in the study for it, the *Cemetery of Uniforms and Liveries No. 2* (1914)—where there are only eight malic molds (the addition was a station-master). Here the very canvas is a palimpsest of stops and starts. The lowest layer is an unfinished painting using *Spring* (1911) as a study; then comes a pencil design for the layout of the *Large Glass,* with the long margins painted in darkly to meet it; finally there is the patternistic overlay of stoppages, each having a stop-cock and a numbered, blood-vessel-like circular bulb. Where the lines of the network overlap the lightly painted *Spring* area and the dark marginal bands along top and bottom, the subservient layers make room for them, leaving halo-like spaces that suggest electro-magnetic fields. This work marks the eclipse of orthodox painting by Duchamp's idea for his great glass construction.

The Bride Stripped Bare by Her Bachelors, Even (1915–23) (Fig. 17)—or as Robert Rosenblum suggests, *The Bride Stripped Bare by Her Own Bachelors*—is the masterwork toward which so many of the earlier and contemporary works which we have considered move. It was the great single enterprise concurrent with the successive bursts of individual ready-mades. By now it must be apparent that for so many motifs, mechanisms, and overtones to be wedded together into a single entity involves an incredibly complex iconographical program. Yes, or else one of incredible mock-complexity. The general relations are easy enough to grasp: those between the bachelors and their world in the lower half and the bio-mechanical bride undergoing a combination strip-tease and assault above. Even so, there is a complicated literary overlay, which is explained by the evidence of the *Green Box* (1934), Duchamp's facsimile edition of notes and documents relating to the *Large Glass.* There, for instance, Duchamp explains that the

> motor with very weak cylinders, the external organ of the Bride, is activated by love gasoline, secreted by the Bride's sexual glands, and by the electric sparks of the undressing (to express the fact that the

Bride does not refuse to be undressed by the Bachelors, and even consents since she supplies the love gasoline and even furthers her complete nudity by developing in a sparkling way her desire to be possessed).[12]

Duchamp used real New York dust and grit fixed with varnish for the *Large Glass,* collected by allowing the glass to rest near an open window, which involves chance and an almost picturesque sense of place in equal intensity. His friend Man Ray took a beautiful close-up photograph (called *Dust Breeding;* 1920) of the dust on the area around the glider, giving that detail alone the scale of an excavation of some Roman Imperial building complex.

Students of Duchamp have framed supplementary theories, such as an alchemical reading of the *Large Glass* growing out of the discovery by Ulf Linde of an alchemical text illustrating the stripping of a bride. For all the interpenetrating complications of the *Large Glass,* including the literary sources, which comprise the largest part of the literature on Duchamp—one must turn to the corps of explicators.

By 1918 the *Large Glass* was pretty much finished. It made its first public appearance in 1926 at the Brooklyn Museum. In the time of Giotto it would have been carried back in procession across the Brooklyn Bridge, but in the twentieth century somebody dropped it or put something down on it or let it fall over, because when it was taken out of the packing case five years later it was smashed. Photographs do not suggest the extent of the damage, just as they tend to minimize the size of the object (which is just under nine feet tall). One must see the *Large Glass* in the flesh in order to appreciate that it was smashed to smithereens. Duchamp accepted this with characteristic stoicism as an uninvited visit from chance and pieced the work back together again in 1936.[13] In 1954 it was permanently installed in the Philadelphia Museum, the gift of Katherine S. Dreier, where it is surrounded by all of Walter Arensberg's Duchampiana and Duchamp's mysterious last major work. Now the breaks take on an interesting relation to the more deliberately accidental elements, including the stoppages and nine tiny holes drilled where paint-loaded matchsticks were shot at the glass.

[12] Quoted in Robert Lebel, *Marcel Duchamp,* with chapters by Andre Breton and H. P. Roche, trans. George Heard Hamilton (New York, 1959), p. 66. Cf. e. e. cummings in *The Enormous Room* (1922): ". . . He predicated *Les Femmes* with one eye, his trousers with another, and converted his utterly plastic personality into an amorous machine for several seconds, thereby indicating the root of the difficulty." (1922; ed. New York, 1970, p. 202.)

[13] See "Restoring 1,000 Glass Bits in Panels; Marcel Duchamp, Altho an Iconoclast, Recreates works," *The Literary Digest,* CXXI, No. 25 (June 20, 1936), pp. 20, 22.

DROP-OUT

The idea that Marcel Duchamp had given up art altogether, not just painting, came into currency around 1923. Duchamp never discouraged it and seems to have enjoyed the mysterious notoriety that it gave him as well as the silent isolation to carry on his activities out of the limelight. Duchamp was said to have taken up a decided anti-art position, abandoning art in favor of playing chess. This happened in something like the way Dietrich Bonhoeffer came to have the concept of the death of God associated with him, even though he continued to work within theology; Duchamp himself preferred a notion of non-art to that of anti-art, and once remarked that atheism has too much to do with God. As it turned out, Duchamp continued to make occasional small pieces and to work on his last major project, *Etant Donnés: 1° la chute d'eau, 2° le gaz d'éclairage* (Fig. 28)* executed during 20 years of secrecy, from 1946 to 1966.

So at this point the public life diverged radically from the work. Duchamp had played chess even as a child, and the rest of the family played too—as they did in Marcel's *Chess Game* (1910). Yet as the myth took hold it emphasized chess to such a point that his games seemed almost to deserve art criticism. If anything, his deep interest and sophistication in the game and its theory, combined with the fact that he played very well for a non-master, went along rather the same trajectory as his youthful involvement with cubism. He was interested in chess theory, especially in the "hyper-modernism" of Aaron Nimzo-witsch (1886–1935) and Richard Reti (1889–1929)—who achieved initial fame with a game in Carlsbad in 1911. Hyper-modernism involves an unorthodox attitude toward the defense of the central area of the board, and the first diagram in Nimzowitsch's *Mein System* (1925) splits the board into halves, not unlike the layout of the *Large Glass*.[14] In any case, Nimzowitsch was as removed from a visual aesthetic as Duchamp; he once remarked, "The beauty of a chess move lies not in its appearance, but in the thought behind it." [15] Duchamp played in tournaments, supported chess organizations, produced with V. Halberstadt a treatise on the end-game, *L'Opposition et les cases conjuguées sont reconciliées* (Opposition and Sister Squares are Reconciled)

* [*Givens: 1st, The Waterfall, 2nd, The Illuminating Gas* (Fig. 28)—Ed.]

[14] Aaron Nimzowitsch, *Mein System; ein Lehrbuch des Schachspiels auf ganz neuartiger Grundlage* (Berlin, 1925, 1926), Vol. I, p. 6, diagram 1, "Die Grenzlinie." There is an English translation: *My System; a Chess Treatise* trans. Philip Hereford (London, 1968).

[15] Quoted by Fred Reinfeld, *Nimzovich; the Hypermodern* (Philadelphia, 1948), p. 154.

(1932); he also made an "assisted ready-made" pocket *Chessboard* (1943) and designed chess pieces (1947).

In 1924 Duchamp executed a gambling project involving the sale of 30 *Monte Carlo Shares* (Fig. 24), designed by himself, in order to support a gambling method he had devised. This, it was hoped, would give him a regular income, but in a stylistically typical manner it broke even, although Duchamp insisted that sticking to it would produce as much money as a clerk working equal time. It is interesting to compare the Monte Carlo scheme with Maurice Maeterlinck's tale "The Temple of Chance," set in the Casino at Monte Carlo. Maeterlinck senses that the pure act of gambling abstracts the value of money, which seems as unsettling to him as it would be charming to Duchamp: "To annihilate the value of money in order to substitute for it a higher ideal would be excellent; but to annihilate it to leave in its place pure and simple nothingness, I imagine to be one of the gravest outrages that can be committed against our existing evolution." For Maeterlinck, "To tell the truth, chance, as the players mean it, is a god that does not exist." [16] Duchamp could have invested the same thought with more wit and significance.

Precedents can be found for major moves in Duchamp's career. For his turn away from painting to do the ready-mades and the *Large Glass* there is a whole history of sweeping remarks against the value or efficacy of conventional art, from Descartes' "Quelle vanité que la peinture!" through Turner's and Paul Delaroche's reactions to photography, to Marius de Zayas' "Art is dead" (*Camera Work,* 1913) to Rodchenko in 1920, and on to the present. For his seeming to have exhausted plastic art and abandoned it for chess there is Descartes' resort to backgammon when he felt he had covered philosophy. For the submission of artistic form and composition to the laws of chance, and in particular for his 1913 music piece composed by drawing notes and notational signs out of a bag ("Erratum musical"), there is Mozart's *Musikalisches Würfelspiel* (Musical Dice-Game) of 1787.[17] Even in Duchamp's clandestine activity at the end of his life, when everyone still thought he had displaced his art with chess, there is a similarity with Mozart, who sometimes appeared to compose music minutes before a concert although he is known to have worked out musical ideas while playing the very game Duchamp played while cutting art school—billiards. But Duchamp's commitment cannot be synthesized from parts. He was elemental and not compoundable.

[16] Maurice Maeterlinck, "Le Temple du Hasard," in his *Le Double Jardin* (Paris, 1913), pp. 33–49.

[17] On which see Ludwig von Köchel, *Chronologisch-thematisches Verzeichnis sämtlicher Tonwerke Wolfgang Amadé Mozarts,* 6th ed. (Wiesbaden, 1964), pp. 581, 910, with bibliography.

Having followed thus far, it must certainly be evident that Duchamp was not involved with beauty in the traditional sense. The place normally occupied by beauty in systems of aesthetics was taken for him by something more like what the eighteenth century meant by "wit"—a skill in the relational play of thought. Nevertheless, his works sometimes become noticeably beautiful, not only a painting like the *Network of Stoppages* (Fig. 15), but even a ready-made like the *Bottle Rack* (Fig. 16)—in which several present-day artists have pointed to surprising qualities of form. The *Bottle Rack* can also be seen as expressively high-strung, just as the urinal *Fountain* (1917) seems markedly voluptuous in form. James Thrall Soby even claimed that Duchamp's addition of whiskers to the *Mona Lisa* in his *L.H.O.O.Q.* (1919) invested Leonardo's original with a "mannerist elegance."

A few of the studies for the *Large Glass* are remarkably beautiful, and more simply so than the *Large Glass* itself, since when the parts are subsumed into the whole they dissolve into a mysteriously immanent suspension. The two *Chocolate Grinder* pictures, *No. 1* (1913) and *No. 2* (1914)—based on the memory of a chocolate grinder in a shop window in Rouen and essential to the iconography of the *Large Glass*—not only mark an important conversion of the identical motif from a painting *subject* (with cast shadow) to an *object* constructed with threads for lines; they are also unusually handsome paintings. The same is even more true of the glass study called *Glider Containing a Water Mill* (*in Neighboring Metals*) (1913–15) (Fig. 14).

As a contraption the *Glider* grows out of the funny, Rube Goldberg-like grinding motion and sound—and the anthropomorphically overconfident functional efficiency—of the chocolate grinder. It also shares in the unapologetically anti-functional charm of the *Bicycle Wheel* (1913) mounted upside-down on its stool. *Glider* itself is a semi-circular pane of glass mounted in a metal frame attached to the wall with two hinges, containing the image of a watermill on a glider skid, which is part of the "bachelor apparatus"-to-be of the *Large Glass*. The shiny semi-circular ends of the foil skids are in elegant harmony with the overall support. Both motif and format are similar to each other and each is a *little* like traditional painting, thanks partly to the thin skin of oil paint held between foil and glass in the main motif and the hanging-against-the-wall feature of the mount.

It is common to stress the opposition between Duchamp's works developing the *Large Glass* themes and his previous commitment to easel painting, although in the *Green Box* (1934) Duchamp described the *Large Glass* itself as "a long canvas, upright." Artists of the 1920s and 30s considered Duchamp's works on glass to be part of the history

of (hip) painting. Thus *Glider* was illustrated under the heading "Painting" by Amédée Ozenfant in his *Foundations of Modern Art* (1928), captioned "Object in Glass and Zinc." And when Naum Gaubo, J. L. Martin, and Ben Nicholson published their *Circle; International Survey of Constructive Art* (1937), a negative, black-on-white version (collection of Man Ray) of the *Ocultist Witnesses* (1920)—a photograph of the carbon paper from which that drawing was transferred —was also illustrated in a section on painting.

All late writings on Duchamp before 1966 had assumed that his career was either dormant or had petered out by then. A retrospective tendency—always present in Duchamp's career, especially in his portable auto-museum, the *Box in a Valise* (1938–41/42)—took over his reputation. Walter Hopps' important retrospective show at the Pasadena Art Museum, in California, took place in 1963. In 1964 Arturo Schwarz, Duchamp scholar and gallery owner in Milan, brought out limited multiple editions of ready-mades approved by Duchamp. In the spring of 1966 a great exhibition of Duchamp's work opened at the Tate Gallery in London, arranged by the English Pop painter and Duchampophile Richard Hamilton and wisely entitled *The Almost Complete Works of Marcel Duchamp*. Duchamp, still alive, was history; his work was viewed as particularly pertinent to current ideas of chance and indeterminacy and to the incorporation of *mundane reality* in Pop Art, then at its height.

But in 1966 Duchamp finished the last of his major projects, the *Etant Donnés: 1° la chute d'eau, 2° la gaz d'éclairage* (Fig. 28), begun in 1946 and continued secretly for the twenty intervening years. The secrecy of *Etant Donnés* (compare *With Hidden Noise*) was of the essence. Like the *Nude Descending a Staircase* and *The Large Glass, Etant Donnés* deals with the female nude and has many self-sufficient studies connected with it. The title means *Givens* (in the sense that things are "given," are taken for granted, in an argument): *1st the waterfall, 2nd, the illuminating gas.*[18] The work is a tableau vivant built around a reclining female nude.

Much more than the *Nude* and the *Bride, Etant Donnés* is totally divorced from modernist abstract tendencies. The tableau, which on Duchamp's order may never be photographed, is viewed through one of two holes in a battered old Spanish door (which in itself resembles Dubuffet's painting *Door with Couchgrass* ([1957]). The prospect thus revealed is, in light of the modern, rational and conceptual thrust of Duchamp's entire career, nothing less than astonishing.

[18] It relates to the ready-made sign *Eau & gaz à tous les étages* (Water and Gas on Every Floor) (1959), fixed to the cover of a boxed limited ed. of Robert Lebel's *Marcel Duchamp* (Paris, 1959).

A mock-up nude woman displays herself before a landscape constructed like window-dressing or the background of a diorama in a natural history museum, with "realistic" model-railroad foliage in combination with painting, and an electric artificial waterfall. She holds a small lamp in her hand (in mockery of Bartholdi's *Liberty Enlightening the World?*), although most of the illumination comes from hidden light sources.

So much is *Etant Donnés* against the grain of modern art—a ricochet relation to the veristic sculpture of the last few years notwithstanding—that seeing it makes one wonder about a final collapse on Duchamp's part. A number of self-sufficient works materialized in connection with *Etant Donnés*, especially the "Three Erotic Objects"— *Female Fig Leaf* (1951), Objet-dard (Dart-Object) (1951), and the *Wedge of Chastity* (1951–52) (Fig. 27), and these, which arrived on the scene before anyone knew they were related to a project as all-consuming as another *Large Glass*, have had a vital impact on conceptualistic sculpture. But one cannot suppress disappointment with *Etant Donnés* as a whole.

Etant Donnés exists in obvious opposition to the *Large Glass* (Fig. 17). In fact, because it may not be photographed (except for the door), everyone who sees it has first to see the actual *Large Glass* (which can never be shipped again because of its fragility), exhibited in the same gallery in the Philadelphia Museum. Where the *Large Glass* suspends abstracted forms in a transparent plane, *Etant Donnés* presents us with illusionistic forms seen through a real hole in an opaque plane. Where the *Large Glass* revels in disarmed iconographic over-complication, *Etant Donnés* "says" next to nothing and yet speaks with frustrated urgency. It seems as mutely meaningful as some Symbolist work Duchamp might have painted in his earliest years, only in more ways than one there is no mode of entry, no key to the door.

Did Duchamp actually realize an escape from art in the fabrication of this work, did he leave art behind just as we thought he had until we found he hadn't? If earlier works by Duchamp are in the most dubious ways still lovely, this one seems startlingly gross and amateurish. It dissolves into a senile hobby, altogether private in its psychological function, out of place and embarrassingly unengaging when shown even to friends. It is not a masterwork of any kind, even though it may be seen as an extravaganza of proto-Funk, and even though it is funny.

Having to look through a tiny hole puts us in the position of a voyeur looking at a realized fantasy from some turn-of-the-century, studio-posed, contraband French postcard. However, *Etant Donnés* does give us some insight into the refreshing scandalousness that used to invest modern art, for a naturalistic tableau by Duchamp is surely

as iconoclastic in the 1970s as a urinal was in 1917. In fact it capitulates us ironically to something like the world of the Armory Show, when the *Nude Descending a Staircase* oddly seemed related to *September Morn*. Above all, it forces us to acknowledge that in a world of entropy even to conceive of something takes time, while to execute it becomes absurd or heroic or both.

1975

DUCHAMP

Guillaume Apollinaire

Marcel Duchamp's pictures are still too few in number, and differ too much from one another, for one to generalize their qualities, or judge the real talents of their creator. Like most of the new painters, Marcel Duchamp has abandoned the cult of appearances. (It seems it was Gauguin who first renounced what has been for so long the religion of painters.)

In the beginning Marcel Duchamp was influenced by Braque (the pictures exhibited at the *Salon d'Automne*, 1911, and at the *Gallery Rue Tronchet*, 1911), and by *The Tower* by Delaunay (*A Melancholy Young Man on a Train*).

To free his art from all perceptions which might become notions, Duchamp writes the title on the picture itself. Thus literature, which so few painters have been able to avoid, disappears from his art, but not poetry. He uses forms and colors, not to render appearances, but to penetrate the essential nature of forms and formal colors, which drive painters to such despair that they would like to dispense with them, and try to do so whenever possible.

To the concrete composition of his picture, Marcel Duchamp opposes an extremely intellectual title. He goes the limit, and is not afraid of being criticized as esoteric or unintelligible.

All men, all the beings that have passed near us, have left some imprints on our memory, and these imprints of lives have a reality,

"Duchamp." From Guillaume Apollinaire, *The Cubist Painters: Aesthetic Meditations*, 2nd ed., trans. Lionel Abel, The Documents of Modern Art (New York: Wittenborn, Schultz, Inc., 1949), pp. 47–48. Reprinted by permission of George Wittenborn, Inc., New York.

the details of which can be studied and copied. These traces all take on a character whose plastic traits can be indicated by a purely intellectual operation.

Traces of these beings appear in the pictures of Marcel Duchamp. Let me add—the fact is not without importance—that Duchamp is the only painter of the modern school who today (autumn, 1912) concerns himself with the nude: *King and Queen Surrounded by Swift Nudes; King and Queen Swept by Swift Nudes; Nude Descending a Staircase* [Fig. 8].

This art which strives to aestheticize such musical perceptions of nature, forbids itself the caprices and unexpressive arabesque of music.

An art directed to wresting from nature, not intellectual generalizations, but collective forms and colors, the perception of which has not yet become knowledge, is certainly conceivable, and a painter like Marcel Duchamp is very likely to realize such an art.

It is possible that these unknown, profound, and abruptly grandiose aspects of nature do not have to be aestheticized in order to move us; this would explain the flame-shaped colors, the compositions in the form of an N, the rumbling tones, now tender, now firmly accented. These conceptions are not determined by an aesthetic, but by the energy of a few lines (forms or colors).

This technique can produce works of a strength so far undreamed of. It may even play a social role.

Just as Cimabue's pictures were paraded through the streets, our century has seen the airplane of Blériot, laden with the efforts humanity made for the past thousand years, escorted in glory to the [Academy of] Arts and Sciences. Perhaps it will be the task of an artist as detached from aesthetic preoccupations, and as intent on the energetic as Marcel Duchamp, to reconcile art and the people.

MARCEL DUCHAMP
AND THE FUTURISTS

Leon Kochnitzky

The story goes that one day, Elijah ben Shelemo, the learned Lithuanian Rabbi of the XVIIIth century, known also as the Gaon of Wilna, passed by two of his disciples, who for hours had been seeking to solve a very difficult chess problem. The Gaon did not look at the chess board nor did he speak to the young men. But as he hurried past, his long sleeve caught in one of the pieces and displaced it. The players cried out in amazement: the problem was solved.

The story takes its full significance when one knows that the Gaon of Wilna was by no means a maker of miracles. He was a resolute opponent to Chassidism and in all his works he upheld rationalism. But the inner-workings of his intelligence were so stupendous that they acted *à l'aveugle,* and could plunge into the depths of the subconscious, with no loss of strength.

I do not recall this anecdote because Marcel Duchamp is a great chess-player, but rather because Duchamp's pictorial achievement seems to me a kind of super-natural solution of a problem that was distressing a whole generation.

By 1910, the painters found themselves in a road which led to nowhere. "Rarely has the conflict between individual and collectivity been imposed upon man with such violence," writes Carl Einstein.

Throughout the struggle that went on during half a century against the ruling classes that spurned and repelled them, the Impressionists had remained faithful to the *petit-bourgeois* ideal of their time and country. Now the artist wishing to preserve his personality was compelled to perform what Carl Einstein calls the *scission of the individual,* giving an abnormal and monstrous aspect to his most impor-

"Marcel Duchamp and the Futurists," by Leon Kochnitzky. From *View; the Modern Magazine,* Series V, No. 1 (March, 1945), 41–42.

tant works. Such a scission could likewise be achieved by adopting a somewhat esoteric, gnostic world-representation; by obeying certain rules unknown to the layman, and still perfectly clear and logical to the initiated. Thus the Cubists drew the inevitable conclusions from Cézanne's plastic discoveries. They abandoned the physical universe of the Impressionists. They took refuge in the world of mathematical forms, of crystals and polyhedrons. There, the *petit-bourgeois* spirit of the masses could not follow them to ferret them out. But their voluntary retirement on these crystal rocks was the result of a purely intellectual decision. All Cubist art—I refer to the authentic cubism of 1908–1912—was under the exclusive control of the spirit. Hence its inhuman character, its limitations and the necessity for its adepts to escape from their chosen island.

The problem remained unchanged. How could the artist solve the conflict between the individual and collectivity? How could he preserve his personality in face of the more and more imperative requirements of a life permeated with social conscience?

The mechanical and technical advances of photography and the cinema lightened his burden. On the other hand, these same advances enabled him to discover new aspects of reality, for instance those derived from chrono-photography.

During the years 1911–1913, several solutions, clearly different from the purely intellectual attitude adopted by the Cubists, came to the fore.

I think that the dozen canvases painted by Marcel Duchamp represent the first valid attempt to give a fully human solution to the problem. Most of the intellectual elements existing in Cubism are to be found in *The Bride* [Fig. 10] and the *Nude Descending a Staircase* [Fig. 8]. But the vigilant spirit alone does not guide the hand of the painter. A magic factor, operating as did the Gaon of Wilna's sleeve, played here a major part. The intervention of such a factor brings back into the work of art the subconscious and the dream-element. For this very reason, Duchamp's painting is a full expression of a personality, which the best cubist picture, confined as it is in the world of the intellect, is not.

The definitive solution of the problem was to be given by Surrealism and by the early paintings of Giorgio di Chirico. Duchamp's work may be considered the first step in the right direction.

In the same year 1911, however, another attempt was made by a group of Italian artists, the *Futurists,* to solve the essential problem. The Futurists failed and none of their works have the profound significance of a painting by Marcel Duchamp. Nevertheless their effort has both an historical and aesthetic importance.

From the beginning, the Futurists and their mouthpiece, F-T. Marinetti, ignored the metaphysical aspect of the question, trying to reduce the whole problem to a notion of "dynamism"—as they boasted —that enabled them to reject the heritage of the past and to grasp the constructive elements of the future. But, contrary to Cubism, Futurist painting was based on "sensation." Marinetti wrote: "Painting and sensation are two inseparable words." For this reason, and despite the claim of the Italian group, Futurism was but a technical and simultaneistic transposition of Impressionism.

Nevertheless, painters like Severini, Boccioni, Carra, Balla and Russolo have achieved certain results that cannot be ignored. Making use of the discoveries of chrono-photography—as Marcel Duchamp has done—they applied this technical process to what they themselves styled "la simultanéïté des états d'âme." In reality, there is no such thing as an *état d'âme* to be found in their paintings, but only a juxtaposition of sensations, each more or less connected with one another by one invariable link; the *pathos* of the artist. Hence a kind of eloquent futility that pervades the best futurist canvases, that is to say, the reabsorption—totally different from the *scission of the individual* advocated by Carl Einstein—of the painter's personality in the multiplicity of fragmentary sensations, belonging to a mass-psychology rather than to an artist's creativeness.

The sensuous attitude of the Futurists was, much more than the intellectual position of the Cubists, an ephemeral experience. Futurism as a doctrine begot very few valuable works, the best being Boccioni's animated sculptures. The most gifted artist of the group, Severini, made a strange evolution towards a kind of neo-classicism. His painting dwindled into a vaguely archaeological and architectural decorative art. But the boasted "dynamism" of Marinetti contained a direct appeal to the lowest mass-instincts. No wonder its demagogic vulgarity charmed the uncultured politicians of Italy in the Twenties. Fascism was born under the spell of Futurism. Many of Hitler's and Mussolini's ethics were to be found in Marinetti's commonplaces about youth, modern life, splendor of warfare, etc.

Whenever a new artistic doctrine not only appeals to the brain, but brings in its train the magic values of the subconscious and the irrational, it overflows the field of pure creativeness, and pervades and moves the psyche of the masses. We may admire Marcel Duchamp for his restraint in any utilization of these facile elements. His "hermetical" attitude cannot be mistaken for indifference and will find its full reward.

MARCEL DUCHAMP, ANTI-ARTIST

Harriet and Sidney Janis

Counter-art-wise Duchamp, arch rebel of 20th century art, stopped painting more than twenty years ago. Nevertheless, new works continue to come into being, appearing sometimes mysteriously, sometimes miraculously, out of the depths of the serenity that surrounds and the quiet that informs his life and his person. These works are scarcely recognizable as the products of creative activity: they are so unorthodox and so far removed from patterns, centuries-old, of the material and conceptual substance of painting and sculpture. A cataloguing of this fascinating miscellany of the last quarter century would include rotoreliefs, cover designs, montages, objects, near-objects, cinema, ready-mades, collapsible sculpture for traveling, and mobiles.

Perhaps more than any other living artist in this revolutionary period, Duchamp has departed from all existing norms. As an example, since his arrival in America in 1941, he installed the surrealist exhibit for the Coordinating Council of French Relief Societies, Inc. Spinning in front of the pictures a veritable maze of cobwebs made from three miles of string, he symbolized literally the difficulties to be circumvented by the uninitiate in order to see, to perceive and understand, the exhibits. He has also been engaged in completing his imaginatively conceived *Boîtes* which contain facsimile reproductions of his life work, in half-tone, in color and in miniature objects. The *Boîte* is a device which, when manipulated, retrospectively unfolds the work of

"Marcel Duchamp, Anti-Artist," by Harriet and Sidney Janis. From *View; the Modern Magazine*, Series V, No. 1 (March, 1945), 18–19, 21, 23–24, 53–54. Reprinted by permission of Harriet and Sidney Janis. This article was reprinted in Robert Motherwell, ed., *The Dada Painters and Poets* (New York: George Wittenborn, 1951; reprinted 1967). Reprinted here with the permission of Carroll Janis Inc.

Duchamp before the spectator in such a way that the presentation constitutes virtually a composite portrait of the artist's personality set forth in esthetic terms.

Despite the prevailing idea that Duchamp has abandoned art, the high spiritual plane on which all of his activity is conducted converts every product, whether a personally selected "ready-made" or his dada installation of a surrealist exhibit, into a work of art. It is such cumulative evidence that attests to a continuing creativity on the part of Duchamp from the time of his earliest paintings done in 1910–11 under the impact of Cézanne to the varied works executed today.

Always an active dadaist, Duchamp's attitudes were articulated, however, in the years preceding dada, and although acclaimed by the surrealists, he retains these proto-dada attitudes in their nascent state. Whether or not dada had been formulated into an organized program, Duchamp would undoubtedly have gone his way just as he has done. Anti-artisan and anti-artist, he is anarchic in the true sense, in revolt even against himself. He says, "I have forced myself to contradict myself in order to avoid conforming to my own taste." Like the German, Kurt Schwitters, he may be regarded as a natural dada personality.

Out of this native dada spirit emerges the invention of a series of new techniques so original and varied, at once so imbued with the spirit of play and of earnestness, of freedom, spontaneity and yet of reflectiveness, so marked with the character of the individual and with that of the period, that they constitute not only an absorbing chronicle of the creative life of a highly sensitive, intelligent and civilized person, but, as well, an imposing contribution to modern esthetics.

These techniques are bound up with Duchamp's philosophic concepts. They spring from the core of his ideology. They are the means to a modern imagery, to a contemporary mythology, to miracle-provoking mechanomorphic fetishes. They are achieved in as detached and impersonal a manner, as unsentimental, unromantic and unemotional a manner as it is possible for a highly speculative and disciplined individual to employ. This asceticism on the part of Duchamp is akin to that of Mondrian, and here a comparison with a similar tendency in another artist merely serves to point up the difference in accomplishment to be found in different personalities. Mondrian's severity carried him to a finality of logic envisioned within the premise of the original canvas rectangle, of primary color, and of paint and brush. To Duchamp, the brush, the canvas and the artist's dexterity of hand, are anathema. He thinks and works in terms of mechanics, natural forces, the ravages of time, the multiplex accidents of chance. He marshals these forces, so apparently inimical to art, and employs them consciously to produce forms and develop objects, and the results themselves he regards as secondary to the means used in making them.

Under such circumstances, his works literally demand consideration in terms of the techniques employed, for these techniques carry the burden, in a new and significant way, of the structure of intellectual, esthetic and spiritual content in the objects which he has made. So organic, and so intimate is the connection between concept and technique in Duchamp's entire work, that it becomes necessary to discuss one in order to show through its reciprocal action upon the other, their joint reason for being.

Duchamp's work falls into categories of threes, intentionally or otherwise: movement, machine concept, and irony. Irony subdivides into three groups: selection, chance and the ravages of time. Chance configurations are designated by Marcel as obtainable by employing the following three methods: wind, gravity and the device termed *adresse.*

CONCEPT OF MOVEMENT AND RESULTING TECHNIQUES

The idea of movement intrigued Duchamp almost from the time of his first painting. It remains a recurring theme which appears constantly in varying ramifications. In 1911 he painted *Portrait,* a monochrome picture with five versions of the figure spreading from a common base across the top of the canvas. This is still partly the idea of *simultaneity* deriving from cubism, but goes further in that it suggests movement of the figure itself as well as movement of the spectator around the figure as in cubism. The *Coffee-grinder,* 1911, charts movement by showing the position of the handle at various intervals within the arc it describes while in motion. *Nude Descending a Staircase* [Fig. 8], 1912, is a progression, giving the kinetic continuity—virtually futurist—of the figure as it moves through a designated area of space. Duchamp terms this "giving a blueprint of movement." In *King and Queen Traversed by Swift Nudes,* 1912, Duchamp opposes figures in motion and static figures; *Passage of the Virgin to the Bride* [Fig. 9], 1912, fuses the concrete idea of the figure in motion with the abstract idea of its transition from one state of being to another. In his chef-d'oeuvre, the large glass titled *La Mariée mise à nu par ses célibataires, même* [Fig. 17], 1915–23, the concept of this picture, to speak in most general terms, deals with cause and effect—the changes resulting in matter from the play of forces upon it. Whatever movement is implied in these changes is not given kinetically, as in other pictures mentioned, but is effected pictorially alone, by virtue of plastic rhythms. These pictorial rhythms interact between the various mechanical forms which are presented as being stationary rather than in motion.

An early mobile, 1916, a bicycle wheel mounted on a kitchen stool, tacitly invited the observer to spin it. Here is the object itself, one that incorporates actual motion, as contrasted with previous painted representations of motion. *Rotary Glass Plaques,* 1920, is the next step. Now the construction is entirely fabricated by Duchamp and is spun this time by a motor. This is an ingenious device consisting of a series of rectangular opaque glass plaques of graduating sizes, spaced a meter deep on an axis and decorated with black and white lines. In motion these lines create an illusion of circles on a flat surface. Thus the object when spun seems reduced to two dimensions.

A further step is *Rotary Demisphere,* 1925. Here a series of eccentric circles is painted upon a hemisphere. When set in motion by the attached motor, these circles optically spiral, alternating away from and then toward the observer.

Rotary Demisphere in turn served as the model, the principal actor, for the film, *Anémic Cinéma,* 1926. There is a further application of this idea in a series of optical discs titled *Rotoreliefs,* 1935 [Fig. 25], which might be called phonograph records for the eye. The discs, placed upon the revolving turntable of a phonograph, exploit through optical illusion many variations of movement in three-dimensional space.

The techniques used throughout the continuity of movement are, first, the conventional paint and brush unconventionally employed, then many original and brilliantly conceived techniques developed for the large glass. These will be discussed later. Subsequently, constructions to be manipulated by hand, motor-driven constructions, as well as cinema, established movement, completing the change from semi-abstract representations of naturalistic movement (*Nude Descending a Staircase*) to actual physical motion, including optically created presentations of abstract movement (*Rotaries* and *Rotoreliefs*).

MACHINE CONCEPT AND
TECHNIQUES OF APPLICATION

In 1911, Duchamp's brother, the sculptor, Duchamp-Villon, asked each of a group of artists to make a picture for his kitchen. Among the artists were Léger, Metzinger, La Fresnaye, Gleizes and Duchamp himself. Marcel's contribution was the *Coffee-grinder,* which he made casually and pleasurably, responding to the mood of the circumstances under which it was requested. However, it was destined to be more than a perfunctory kitchen decoration, for while working on it, his interest shifted from the outward aspect of the object to its mechanics, to the manner in which it worked and moved as a machine.

This incident served to release the inventive and fecund personality of Duchamp as it exists today, as if inadvertently he had exposed to light and air, to the necessary elements, a nucleus from which his own psyche could develop and grow. Duchamp regards the *Coffee-grinder* as the key picture to his complete work. Looking back through the structure of his achievement, the elements, constantly in one mutation or another, in one degree of complexity or another, are all present in simple form in the *Coffee-grinder*: movement, already referred to; the magic of mechanics; and the inimitable flair for pointed irony.

From the time of the *Coffee-grinder*, physical, poetic, esthetic or ironic references to the machine are part of Duchamp's created world; the kinetics of the machine, its dynamics, energy and rhythms, machine-made products, machine forms, and the machine itself formulate its physics, fill its space. In this world, the human mechanism operates like a machine and resembles the machine, natural forces are synchronized with man-made power. Duchamp animates the machine, mechanizes the soul. Between these counter effects, motion becomes pure operation without objective or consciousness.

Fascination with the mechanics of the *Coffee-grinder* became diverted to those of the human form, in paintings, and especially in the drawings, sketches and paintings made as preliminaries to the large glass. *Passage of the Virgin to the Bride* is as complex in its mechanical aspect as in its movement, for changes in the form of the inner mechanism of the bride follow changes in her state of being. *The Bride*, 1912, is perhaps the most poetic version on canvas of a work in the mechanomorphic concept.

By 1913, Marcel is rejecting as well as accepting this interest in the internal structure and workings of the human mechanism, for simultaneously with these constructions, he drew a pattern, another "blueprint," called the *Cemetery of Uniforms and Liveries* [Fig. 12]. This is a plan for the group of malic forms or bachelors used in the large glass, and conceived, as it were, as empty hoods—"hoods without motors beneath." The large glass visualizes both the inner and external character of objects and persons. The inner is that of the bride's structure, highly mechanized and abstract, which has been transformed, as we have seen, through the series of changes in the various preliminary sketches and paintings made for it. The bride has been further transformed by the malic forms in the glass itself. These are depicted in their outer aspects as moulds, or uniforms, symbolic of their occupations identified by Duchamp as those of priest, delivery boy, cavalry man, cop, undertaker, servant in livery, bus-boy, station master, gendarme.

They are responsible for setting in motion the series of causes and effects transmitted by the Duchamp-invented machinery and ex-

perimental apparatus: the glider, the chocolate grinder, the large scissors and the cones; also by visualized mechanical processes as in the three circles, or "optical evidences" of change.

In 1914, a year before starting the large glass, Duchamp had arrived at a speculative point of view as a result of which he designated objects as ready-mades. Ready-mades are what the name implies, complete objects which are at hand, and which by reason of the artist's selectivity are considered by him as belonging in the realm of his own creative activity. The assumption is that the object, conveying properties which coincide with the artist's angle of approach, is endowed as a work of art by virtue of the insight and authority of the artist's selection. Selection is here no longer just a step in a process. It becomes a completed technique.

That these objects, which Duchamp signed, were most frequently machine-made, reflects the conditioning imposed by his interest in the machine esthetic. Examples are the famous *Fountain,* 1917, rejected from the Independent Show in New York that year, the Underwood typewriter hood, 1917, a coat rack, an arm from a hat rack, later used for a shadow in the sensitively achieved mural entitled *Tu m',* 1918. Occasionally, as with the bottle rack, his first ready-made, he added an inscription, or as with the shovel suspended from the ceiling and entitled *In Advance of the Broken Arm,* 1915, he gave a literary title to "create another form, as if using another color." There is also the ready-made-aided, in which details are added to stimulate various responses. In the object subtitled *à bruit secret,* 1916, a device to express the idea of compression, two pieces of metal fastened by bolts compress a ball of twine. The ready-mades may be unique as a concept, but they are not necessarily intended to be unique as examples. For instance, the bottle rack was lost and replaced by another. Although the original inscription was forgotten and no other substituted, the act of replacing the object itself grants to the product of mass production the same validity as nature grants to any star in the skies or grain of sand upon the earth.

The ready-made is the forerunner of the surrealist *objet trouvé,* objects generally found in nature and singled out for possessing, through the workings of the elements of nature, fantasy, esthetic configuration or paranoiac images.

IRONY AS CONCEPT AND TECHNIQUE

"The distinguishing quality of irony is that the meaning intended is contrary to that seemingly expressed. Irony may be gentle or cutting."—N. Webster.

"Irony is a playful way of accepting something. Mine is the irony of indifference. It is a 'meta-irony.' "—M. Duchamp.

Duchamp's credo for working is based on a highly evolved logic outside of the esthetic considerations of "good" or "bad." The esthetic result is not only not an objective, it is intentionally disregarded. That a high esthetic quality stamps all that he touches is the result, not of intention, but of Duchamp's high degree of sensibility. He identifies the means of working, the creative enterprise, with life itself, considers it to be as necessary to life as breathing, synonymous with the process of living.

There is implied here the attempt to animate art, to establish a vital and meaningful interpretation between life and art, to cause both to pulsate as one natural living process. Merging the impulse of procreation with that of artistic creation, there apparently accrues for Duchamp a sense of universal reality which interpenetrates the daily routine of living.

Just as a child often cancels out a picture he has made by running a brush across it, Duchamp negates the seriousness of his own inner motivation by running it through with skepticism. Possessing a revolutionary attitude of mind, Duchamp postulates his responsibility to himself and to society, but, under the influence of his own philosophic detachment, disclaims such a responsibility. Here is the core of the inner drama, the conflict between acceptance and rejection that is the basis of Duchamp's philosophic and esthetic rationale. He resolves it by accepting both sides as concomitant parts of reality. Total skepticism could have meant suicide, as it did subsequently for one or two of the early surrealist poets. Or it could have meant complete inactivity resulting from a constant state of bewilderment or a persisting mood of indifference. (It has long been the general impression that Duchamp fell into this condition because he does not paint on canvas or make sculpture that is readily classifiable as such.) Irony, the "playful way of accepting something," has made it possible for Duchamp to attempt a synthesis. Instead of accepting the alternatives of annihilation or of living in a vacuum, he has worked out a system that has produced a new atmosphere in which irony functions like an activating element, causing a pendulum-like oscillation between acceptance and rejection, affirmation and negation, and rendering them both dynamic and productive.

The *Coffee-grinder* is Duchamp's earliest proto-dada work, his first gesture of turning against the practises as well as the symbols of the traditional artist. Here for the first time, he dissects the machine, and in exploring its parts, makes a new machine, showing in the process sardonic amusement with, and irreverence for, the power of the machine and the modern sanctities of efficiency and utility. Something

of this general attitude is present in Rube Goldberg's humorous play on mechanization, where a complex and fantastic display of ingenuity is employed to obtain a disarmingly simple result; in Ed Wynn's delightfully preposterous and satirical invention, contrived on the principle of the typewriter, as an aid for eating corn on the cob; and in Charlie Chaplin's film *Modern Times*, especially where the efficiency of the system for feeding the worker seeks to destroy the last vestige of human will and to convert him into a robot or a cog in the machinery.

All of Marcel's human mechanism pictures are both playfully and seriously ironical in their implications, *Nude Descending a Staircase* [Fig. 8], *The Bride* [Fig. 10], and especially the *Large Glass.*

With Duchamp, irony transcends individual doubt and frustration to become a commentary on the universal predicament of man in his world. Knowingly or otherwise, the large glass appertains in concept to the Christian tradition in painting. It is essentially an Assumption of the Virgin composition, with the lower part given over to the secular world and its motivations, the upper to the realm of the inner mechanism and inner spirit. The basic plan serves, not for spiritual elevation in the religious sense, but for man's exaltation of woman—a satire on the deification of woman under the prevailing culture. Thus, though it follows the pictorial form of a religious picture, it is opposed to contemporary mores directly traceable to religious influences.

This picture is only one of a series of comments on contemporary culture which Duchamp has made. Another is the picture, quite disrespectfully titled in French *L.H.O.O.Q.*, 1919, a print of the *Mona Lisa* to which he added a moustache and beard as a boy marks up a poster in the subway. This act was evidently intended to register contempt for Renaissance culture, for the glorified sentimentality of the *Mona Lisa*, for the mere virtuosity of brush and of hand. A commentary on the level of popular taste exists in the ready-made-aided, *Pharmacie*, 1914, a vapid and fuzzy autumn scene, an existing chromo, adorned by Duchamp with red and green pharmaceutical vases, perhaps as "stop" and "go" signals for would-be art lovers.

Definitely incisive is the irony that exists in *Unhappy Readymade*, 1922–23. This object was constructed from a text book—a treatise on geometry—opened face up, hanging in midair and rigged diagonally to the corners of a porch. It was left suspended there for a period of time, during which the wind could blow and tear its pages of geometric formulae, the rain drench them, and the sun bleach and fade them. Thus exposed to the weather, "the treatise seriously got the facts of life." ("What is the solution?" Duchamp proceeds to ask. "There is no solution because there is no problem. Problem is the invention of man—it is nonsensical.") This ready-made epitomizes the

conflict between human knowledge and the eternal verities. Duchamp accepts as inevitable the action of the forces of nature, the changes which time effects, its proclivity for corroding, destroying, reducing to rubbish all that man builds, its haste in covering all human traces with dust.

At one time the large glass lay under a coat of dust which had accumulated over a period of six months. In this condition, it was dramatically photographed by Man Ray, and, the photograph titled *Elévage de Poussière,* all but resembles the traces of a lost civilization spotted from an airplane. Duchamp dropped fixative on the glass where the dust covered the cones, using the mottled effect of discoloration, as a color externally imposed. Preserving this as a memento of a condition prevailing at a given moment, he cleared away the remainder of the dust and began to work again. Here he submits to, but is not dominated by, the inevitable. Sometimes, as in *Unhappy Readymade,* he goes out to meet the situation, establishing the conditions under which the elements may act. The ravages of time he accepts with philosophic detachment, as in the ready-made consisting of the rusted metal comb, a contemporary object primitive enough in its form and aged enough in its incrustations to conjure up in advance the image of its appearance if, in the remote future, it were to be dug out of ruins. As the shovel predicts "the broken arm," the comb is offered as a sample of the state of archeological findings to be unearthed .hundreds of years hence.

THE ELEMENT OF CHANCE

Chance is a sub-category of irony in the work of Duchamp, its use springing from the ironic point of view and its application highly charged with mockery. The results of his experiments with chance are applied with the precision and detachment of mathematics. Selection enters before and after the fact. Anomalous as this may sound, Duchamp uses chance intentionally. Through its use he arrives at "a new unit of measure," finding forms independent of the hand. A rich variety of techniques has developed from its use. Three basic means are employed—"wind, gravity, and aim."

Duchamp supplies the following key to his first experiment with chance: "Draft is a force. If you capture it, you can make a piston move." Air currents blowing a piece of mesh gauze against a screen, imprinted a limpid rectangle upon it. The experiment repeated three times gave three chance images, variations on the square, which were used in their precise configuration on the cloud formation in the large glass.

Choosing deliberately a thread a meter long, Duchamp held it "straight and horizontal" at a height of a meter from the floor. This preparation was a kind of mathematical ritual. Then, chance and gravity were allowed to play their parts. The thread was dropped on to a horizontal plane where it was fixed in the chance line that it formed. This experiment was repeated three times, giving three variations of the chance line which were used in several pictures. These lines, titled *3 stoppages étalon,* 1913–14,* arranged into three different groupings for a total of nine, were projected on the large glass in relation to the nine malic forms. The lines fanned out like huge cracks, anticipating the direction the actual cracks took when the glass was eventually broken by accident. Here again, perhaps, is Duchamp's acceptance of the intervention of nature, or at least of "fate." In using glass, he surely knew, even though he ignored the fact, that the chances were it would be broken. All the more reason, it is astounding that by the use of chance, he was to anticipate the configuration when the breakage occurred.

The third device in allowing shapes to create themselves and thus void the responsibility of the hand, is termed by Duchamp *adresse,* that is, skill in aiming. Nine marks were made upon the glass by the impact of shots of matches dipped in paint, from a toy cannon ("If the instrument is bad, the skill is tested more.") Aiming nine shots at a given point, these formed a polygram as a result of variation in the aim-control and accompanying conditions. He then converted the flat polygram or floor plan into an elevation plan. Here the nine points became the locations for the nine malic forms in perspective.

Duchamp accepts as ineviatble the action of the forces of nature, the changes which time effects, its proclivity for corroding, destroying, reducing to rubbish all that man builds, its haste in covering all human traces with dust.

The laws of chance were later exploited in dadaism by Arp and, in surrealism, Ernst's decalcomania of chance has been the means for releasing the springs of inspiration for many of the younger surrealist painters.

The various techniques already mentioned in connection with Duchamp's work are only a part of those implicit therein. There might also be mentioned as of particular interest, the "optical evidences" in the large glass, actual optical drawings for the correction of eyesight, transcribed in perspective and scraped out of quicksilver that had been applied, mirror-fashion, to the glass. There is also the use of lead wire and string to supplant the hand in drawing lines. The device of kinesthetic surprise is employed in the object sardonically titled *Why Not*

* [3 Standard Stoppages (Fig. 13)—Ed.]

Sneeze?, 1921. Here in lifting a wire cage filled with cubes of sugar, one is startled by its unexpected weight, for the cubes are marble, not sugar.

The mural *Tu m'* is rich in inventive techniques, and combines most of those so far discussed. Further, it contains many new ideas. *Trompe l'oeil* is introduced—Duchamp painted a simulated rent in the canvas "held together" with real safety pins. Shadows and the ghosts of shadows appear, forecasting the later *fumage* of Paalen, Matta and others. These shadows are thrown by the hat rack, bicycle wheel and a corkscrew. Set in the center of the canvas is a pointing hand, the sign painter's *cliché*, for the execution of which Duchamp brought in a local artisan; and, projecting at right angles from the canvas, is a ready-made object consisting of a bristle brush.

As fascinating as are the many techniques and philosophic ideas in themselves, they serve the more important function of being aids to the reexamination of esthetic concepts, of contemporary culture and its relation to culture in general. That Duchamp's esthetic sensibility enabled him to do this on a high spiritual plane adds immeasurably to the stature of his achievement. Perhaps more than any one of his contemporaries he has rediscovered the magic of the object and its esoteric relation to life, for centuries obscured in the Greek concept of sculpture. Contemporary points of view may be found in Duchamp's work, cubism, futurism, *collage*, dada, and surrealism. This is not eclecticism, but the varied activity of a creative nature too large to be confined in any one movement. So all-encompassing, so pulsating with contemporaneity and so fecund is his work that as various phases of vanguard art unfold and develop, they find in it their counterpart. Picasso's energy is so intense that he exploits every possibility implicit in his inventions. Klee's fantasy leaves more space for the investigations of the younger painters. But the treasure trove of subtleties in creative ideas and techniques in Duchamp's work is still essentially untouched. Tapping these resources will provide a rich yield for the new generation of painters, in whose awareness lies the future of twentieth-century painting; for here, deeply embedded with meaning, is one of the great, little explored veins in contemporary art.

REFLEXIONS ON MARCEL DUCHAMP

William Rubin

Marcel Duchamp is the only painter to have impressed the world of art as much by what he did not do as by what he did, but it took an age in which painting had become an autonomous ideal, a way of life, and even, in Malraux's terms, a quasi-religion, for his inaction to be consequential. After "incompleting" the *Large Glass* in 1921 [Fig. 17], and retiring to a life of chess punctuated occasionally by the creation of ironic "machines" and other forms of Dada activity, Duchamp functioned as a living myth, the personification of Dada's refusal to distinguish between "art" and "life." He represented a constant threat to the community of artists by his insistence that painting is but "one means of expression among others and not a goal destined to fill an entire lifetime." For an age in which painting has been identified with freedom, his greatest freedom became that of disengagement from painting.

The persistence of a myth depends, however, not on the authenticity of the facts or events which form its nucleus, but on the collective consciousness of the age which uses it. The sense of crisis which pervaded art between the wars lent great prestige to Duchamp's nihilism. In this regard, the hearty reaffirmation of pure painting that followed World War II (the New American Painting and its counterparts abroad) took some urgency out of the Duchamp myth. Though his personal prestige with the immediate post-war generation was great, the philosophical implications of his work and of his disengagement from it were disregarded. Picabia was identified as a more heroic figure since, though departing from substantially the same point as

"Reflexions on Marcel Duchamp," by William Rubin. From *Art International*, IV, No. 9 (December 1, 1960), 49–53. Reprinted by permission of the author.

Duchamp, he continued to paint, to carry on the struggle, until his death. But, if the first command of an artist is to be true to that within himself which he must express, then Duchamp's abandonment of painting was the ineluctable consequence of his particular genius. The work which Picabia produced after 1920 was, in any case, deplorable and served only to vitiate his image. Picabia's painting, paradoxically, made less of an impression on post-World War I generations than Duchamp's rejection of art.

Here in America, during the last few years, there has been a marked increase in what we might call pseudo-Dada activity on the part of the younger artists, a response related in part to the atmosphere of indecision—even crisis—which has followed in the wake of the massive advances wrought by Pollock, Still, Rothko, and others. Some members of the Second Generation seem to feel that there is nothing left to say within the bounds of oil painting. This tendency, signalled by two exhibitions at the Martha Jackson Gallery entitled New Media—New Forms (an entirely unwarranted juxtaposition of assumptions), bears witness to the recent revival of interest in Duchamp and suggests the need for a critical look at the man whose "anti-art" is still the standard by which such excursions must be measured.

The works in the Martha Jackson exhibitions tended to polarize into two groups: one, in which unusual materials (plastic, concrete, styrofoam, steelwool, cork, sponge) were substituted for the familiar media of painting and sculpture but were manipulated in essentially the same fashion; the other, in which the inclusion of nylon stockings, bicycle wheels, stuffed chickens, and railroad ties directed the viewer's interest to these materials as pictorial ends in themselves. For the former group Duchamp is not important; for the latter, he is the pioneer. The Cubists and Futurists, and not he, had opened the door to the esthetic manipulation of new and unusual materials. Duchamp is not fundamentally an explorer of media; his major contribution in that regard—painting on glass—found only one disciple, his brother-in-law Jean Crotti. Duchamp's signal contribution was rather that form of anti-art expressed by his Readymades (in both their simple and combined forms); and here his absolute unwillingness to yield to estheticism gave his "objects" a mordancy lacking in those of most of the Americans where the exoticism of the object-elements often serves to mask the fact that they are thrown together according to old-fashioned (1947–52) esthetic formulae.

Nothing in Duchamp's work prior to his emergence as a mature painter in 1911 prepares us for the rapidity of his development during the subsequent four years. By 1915, when he began the *Large Glass*, all the essentials of his contribution as an artist had been established.

No four years in the work of any other modern painter demonstrate such rapid morphological development nor witness so many radical departures in method and idea. Remarkably, the various stages of this progress are seldom represented by more than one picture. In fact, between the *Sad Young Man on a Train* of 1911 and Duchamp's last painting, *Tu m'* of 1918, he executed only six oil paintings, two oil sketches, three works on glass, some thirteen Readymades and other objects, and around twenty small works in pencil, watercolour, and mixed media. To appreciate the sparsity of such an œuvre we have only to consider that these works cover a morphological progression more extensive and more variegated than the four years spanning the beginning and the end of Analytic Cubism, the stages of which are witnessed, in Picasso's painting alone, by thousands of paintings and drawings. This remarkable disparity testifies to the wholly different mechanism at work in Duchamp's evolution. Picasso finds his way through Cubism *in the act of painting*. The morphological change is by accretion, slight changes taking place from work to work. Duchamp advances speculatively, not by painting but *through cerebration;* the finished work represents the plastic re-creation of a reality which has grown to maturity in the mind.

Portrait and *Sonata* [Fig. 3] painted early in 1911 mark the beginning of Duchamp's rapid advance. Until that time he had been occupied by Fauvist techniques already put aside by the leading Fauve masters. Now, with his brother Jacques Villon's canvases as catalysts, Duchamp caught up with the avant-garde. From Villon he adopted a tenderly coloured, transparent form of Cubism that leaned more heavily on the aquarelle-like overlapping of translucent facets of some late Cézannes than on the contemporary work of Picasso and Braque. Though the colour facets of Duchamp's pictures are flat, and traditional modelling, still abundant in some of his Fauve canvases, has been minimized, the remnants of a perspective space, particularly in *Sonata*, suggest that Duchamp had not responded to the need to affirm the picture plane which was leading the pioneer Cubists towards an increasingly flat image. In fact, we may distinguish even the mature paintings of Duchamp in 1912 from the Analytical Cubism of that time by the fact that while Picasso and Braque had virtually dissolved the tactility of the forms and set them floating in a narrow space, Duchamp never renounced the taste for punching perspective "holes" in the canvas, nor for the chiaroscuro modelling concomitant with such illusionism.

Cubism had been a catalyst which had helped Duchamp decompose forms; now he was to recompose them in a manner related to Futurism. In *Portrait* he had already shown simultaneously five different positions of the same figure. There, the phases did not con-

stitute a series; the *Sad Young Man on a Train,* however, picks up this idea, which had been in the air since 1910. At that time the Futurists, in their "Technical Manifesto," had spoken of retinal after-images and posited a kind of art that would suggest motion by superimposing images of the figure at slightly differentiated stages of action (as is demonstrated to academic perfection in such works as Balla's *Dog on a Leash).* But it is unlikely that Duchamp's departure was directly influenced by Futurism, for although he knew Severini, he had developed his ideas on motion well prior to the First Futurist Exhibition in Paris, held in January, 1912, at the Galerie Bernheim Jeune. It is probable that both Duchamp and the Futurists were influenced by common sources: the cinema and the Chronophotographs of Muybridge and Maree. "Chronophotography was in vogue at the time," Duchamp recalls. "Studies of horses in movement and of fencers in different positions, as in Muybridge's albums, were well known to me."

The definitive version of the *Nude Descending a Staircase* (No. II) was painted in January of 1912 in monochromatic shades of brown, grey, and green, identical with the palette of Analytic Cubism, but with a diluted matière that harks back to the Villonesque works of 1910. The articulation is not through colour but through the subtle play of light and dark, as is confirmed by the satisfaction given by version No. III (1916) [Fig. 21], which is a black and white photograph of No. II tinted with watercolour, ink, and pastel. The elements of the male body have been generalized into ciphers. "The reduction of the head in movement to a bare line," says Duchamp, "seemed to me defensible. A form passing through space would traverse a line; and as the form moved, the line it traversed would be replaced by another line—and another and another." Amid the shuffled lines and planes one shape distinguishes itself especially: the semi-elliptical device of the hips. It alone adumbrates (but only slightly) the half mechanical, half organic morphology of the subsequent oils.

The nude descends along a diagonal running from the left to the right side of the canvas, the action "stopped" at various points in a manner foretelling the effects of stroboscopic photography (cf. Mili's photo of Duchamp descending a staircase). The picture hangs together better than the *Sad Young Man* because Duchamp extended the composition to fill the areas around the outside of the canvas which remained empty in the earlier picture. But though the staircase fills the lower left and upper right of the canvas, the lesser density of shapes, the darker tones, and above all the perspective devices of those areas preclude that degree of surface continuity achieved in different ways by both Matisse and the Analytic Cubists at that time. It is symptomatic that the spatial perspective in the upper right of the *Nude* should influence only one later painter—Matta (in such pictures as *Being*

With)—the only painter after Duchamp to explore the possibilities of a new kind of illusionistic space.

The public consternation caused by the *Nude Descending a Staircase* when exhibited in Paris in 1912 and even more at the Armory show in New York has given it an exaggerated reputation as regards its place in the development of modern painting and in the œuvre of Duchamp himself. It is not Duchamp's masterpiece. Among the oil paintings, the *King and Queen Surrounded by Swift Nudes* and especially the *Passage of the Virgin to the Bride* [Fig. 9], are superior to it in both plastic and iconographic inventiveness, as is, of course, the *Large Glass*. Robert Lebel, in his profoundly sensitive if sometimes uncritical monograph on Duchamp, attributes the public reaction to the fact that with the *Nude* Duchamp "had moved to the farthest limits of painting." On the contrary, I believe that it is only with the later work that Duchamp breaks entirely new ground and that, plasticly speaking, the *Nude* hardly compares in adventurousness with the great Analytic Cubist paintings of the same year. Lebel's assertion that Duchamp had "overtaken Picasso and Braque in a few months by simultaneously liquidating objective form and colour" is incomprehensible to me. Of objective form there is quite evidently a great deal in the *Nude*, as compared with the merest fragments in the Cubist pictures of 1912, where for all practical purposes the subject has disappeared. Moreover, the monochromatic tonalities of the *Nude* had already been in use for years by the Cubists. One reason why public interest centered on the *Nude*, I suspect, is that while obviously avant-garde, it was, paradoxically, less advanced, more gimmicky, than the Analytic Cubist pictures of the same date. With the aid of the very clear title, spectators could make out the cinematic action of the painting, and, grasping it by that handle, could compare it with their a priori notion of what a nude descending a staircase should resemble. This possibility is precluded by the more marked abstraction of either a Picasso or a Kandinsky of 1912. The *Nude's* position in modern painting is parallel to that of Futurist pictures. Its novel element—the "representation" of movement by imaging simultaneously its successive phases—is a *narrative*, not a plastic, innovation and was not destined in either the Duchamp or Futurist versions to open a new direction in modern painting.

It is with the *King and Queen Surrounded by Swift Nudes* that we pass, morphologically speaking, out of Futurism and into the internalized world of organo-mechanical beings that are entirely Duchamp's own. At the same time we pass from external, retinal appearances of events to what Gabrielle Buffet called the "capturing of the non-perceptible." The enigmatic title is hybrid: the King and Queen are taken from chess, though they more resemble fantastic mechanical

analogues of human beings. It is as if, in a dreamlike confusion of different levels of reality, the images of chess (long a favorite subject of Duchamp and later his major preoccupation), machines (rapidly becoming the central metaphor of his imagery), and human beings (Duchamp's parents, within the framework of a psychological reading) had been fused. Iconographically, the "swift nudes" can be interpreted as the Duchamp children, "turbulent offspring," according to Lebel, who threaten the "totemic stability" of the "Father and Mother machines."

The new morphology is based upon a principle of reduction but not abstraction. Duchamp's interest in man—his psychology and physiology—leads to a path quite opposed to Cubism. "Reduce, reduce, reduce was my thought," he recalls. "But at the same time my aim was turning inward, rather than toward externals. . . . I came to feel that an artist might use anything—a dot, a line, the most conventional or unconventional symbol—to say what he wanted to say. . . . [In the *King and Queen*] there are no human forms or indications of anatomy. But in it one can see where the former [would be] placed; and for all this reduction I would never call it an 'abstract' painting." The *King and Queen* leaves behind the predominantly straight-edge forms of the *Nude* in favor of fragmentary cylindrical and conical shapes which stand equidistant between Léger's painting at the time and the more organic morphology firmly established two months later in the *Passage from the Virgin to the Bride*.

The *Passage from the Virgin to the Bride* is in every sense Duchamp's masterpiece as an oil painter. Its structure is more tenuous, less obviously mechanical than the tighter, more descriptive earlier paintings or *The Bride*, with which it is contemporary. Its more painterly appearance proceeds from the fact that its forms are modelled in low relief rather than in the round, with a tenderness which suggests their having been applied with the fingers rather than the brush. Here, though the monochromatic colouring is still essentially that of Analytic Cubism, we cannot escape the allusion to human physiology in the pink and fleshy tones. The complex of forms, spreading to cover most of the surface, seems to be moving, and suggests an internalized, psycho-sexual counterpart of the objective sensory experience of motion in the *Nude Descending a Staircase*—the image of an interior event.

The structure of these oil paintings and of the *Large Glass* which summarizes their elements, constitutes an attempt on Duchamp's part to find a morphological counterpart for irrational and extrasensory experience. It presupposes the existence of another "dimension" to existence, one of which man becomes aware only in moments of epiphany: a "meta-world" that Duchamp has described as "fourth

dimensional" and posited in his work as the "unknown quantity." We need not consult Einstein to grasp this; Duchamp explains very simply that if a shadow is a two-dimensional projection of a three-dimensional form, then a three-dimensional object must itself be the projection of a four-dimensional form. A picture is therefore (echoing Plato) an illusion of an illusion, or, to use Duchamp's own words, a "lunar projection of an invisible form." The most ordinary object thus holds the possibility of an epiphany; it requires only the genius of the artist to see this and, through singling out the object, to make manifest its meanings. Duchamp performed this magical act for the first time in 1913 when, through selection alone, he promoted a common *Bicycle Wheel* [Fig. 11] to the status of a work of art.

During his stay in Munich in the summer of 1912, Duchamp had executed a pencil˙sketch entitled *The Bride Stripped Bare by the Bachelors,* which announced the next in his series of oil paintings. Before advancing this image further, however, he underwent a major intellectual crisis, which was to cause him to renounce oil painting and take up a more mechanistic, pseudo-scientific, verbally inspired imagery. The new direction culminated in the *Large Glass, The Bride Stripped Bare by Her Bachelors, Even,* which, despite the similarity of its title to that of the drawing of 1912, is radically different in structure and iconography.

On his return to Paris Duchamp had found himself increasingly disillusioned by the emphasis avant-garde circles were placing on "pure painting" and by the fact that even his own admirers tended to regard his painting from the point of view of the esthetics alone, overlooking the metaphysical implications which, for him, constituted the core of the work. The decisive break in his art is marked by the *Chocolate Grinder,* the two versions of which date from the spring of 1913 and February, 1914, respectively. "One day, in a shop window," Duchamp recounts, "I saw a veritable chocolate grinder in action and *this spectacle so fascinated me* that I took this machine as a point of departure." The first *Chocolate Grinder* was executed in traditional oils on canvas but differed from Duchamp's earlier "composed" and morphologically inventive pictures in being simply a dry, almost academic, perspective study of a real object. But though such academic oil painting constitutes, in the twentieth century, a form of anti-art, as Magritte and Dali were later to confirm, its methodology was not sufficiently unplastic to suit Duchamp, and in the second version of the *Chocolate Grinder* he eliminated the chiaroscuro modelling and articulated the forms with lengths of thread, glued with paint and varnish and sewn to the canvas at all intersections.

From an anti-esthetic trompe d'œil replica of a real object, it was only a short and logical step to the object itself. Not long after the

revelation of the *Chocolate Grinder,* Duchamp placed a *Bicycle Wheel* [Fig. 11] upside down on a stool and thus "created" the first Readymade. Inverted in position and isolated from its usual outdoor setting, the *Bicycle Wheel* proved a disturbingly enigmatic and yet humorous object—but it had taken Duchamp to realize its potential. What he had done was to subject the object to the same dépaysment—disassociation or displacement—to which the symbolist poets had subjected words in an attempt to liberate their hidden meanings. The Symbolist poet Isadore Ducasse ("The Count of Lautréamont"), later fêted as a precursor by the Surrealists, had provided the classic example in his "chance encounter of a sewing machine and an umbrella on a dissection table."

Readymades result from almost predestined confrontation of Duchamp and objects ("it is a kind of rendez-vous"), but they may be conceived of in advance ("buy a pair of ice-tongs as a Rdymde" goes a note from the Green Box), or made by proxy (e.g., the *Unhappy Readymade,* constructed by Duchamp's sister in Paris on his instructions from New York). There even exists a project for a *Reciprocal Readymade:* "Use a Rembrandt as an ironing-board." As the Readymades proliferated, they created an environment in themselves (as attested by the photograph of Duchamp's West 67th Street apartment [1917–18]); Gabrielle Buffet-Picabia remembers Duchamp living "in a kind of Capernaum surrounded by chosen objects." Duchamp also "assisted" and joined objects to produce hybrid Readymades like *Why Not Sneeze?* (1921), a birdcage filled with cubes of sugar into which a thermometer has been thrust. The spectator who has adjusted to this unexpected juxtaposition then lifts the cage and discovers by its tremendous weight that the "sugar lumps" are really carefully carved cubes of white marble. Thus Duchamp goes illusionistic art one better by creating illusionistic anti-art: the trompe-l'œil object.

However interesting we may find the formal structure of these objects (Robert Motherwell has observed that the *Bottle-Rack* [Fig. 16] is more beautiful than any sculpture created in the same year), they were intended as a form of communication *devoid of esthetic interest.* Perhaps the fact that many of the Readymades have plastic appeal nevertheless, is a partial explanation of why Duchamp later ceased making them. In any case, an object like the *Bicycle Wheel* is quite opposed in nature to what appear at first to be related objects, like Picasso's *Bull's Head,* created by joining a bicycle seat and handlebars. The Picasso work revolves, not around the epiphany of the object, but its metamorphosis by the artist. The conversion from bicycle to bull's head is *in the interest of plasticity,* and though the work retains a kind of Surreal poetic quality (which it lost when Picasso later

cast it in bronze), it attests more to the activity of the artist as manipulator than to the passive insight of the seer.

Duchamp's renunciation of the profession of painting had necessitated the search for a means of support; he found it for a while in a post as an assistant in the Bibliothèque Ste-Geneviève. There, in an atmosphere conducive to reflection and study, Duchamp created the "new physics" without which, he was convinced, future art would be anachronistic. Assertions of the inter-relationship of abstract painting and modern science had been in the air since the advent of Cubism. Not that Picasso or Braque had any interest in science; but to people unable to understand and accept Cubism in its proper painterly terms, its association with science (of which they were generally equally ignorant) seemed to justify it, to legitimize it as an aspect of technological civilization. The insurance clerk Princet, a friend of many of the advanced painters and an amateur mathematician, did not a little to disseminate these ideas, since then the scourge of every popular history of modern painting. The weaker, conservative Cubists, like Metzinger, were particularly attracted by such notions, which allowed them to "reason" the need of the new abstract art. Severini was later to use the same pseudo-scientific, mathematical jargon to reason himself out of Cubism and into Neo-Classicism. "There were discussions at the time of the fourth dimension and Non-Euclidian geometry," recalls Duchamp, "but most views of it were amateurish. . . . Yet for all our misunderstandings, these new ideas helped us to get away from the conventional way of speaking [about art] . . . from our studio platitudes." Only Duchamp, among the painters, was to devote himself seriously to these studies, reading Lobachevsky and Rieman and attempting to assimilate the speculations of modern mathematics to those of art, though even his science remained, at best, pseudo-science.

In his conviction that art must derive its underpinning from the artist's knowledge of the phenomenological world, Duchamp reminds us of Leonardo. But the world of Renaissance science was one that could be seen with the naked eye, and the mathematics of Leonardo's day was on a high school level. Leonardo's equal knowledge of these fields is inconceivable in an age of advanced science and professional specialization. For Leonardo, scientific knowledge not only guaranteed a more "correct" image of the real world, but allowed the picture to recapitulate and therefore symbolize the tremendous advances in science which prop up the optimism of the Renaissance. The modern painter can use science practically only in a more limited way. Seurat might avail himself of it in connection with his use of colour, but even there it was more the "scientific method," more the spirit of science, than its actual data, which characterizes the work. Yet the desire to

incorporate science, as a way of recreating the spirit of one's age, was
no less legitimate on Duchamp's (and later Matta's) part than it was
for a Renaissance artist (or than it had been with the Futurists in
regard to technology). Since there was no question of using science in
the direct manner of Leonardo, Duchamp was to create a simulacrum
of science, an "amusing physics," as he called it, which from one side
appeared a serious apotheosis of quantitative knowledge and from the
other, an ironic critique of science through humor. (His notes, as
Lebel observes, are full of such phrases as "matter of oscillating den-
sity," "emancipated metals," and "divergence of molecules," in formu-
lae which strain the laws of physics "just a little.")

The first thing Duchamp needed, in order to apply the mathe-
matics of his "new science," was a unit of measure. A note from the
Green Box tells us that "a straight horizontal thread one meter in
length falls from a height of one meter onto a horizontal plane while
twisting *at will* and gives a new form to the unit of length." Three
such threads were fixed to strips of cloth mounted in turn on glass to
make the "Three Standard Stoppages." Together with wooden forms
cut in the profile of the fall of the threads they were enclosed in a
specially prepared croquet box ("canned chance"). Drawings for the
Bachelor Machine at this time begin to resemble engineers' designs
filled with what appear to be serious, if highly cryptic, indications of
length. Since everything that pertained to the painterly execution of a
picture was now rejected, the "new art" would be based entirely upon
mathematical computations as expressed within the framework of
mechanical drawing, thus determining the entire work in advance of
its "execution": "I wanted to return to an absolutely dry drawing, to
the creation of a dry art, and what better example of this new art than
mechanical drawing. I began to appreciate the value of exactitude, of
precision. . . ."

It was in New York, where Duchamp settled in 1915, that all
these interests in language and science, along with virtually the whole
of his previous artistic speculations were summarized in the *Large
Glass, The Bride Stripped Bare by Her Bachelors, Even,* begun shortly
after his arrival and left definitively incomplete in 1923. It consists of
two large panes of glass in metal frames forming together a field a bit
over 9 feet tall and slightly under 6 feet wide. On one side of the glass
a series of forms covering roughly a third of its surface have been ap-
plied with lead wire and paints. A spectator unfamiliar with Du-
champ's iconography would not immediately divine that he was in the
presence of "a mechanistic and cynical interpretation of the phenomena
of love" (Breton) but would respond to it only as a perspective study
for some strange and humorous machine of indeterminate purpose. He
would note that although the parts are connected mechanically, they

are antisequential and unexpected in their various individual identities. A water-wheel, chocolate grinder, cloud, and what appear to be dry cleaners' blocking and pressing forms seem to function together like a very serious and carefully engineered counterpart of a Rube Goldberg apparatus (one such Goldberg "machine" was published by Duchamp in "New York Dada").

Since an account of the iconography of the *Large Glass* [Fig. 17] would require an article, if not a book, in itself, I shall have to content myself with referring the reader to the classic description by Breton (in "The Lighthouse of the Bride") and the monograph by Lebel. But though such iconographic description is useful in enriching our responses to the work, the *Large Glass* makes a most remarkable impression in terms of its visual data alone. Here Duchamp's method of suspending the shapes in isolation against transparent glass created an unusual and potentially infinite series of effects. With the aid of the photograph of Katherine Dreier's library in 1937, we can conjure up an image of the *Large Glass* in the normal living environment of human beings rather than the neuter and very barren context of the museum chamber in which it now resides. Against a background of everyday, recognizable objects, "a Readymade continually in motion" (Lebel), the unexpected forms of the *Large Glass* materialize as if a giant x-ray plate had suddenly revealed the extra-retinal aspects of the realities in our midst.

What seems in retrospect to be an ineluctable progression away from art reached its final phase around 1920 when Duchamp ceased making illusions of machines and began constructing the machines themselves. This change from "anti-artist" to "engineer" found him true nevertheless to his ironic view of experience, for his machines pulled the rug out from under the technological world by denying, through their absolute uselessness, the essential premise of machinery. The two most significant are the *Rotary Glass Plate*, painted segments of glass which give the illusion of a circle while rotating on their metal axis, which Duchamp constructed in New York (1920) with the aid of Man Ray, and the Rotoreliefs, a series of cardboard disks covered with patterns of coloured lines that create three-dimensional illusions when turned at around 33 revolutions per minute (a kind of visual phonograph record). In another extension of his earlier concerns as a painter, Duchamp now began to develop the possibilities of the disks in terms of the motion pictures, a logical extension of the cinematic effect of such pictures as the *Nude*, and in 1926 created *Anemic Cinema* in collaboration with Man Ray and Marc Allegret.

In the years between the wars Duchamp created occasional Readymades, devised ironic pranks, and collaborated with the Surrealists in the staging of their most important exhibitions and in other

respects, but these gestures were infrequent, and far more time was devoted to the play and study of chess. Like Leonardo, Duchamp had always been more interested in the process of structuring a work of art than in the final execution and ultimate result. Chess seemed to make possible a constant renewal of this process ("the game itself is very, very plastic"), involving a combination of mathematics and space, logic and imagination, in which the end result is zero in the sense that the board is swept clean. Thus, as a form of mathematic-esthetic speculation, chess playing recapitulated Duchamp's renunciation of painting and summarized the Dada belief that the value of creative activity lies in the process, in the act of making, rather than in the esthetic significance of the thing made.

In "Les Fleurs du Mal" Baudelaire had called Rubens, Rembrandt, Michelangelo and Delacroix (among others) "les phares," or beacons of art, an image adapted by Breton for the title of his essay on Duchamp, "La Phare de la Marlée" (usually translated "The Lighthouse of the Bride"). Indeed, for the Dada-Surrealist generations of the "entreguerre," Duchamp provided the ultimate example of the anti-esthetic ideal which, to varying degrees, marked the avant-garde art of that period. If no longer a model for emulation, Duchamp is nevertheless still a fixed point for navigation. Though his only influence today is indirect, we are constantly aware of him out of the corner of our eye. His Readymades have become monuments to the enigma of seeing, reminders that visual meaning cannot be defined in plastic terms alone, or within the cumulative conventions of any art. In a world of competing painterly formulae, he argues the transcendence of creative seeing—that genius lies purely in the eye, and not at all in the hand, of the artist.

MARCEL DUCHAMP
AND EMBLEMATIC REALISM

Werner Hofmann

> The natural surface of objects is beautiful but their imitation is something dead. Objects give us everything but their representation no longer gives us anything.

These sentences from Mondrian's Paris diaries could have been written by Duchamp (b. 1887). In fact he could have made such notes at approximately the same time, between 1911 and 1914.[1] They sound like a commentary for the *Bottle Rack* (1914) [Fig. 16] and the *Bicycle Wheel* mounted on a stool (1913) [Fig. 11].

Before we ask what Duchamp—the brother of the painter Jacques Villon and the sculptor Duchamp-Villon—may have intended with such demonstrations let us first examine, from the point of view of a present haunted by "Pop," the problem of "artlessness." Duchamp's ready-mades pose the problem in the most radical way. Here we encounter, for the first time, what Ruskin called "facts without art." Ruskin's reflections, from *The Stones of Venice* [Vol. II., ch. vi, pars. xiii–xliv], are worthy of our consideration:

> We are to remember, in the first place, that the arrangement of colours and lines is an art analogous to the composition of music, and entirely

"Marcel Duchamp and Emblematic Realism," by Werner Hofmann. From *Merkur; Deutsche Zeitschrift für europäisches Denken*, XIX, No. 10 (October 1965), 941–55. Translated for this volume by Wolfgang Heuss. Reprinted by permission of *Merkur; Deutsche Zeitschrift für europäisches Denken* and the author.

[1] Marcel Duchamp was born in Rouen and now lives in New York. His writings appeared in the volume *Marchand du Sel* (Paris, 1958). Selections, with a good commentary, in *Theorien zeitgenössischer Malerei in Selbstzeugnissen*, ed. Jürgen Claus (Reinbek, 1963).

independent of the representation of facts. Good colouring does not necessarily convey the image of anything but itself. It consists in certain proportions and arrangements of rays of light, but not in likenesses to anything. A few touches of certain greys and purples laid by a master's hand on white paper, will be good colouring; as more touches are added beside them, we may find out that they were intended to represent a dove's neck, and we may praise, as the drawing advances, the perfect imitation of the dove's neck. But the good colouring does not consist in that imitation, but in the abstract qualities and relations of the grey and purple.

In like manner, as soon as a great sculptor begins to shape his work out of the block, we shall see that its lines are nobly arranged, and of noble character. We may not have the slightest idea for what the forms are intended, whether they are of man or beast, of vegetation or drapery. Their likeness to anything does not affect their nobleness. They are magnificent forms, and that is all we need care to know of them, in order to say whether the workman is a good or bad sculptor.

Now the noblest art is an exact unison of the abstract value, with the imitative power, of forms and colours. It is the noblest composition, used to express the noblest facts. But the human mind cannot in general unite the two perfections: it either pursues the fact to the neglect of the composition, or pursues the composition to the neglect of the fact.

And it is intended by the Deity that it *should* do this; the best art is not always wanted. Facts are often wanted without art, as in a geological diagram; and art often without facts, as in a Turkey carpet. . . .

Strict Naturalism had renounced, of necessity, the process of formalization, charging it with allowing formal content to do violence to factual content. When the perceptible world is recorded in a fashion aiming at illusion, something comes to the fore which distracts from and may even overshadow drily factual statements: individual "*sprezzatura.*" The word was coined by Castiglione; it refers to the casual brush strokes particularly cultivated by the sixteenth century Venetians. By working in this manner the artist indicates his sovereign stance above perceived impressions. He will not be misled into painstaking overcomplication and he focuses on the overall impression. Admittedly, the viewer must adapt to the formal idiosyncrasies of such nonchalance. Diderot's remarks about Chardin indicate how ambivalent the method is. Viewed from a certain distance the colored surface is transformed into an illusionistic image, while at closer range it appears to be a mere conglomeration of brushstrokes from which no factual content can be read. Nevertheless, factual and formal content still coexist, although in a highly unstable balance. During the nineteenth century the balance shifted more and more in favor of formal

content. Eventually this led to a provocative neglect of the imitative qualities of the picture. More and more, paintings changed into that reality, autonomous and superior to perceived impressions, which [Conrad] Fiedler calls the "production of reality."

Duchamp's criticism of this process in which the *gestalt* of the picture becomes autonomous was tantamount to a renewed consideration of objects recorded soberly and factually. Basic points of his criticism were indebted to the program of naturalism, which rejects *sprezzatura*.

Moving rapidly through several stages, Duchamp became familiar with the practice and the artistic licences of "production of reality" (Fiedler) which he later scorned. In 1904–1905 he attended the Académie Julian, a reputable Paris painting school. Next he studied the Fauves and Cézanne; nudes and portraits give evidence of that confrontation. In 1911, his initially pasty application of color hardened. At first glance the result is a classicistic look, but it is really the earliest indication of the "dry manner" of later years. Also in 1911, Duchamp borrowed from the Cubists formal fragmentation of the body. But his faceting is more delicate and subtle [than theirs], and does not use archaic rigidity. Rhythmic variations, reminiscent of Hogarth's S-curve, run through it. In *Sad Young Man on a Train* (1911), the body is transformed into a carefully structured mesh of phases of movement. The painting was inspired by photographs of processes of movement which were frequently reproduced in journals of the time. Having joined the Section d'Or, and independently of the Futurists (later he accused them of lacking a sense of humor), Duchamp painted a number of pictures in 1912 which mark the climax and the final point of his career as a painter: *Nude Descending a Staircase* [Fig. 8]; *King and Queen Surrounded by Swift Nudes; The Passage From the Virgin to the Bride* [Fig. 9]. Superficial comparison would ascertain relationships to Futurist dynamism and to the buttressing and boxing of Analytic Cubism. In a way, Duchamp is at the height of contemporary development. But there is a difference, and it is more important than the similarity: Duchamp gives a different degree of reality to his pictures. He successfully evokes the illusion of limbs in action by using a metamorphous anatomy which holds an ironic balance halfway between organic bodiliness and mechanic functioning. He invents a transitory intermediate realm. While its anthropomorphous rhythm appears detached in automaton fashion, its cold, machine-like character seems to be humanized. This has rightly been called a mechanized ballet. Because of their trans-human, puppet-like character these "creatures" are different from both the Cubist still life world and the excited pathos of the Futurists.

These pictures must be credited with originality of idea as well

as formal maturity and accomplishment. Yet Duchamp stopped painting the moment he had conquered his terrain and demonstrated its autonomy vis-a-vis the Cubists and the Futurists. He stated that he could have painted ten more nudes descending a staircase but he didn't want to repeat himself. This proud resignation entailed a reproach for the contemporary practice of painting. Skeptically, and with increasing intellectual superiority, Duchamp watched the formal and manual exhibitionism of a mode of painting which never tires of paraphrasing (and commercializing) the pictorial idea it has found. In Duchamp's opinion this mode is ultimately concerned only with what Breton was to call the "stupid glorification of the hand." Duchamp doubted the intellectual honesty of an approach that seems to be interested only in proving that skill is the mainspring of art. "Haphazardly splattering paint on the canvas with a brush" to him was an activity without sufficient legitimacy. Therefore he wanted to get away from the "physical emphasis" and the "materiality" of painting.

> I was interested in ideas, not in visual results. Once again I wanted to put painting in the service of the mind. And of course my painting was immediately considered "intellectual" and "literary." In fact I tried to find a place as far away as possible from "pleasing" and "attractive" physical painting.

Duchamp considered the exhibition of the act of painting an unnecessary show of force, a physical waste disproportionate to the intellectual substance displayed. He was convinced that he could attain greater lucidity with less effort.

In turning away from "culinary" painting he was forced to make up his mind to unlearn what he had learned. This approach is not really new. Reynolds granted the painter the need "to unlearn" in order to gain distance from the acquired knowledge about art. From Romanticism down to the twentieth century this view has been combined with increasingly archaic formal acts which are supposed to guarantee innocence and immediacy. We find none of that in Duchamp. His renunciation of *macchia* and *sprezzatura* does not present itself as deliberately primitive but rather as sober and precise. As a pretext for a new, artless precision in rendering objects he used a chocolate grinder.

> In my childhood I often walked the streets of old Rouen. One day I saw in a shop window a real, working chocolate mill, and I was so fascinated by the sight that I took the machine as a point of departure. I was not interested in its mechanical aspect but in the design of a new technique. I wanted to return to an absolutely dry design, to dry art. What better example could I find than a mechanical blueprint. I began to appreciate the value of exactitude and precision, the significance of chance.

Two pictures attest to the result of such intentions. The first version still shows graduations of light and shade, that is, a minimum of painterly qualities. The second version does without them and it is as polished as a blueprint. But just that anonymous, mechanical precision of detail makes the object appear mysteriously entranced. Duchamp expressed his doubt about the justification of painterly "ingredients" by glueing or sewing thin strings onto the drums of the apparatus. These parts of the picture acquire a tangible surface relief. An element of "real" reality is incorporated into the imaginary reality. These strings are ambivalent. They designate both a surface pattern and objective realities which have an independent existence. They can be lifted off the surface and they might just as well be integrated in a different context. Here Duchamp took the step towards objectification which was paralleled by the rejection of the ideal illusionary reality of the work of art. At the same time Duchamp thus made a comment on Kandinsky's statement (which he probably didn't know) that an object can function as a line just as a line can function as an object.

In his own way this painter thus gained insight into the pluralism of meaning in the phenomenal world. He could have capitalized on that, joining the camp of Grand Abstraction. But his aversion to "physical painting" made him take another road, which would make demands on his speculative rather than his manual talents. He discovered that the ambiguity of the world, which has its basis in man's intellectual freedom, can be revealed with the utmost economy of gestures, with a minimum of organizing energy. So he arrived at three-dimensional image elements, and subsequently at the proclamation of ready-mades, in other words: he entered the realm of Grand Realistics.

What does that mean? Kandinsky saw "the root of the new grand realistics" in making visible the "inner ring" while rejecting "embellishments" and "epicurean delicacies." "The outer shell of the object, when rendered perfectly and simply, is already a separation of the object from the practical and useful; it is an external resonance of the internal." Kandinsky still saw a rôle for the act of painting. He called the *douanier* Rousseau the father of grand realistics, probably because he was fascinated, as were many contemporaries including Picasso and Apollinaire, by the directness and naiveté of this "Sunday painter." Duchamp, on the other hand, limited himself in his ready-mades to the act of separation. Of his own will he made certain objects special objects, i.e. ready-mades. The selection renounces transformation into an artistically formed structure. Demonstration takes the place of metamorphosis.

The experiment of the *Trois Stoppages Etalon* (1914)* marked

* [Three Standard Stoppages (Fig. 13)—Ed.]

an early stage. It is significant because it points out the multivalence of an everyday object separated from the "practical and useful." From a height of one meter Duchamp dropped three pieces of string, each one meter long and held horizontally, onto an horizontal plane. Each string assumed a random linear figure. The result was three "new figures of the linear measure," picked from among an infinite number of possibilities. The result was achieved without "artistic" interference, without the intervention of preconceived formal intention. The three figures, produced by chance, demonstrate in an exemplary way the principle of unlimited freedom, that is, the possibility to extract from matter an infinity of possibilities of transformation. Unlimited freedom and precision coexist in one and the same object. The latter is actual (it may be verified with a yardstick), the former is potential. The result is the discovery of the multi-valance of the object which has been dropped. The strings are a) three-dimensional tangibles, b) conventional linear measuring units, and c) strangely arbitrary "figures" produced by chance. This last characteristic makes them visual metaphors of the unforeseeable. Obviously, Duchamp also accepts the seduction through the "artistic means" (the strings), but he leaves their control to chance rather than to his subjective artistic will or desire for expression. "The first discoverer," said Nietzsche, "is usually that very common and uninspired dreamer, chance."

This retreat from authoritarian making toward letting things happen, from shaping to mere showing, reveals an aspect of the anti-artistic frustration which far exceeds Kandinsky's and Mondrian's similar intellectual positions because of its radical conclusions. Like Mondrian, Duchamp is convinced of the "temporary character of art." But he doesn't hope for the suspension of the isolated formative act by a more comprehensive one. Instead he proclaims given reality in all its variety (and "insignificance") a ready-made, a multi-level carrier of meaning. By means of alienation (separation of the object from the practical and useful) he lays the foundation for an *emblematic realism* which is based on speculation and has a range of action as unlimited as Mondrian's "Neue Gestaltung." But while the latter aims at a total transformation of reality (including everyday objects) with the aid of formal harmonization, like the Bauhaus, Duchamp focuses on the alienation of reality. He achieves no new *gesamtkunstwerk*, no comprehensive *basso continuo* that runs through everything from the smallest object to the city. But he does achieve an intellectual penetration which may also be considered a total transformation of reality as given, even though it only takes place in the realm of speculation.

Like Kandinsky, Duchamp denies the existence of a "question of form in principle." But he goes further and takes sides partially, deny-

ing that Grand Abstraction (that mode which "haphazardly splatters paint on the canvas with a brush") communicates intellectual content. In this respect he opposes the creator of "dramatic improvisations." Decades later Duchamp wrote, by no means accidentally, that Kandinsky's importance as a painter rested upon his cool geometric works but not on the pre-war eruptions.

Like Kandinsky and Mondrian, Duchamp broke with the aesthetics of the self-sufficient picture:

> I consider painting to be a means of expression, not an ultimate goal. One means of expression among many, not a goal that fills an entire life.

Neither Kandinsky nor Mondrian reached this renunciation. We can sense the impulses which urged Duchamp to give up painting if we remember the equivalence, proclaimed by Kandinsky, of the Grand Real and the Grand Abstract. Kandinsky thought that any object of our perception ("even if it is only a cigarette butt") contained two independent effects, the inner ring and the outer meaning. Accordingly, the artist has the right "to use any form he inwardly needs, whether it be an everyday object, a celestial body, or a form already materialized artistically by some other artist." And because "this inner ring grows stronger when the oppressive practical and useful outer meaning is removed," the possibility arises to substitute the selective act for the formative act, and simply to do without "physical painting."

Duchamp did just that. He renounced the act of painting not merely for reasons of intellectual economy, but because he considered it incapable of making intellectual connections and problems transparent. In other words, he was convinced that material expenditure conceals and disguises the intellectual. He doubted the possibility of making the expressive signs agree with the expressive intentions or with the objects of perception. This thought paraphrases negatively the autonomy of the work of art, stressed by Fiedler, i.e. the fact that an unbridgeable gap exists between the formal contents of the work of art and the contents of the artist's perception and sensation. However: Duchamp suspected falsification of, and distraction from, the intellectual where Fiedler saw the justification of the work of art. Just because he was aware of the pluralism of meaning of all signs, linguistic as well as artistic, Duchamp distrusted the distracting obstinacy of signs. He took a position related to that of Wittgenstein's critical reflections on language, formulated at the same time:

> Language disguises thought in such a fashion that from the outer form of the garb one cannot draw conclusions about the form of the garbed thought. For the outer form of the garb serves purposes other than that of making the form of the body recognizable.

A negative answer is given to Nietzsche's question: "Do designations and objects correspond? Is language the adequate expression for all that is real?" But while Wittgenstein, like a painter when he sets down forms, settled within the boundaries of his idiom ("The boundaries of my language mark the boundaries of my world."), Duchamp endeavoured to present the self-expression of objects, the expression they are denied by the manmade, conventional, and inadequate signs of language. He did this neither by expressing nor by describing the objects but by simply declaring them ready-mades.

Is the self-expression of the alienated bottle rack less equivocal than that of a painted bottle rack (if such a painting existed)? That is asking the wrong question. Where every object without exception is multivalent, the brushstroke as much as the cigarette butt, it is not a matter of being unequivocal. The point is to make people conscious of the ambiguity of the world of phenomena by means of vivid demonstrations. And the alienated bottle rack serves this purpose just as well as the painted one—or even better—in Duchamp's view, since *macchia* is not superimposed over the intellectual problems.

Duchamp, who is nothing less than a self-assured dogmatist, is liberal enough to know that his demonstrations don't express fixed, eternally valid certainties. Like Wittgenstein, who wants to stimulate his reader to engage in "language games," Duchamp includes in his calculation the creative cooperation of the viewer:

> . . . for the viewer establishes contact between the work and the outside world by deciphering and interpreting its deeper qualities, thereby making his own contribution to the creative process.

The viewer fills the distance, so to speak, which the artist must allow to stand between his intentions and his realizations. He invents connections, in accordance with Wittgenstein's remark:

> Any sign *alone* appears dead. What makes it come alive? It lives when it is in use. Does it then have living breath within? Or is the use its breath?

The ready-made, separated from its everyday useful purpose, is thus soon put to use again, this time by its interpreters. I will show that highly varied and even contradictory views may be voiced about it.

The word ready-made was invented by Duchamp. It exemplifies the intellectual dignity of the creative act neither burdened nor tarnished by a craftsman's manipulation. An object is selected and given a name. To what purpose? Breton thought of manufactured objects endowed with the dignity of works of art through the artist's choice.

H. P. Roché thinks Duchamp wanted to say, when he submitted a urinal for exhibition in 1917, "Beauty is where you invent it." [2]

The art-historical perspectives opened up by these interpretations place the bicycle wheel and the bottle rack in the tradition of European anti-idealism. From this tradition repeatedly came the decisive impulses to expand the artist's repertoire of reality. Duchamp treated an insignificant, everyday object with distinction. Against the idealistic concept of the dignity of the subject matter he set the dignity of the nameless and insignificant. As we have seen [elsewhere], Schopenhauer was a nineteenth-century spokesman for this view. This ennobilization continued the object-oriented still life painting of the past. In this respect Duchamp restated the conviction of the nineteenth-century naturalists that any object is artworthy. He directed the viewer's attention at a piece of lowly, previously ignored reality and forced us, through this promotional act, to abandon our perceptual habits. He confronted us with the shock experience of new and unaccustomed things. Historically the method is legitimized by numerous models. All this leads to the conclusion that ready-mades are nothing but a new chapter in the incessant expansion of European art's repertoire of objects.

This interpretation needs to be supplemented by a consideration of Duchamp's renunciation of artistic forming—that is, "disguising"— of his objects. By idolatrizing the brute fact Duchamp not only placed himself in a tradition of art history but also in opposition to it. His act of choice consciously opposed the glorification of subjective creation and the principle which holds that the lowly object is ennobled by artistic "expression." Filled with the doubt once expressed by Goethe in 1776 ("There is something untrue about any form, even if it is felt most intensely."), Duchamp argued the renunciation of any forming process. From an extreme position he faced two directions: as regards the past, he carried to an extreme the naturalist tendency to neglect form, that is, he radicalized it to the point of renouncing form altogether. For the future he proclaimed the possibility of extra-artistic production of reality and thus took the step from art to artlessness.

So the ready-mades have a double meaning. Their antiaesthetic provocation mocks both the artistic arrogance which flaunts the achievements of subjective style, and the sacrosanct values of "good

[2] Cf. Robert Lebel's monograph, *Marcel Duchamp*, with texts by André Breton and H. P. Roché, trans. George Heard Hamilton (New York, 1959). Gautier wrote in the preface of *Mademoiselle de Maupin* (1834): "L'endroit le plus utile d'une maison, ce sont les latrines." He wanted to establish the art-for-art's-sake tenet that the ugly and the useful are identical. It follows that the useful becomes beautiful once it is removed from its utilitarian purpose. Perhaps Duchamp wanted to furnish vivid proof of this.

taste." But isn't the anonymous utensil endowed with new dignity soon after it has been picked out from the "anarchie même de la vie" (Laforgue) and been divorced from the utilitarian realm? If the question is answered positively one arrives at the conclusions of Breton and Roché, cited above. It would be a mistake, however, simply to equate the beauty of the unusual with the acquisition of new levels of reality. Duchamp's "naturalism" (the quotes are essential) is not superficial and material, it is emblematic. His ready-mades, when considered as works of art, share in the pluralism of meaning. Let me illustrate the point.

The alienated bottle rack becomes a special bottle rack. Others are found in stores but this one, signed by Duchamp, is found in exhibitions and museums. Its "aura," to use Walter Benjamin's term, sets it apart from other bottle racks. In isolating it, Duchamp lent the object an authority the consumer article didn't have. Apparently he wanted to comment on the stereotyped character of mass products, and at the same time to make the viewer aware that an anonymous consumer product may acquire an aura if one concedes that its utilitarian reality represents only one of its many levels of reality. Duchamp's attempt to make us aware of these levels is an important contribution to the understanding of the mass aspect of our civilization.

Restoring the aura of an everyday object does not just mean a new dignified sphere for the object beyond the realm of usefulness. The aura can make us so object-conscious that ultimately we experience the entire world of phenomena as alienated and mad. The familiar object is overturned and becomes an unfamiliar fetish which epitomizes all that is enigmatic and unfathomable. Breton interpreted the chocolate mill, which Duchamp used to design a new dry technique, as an infernal machine. Hofmannsthal described, in his "Letters of the Man who Returned" (1907), how even a normal encounter with everyday objects in their utilitarian sphere may suddenly cause insecurity:

> It sometimes happened in the morning that the pitcher and wash bowl, or a corner of the room with the table and coat rack, appeared unreal to me. In spite of their indescribably ordinary character they seemed not at all real, but ghostly, as it were, and at the same time temporary and waiting, taking up for the time being the place of the real pitcher and the real, water-filled wash bowl. . . . It was like hovering for a moment above the bottomless, the forever empty. . . .

Beside this psychopathological encounter with the bottle rack there is the formalist one. It is contingent upon the viewer's decision not to be satisfied with the shock experience of a trivial reality but instead to "see the objects as form per se, regardless of their conven-

tional significance" (Hofmannsthal). Such an interpretation free of factual meaning formalizes and aestheticizes the ready-made. It also confirms the equivalence stated by Kandinsky: if an everyday object (Kandinsky mentions a table and chairs) is the equal of a line as "object," it is also its equal as a formal value as soon as its "practical and useful meaning" falls away.

Finally, there is yet another interpretation, not at all philosophical, which expressly insists on the practical and useful meaning and declares the bottle-rack beautiful anyway. Such an interpretation opposes the art-for-art's-sake position (beautiful is that which doesn't have to serve a useful purpose). It lets the formal value of the object coincide with its utilitarian value, and takes the bottle rack as an example of the "beauty of that which is simply useful" (Mondrian), that dazzling beauty the Futurists had seen in the forms of a racing car.

These thoughts make it clear that Duchamp's achievement as an artist and thinker was not the invention of new forms. This is what constitutes his exemplary rank, a rank he shares with no one. His career is strangely fascinating. Here the usual is made unusual, and familiar ways of relating to reality are arbitrarily inverted. Yet it is done so unassumingly that it seems self-evident. If you manage to adopt some of the calmness with which Duchamp proposes his ready-mades, you think you are in a region where everything appears profound and yet transparent and suspended. His economical gestures are presented with an almost Eastern effortlessness and non-involvement —in some years Duchamp did not demonstrate anything but limited himself to playing chess. You not only sense that every object is equally valid to the inventor of the ready-made; you begin to suspect that the philosophy of indifference is linked to the experience of equivalence. *My irony is the irony of indifference: meta-irony,* Duchamp once said. And: *There is no solution because there is no problem.* This statement touches upon the paradox of Duchamp's world view. For even the unquestioning, indifferent acceptance of the world becomes a problem for itself. It leads to the question about the forms (modes of behavior) that are at man's disposal as he comes to terms with the world. What is at stake are no longer artistic issues but rather a life style, man's orientation in a thoroughly ambiguous reality. An optimistic method of orientation would try to cast a net of meaningful relationships over reality ("connective beauty" à la Mondrian) in order to gain a hierarchic structure. Duchamp, however, emphasizes the absence of connections. For him there exists no preconceived hierarchy of values, no delineated genres, no categories functioning like drawers. This is evident when he questions the category "work of art," blurring its boundaries, or when—with the ready-mades—he makes the entire

region of the genre "everyday object" enigmatic. Only particulars exist. Even a surprise combination of objects, such as a bird cage with (marble) sugar cubes and a thermometer [and cuttlebone] (*Why Not Sneeze?*, 1921), does not establish connective beauty after the fashion of Mondrian's universal harmony. Instead, it becomes a manifestation of the absurd. Since everything can be "made compatible" with everything else, all is basically incompatible.

Occasionally Duchamp allows a pseudo-correspondence to flash up in the paradox of a pun. He does this only to make us aware, over the false bottom of ambiguity, of the restrictions of our linguistic conventions. He shows that reality is more complex than the incommensurate instruments we use to designate it. This insight is consistent with the demonstration that the data of perception can only furnish phantoms. The figures formed by the three dropped strings look as if they differed in length; the marble cubes resemble sugar cubes. With the ready-mades Duchamp arrives at a point where he assumes an absolutely unlimited pluralism of meanings. (Every object is determined by its surroundings.) This pluralism seems to compensate for isolation, but at the cost of dissolving the identity of the object with itself. The basic principle of this life style is separation and isolation. This claim raises one aspect which Duchamp's casual indifference tends to play down. Isolation is the tragic, climactic form of man in a world of total incompatibility. *The Bride Stripped Bare by Her Bachelors, Even* (1913–23), a picture mounted on a large plate of glass (characteristically, it may be looked at from either side), is Duchamp's *magnum opus*. Duchamp has summoned here the most important components of his fetish repertoire to suggest—with his special meta-irony—that union is withheld from humans even in the act of love, which is no more than a convention that reveals the incompatibility of our acts and needs with their realizations. This illustrates for us another peculiarity of the ready-mades: they are productions of reality, or, more precisely, suggestions of reality subject to recall. From this aspect, finally, they attain paradigmatic significance. Their isolation represents that of man. At the same time, their referential pluralism (postulated by us) is the only useful orientation aid available to man in the labyrinth of his existence. Only as *homo ludens*, who constantly plays new games of meaning, is he the sovereign possessor of an unlimited freedom.

Duchamp is a much sought-after patron for most of the recent manifestations of artlessness. What he thinks of them is made clear in a letter to Hans Richter, dated November 11, 1962:

> This Neo-Dada which now calls itself New Realism, Pop Art, Assemblage etc. is cheap fun living off what Dada did. When I discovered

the "ready-mades" I intended to discourage the aesthetic hullabaloo. But in Neo-Dada they are using the ready-mades to discover their "aesthetic value"!! I threw the bottle rack and the urinal in their faces as a challenge and now they admire them as something aesthetically beautiful.

To resist this process seems an idle effort, especially because Duchamp himself rates highly the viewer's share in deciphering the contents of meaning when he says:

> The artist does not perform the creative act alone. The viewer establishes contact between the work and the outside world by deciphering its deeper qualities, thereby making his own contribution to the creative process.

To be sure, this is nothing new. Every object undergoes changes of meaning: the sacred vessel, the fetish, the canvas painting, and the ready-made. Historically, all meaning is initially purpose-oriented. The object serves magic or religious or philosophical positions. It enters the realm of "disinterested appreciation" only later. One must allow for that process and should not consider it negative only. The medieval painter of a madonna thought no more of the museum than did Duchamp with his ready-mades.

Neither should one forget that Duchamp recently multiplied the opportunities for admiring his bottle rack and his urinal when he permitted an Italian art dealer to make about a dozen replicas and put them on the market in a travelling exhibition. By doing this Duchamp joined the wave of museum-oriented commercialism which carries and cashes in on Pop Art and Nouveau Réalisme. Yet he is irritated by vulgarized Dada. He is repulsed by the hawkers' noises and the hypocritical protestations of artistic intentions. Duchamp feels this way even though he himself, with his ready-mades, has long since entered the museums and hence has become ambivalent.

Fifty years ago you turned to the happy few and cultivated an aphoristic asceticism. Today the methods are cruder, and the results certainly don't come anywhere near the incomparable esoterics of Duchamp. But that increased coarseness is to be found everywhere. Modern art in all its variations has lost the enchanting spell that issues from its incunabula. That is not always pleasant for the "fathers." They are no longer among themselves, their secret formulas are for sale in the market place and being academized in the schools. Fifty years ago you openly attacked the "aesthetic hullabaloo," today you stage it. I guess it works like a Trojan horse: the opponent—the public—is caught by surprise at its weakest point. Perhaps "aesthetic hullabaloo" can best be unmasked if it is encouraged to the point of paroxysm.

We should not overlook the fact that the commercial success enjoyed by today's late followers lies exactly down that road of the self-unmasking of our civilization that Duchamp aimed for. The same bourgeois snob who fifty years ago was horrified by the bottle rack pays good money for it today. In both cases his reaction is aesthetic. The rejection in those days and the applause today are merely two aspects of one and the same unmasking process.

26 STATEMENTS *RE* DUCHAMP

John Cage

HISTORY

The danger remains that he'll get out of the valise we put him in. So long as he remains locked up—

The rest of them were artists. Duchamp collects dust.

The check. The string he dropped. The Mona Lisa. The musical notes taken out of a hat. The glass. The toy shotgun painting. The things he found. Therefore, everything seen—every object, that is, plus the process of looking at it—is a Duchamp.

DUCHAMP MALLARMÉ?

There are two versions of the ox-herding pictures. One concludes with the image of nothingness, the other with the image of a fat man, smiling, returning to the village bearing gifts. Nowadays we have only the second version. They call it neo-Dada. When I talked with M.D. two years ago he said he had been fifty years ahead of his time.

Duchamp showed the usefulness of addition (moustache). Rauschenberg showed the function of subtraction (De Kooning). Well, we look forward to multiplication and division. It is safe to assume that someone will learn trigonometry. Johns

"26 statements *re* Duchamp." From John Cage, *A Year from Monday* (Middletown, Conn.: Wesleyan University Press, 1969). Copyright © 1963 by John Cage. Reprinted by permission of Wesleyan University Press. This article also appeared in *Art and Literature*, No. 3 (1964), pp. 9–10.

ICHIYANAGI WOLFF

We have no further use for the functional, the beautiful, or for whether or not something is true. We have only time for conversation. The Lord help us to say something in reply that doesn't simply echo what our ears took in. Of course we can go off as we do in our corners and talk to ourselves.

There he is rocking away in that chair, smoking his pipe, waiting for me to stop weeping. I still can't hear what he said then. Years later I saw him on Macdougal Street in the Village. He made a gesture I took to mean O.K.

"Tools that are no good require more skill."

A DUCHAMP

Seems Pollock tried to do it—paint on glass. It was in a movie. There was an admission of failure. That wasn't the way to proceed. It's not a question of doing again what Duchamp already did. We must nowadays nevertheless be able to look through to what's beyond— as though we were in it looking out. What's more boring than Marcel Duchamp? I ask you. (I've books about his work but never bother to read them.) Busy as bees with nothing to do.

He requires that we know that being an artist isn't child's play: equivalent in difficulty—surely—to playing chess. Furthermore a work of our art is not ours alone but belongs also to the opponent who's there to the end.

Anarchy?

He simply found that object, gave it his name. What then did he do? He found that object, gave it his name. Identification. What then shall we do? Shall we call it by his name or by its name? It's not a question of names.

THE AIR

We hesitate to ask the question because we do not want to hear the answer. Going about in silence.

One way to write music: study Duchamp.

Say it's not a Duchamp. Turn it over and it is.

Now that there's nothing to do, he does whatever anyone requires him to do: a magazine cover, an exhibition, a movie sequence, etc., ad infinitum. What did she tell me about him? That he gave himself except for two days a week (always the same days, Thursdays, Sundays)? That he's emotional? That he formed three important art collections? The phonograph.

Theatre

BUDDHA OF THE BATHROOM

Louise Norton

I suppose monkeys hated to lose their tail. Necessary, useful and an ornament, monkey imagination could not stretch to a tailless existence (and frankly, do you see the biological beauty of our loss of them?), yet now that we are used to it, we get on pretty well without them. But evolution is not pleasing to the monkey race; "there is a death in every change" and we monkeys do not love death as we should. We are like those philosophers whom Dante placed in his Inferno with their heads set the wrong way on their shoulders. We walk forward looking backward, each with more of his predecessors' personality than his own. Our eyes are not ours.

The ideas that our ancestors have joined together let no man put asunder! In *La Dissociation des Idees*, Remy de Gourmont, quietly analytic, shows how sacred is the marriage of ideas. At least one charming thing about our human institution is that although a man marry he can never be *only* a husband. Besides being a money-making device and the *one* man that *one* woman can sleep with in legal purity without sin he may even be as well some other woman's very personification of her abstract idea. Sin, while to his employees he is nothing but their "Boss," to his children only their "Father," and to himself certainly something more complex.

But with objects and ideas it is different. Recently we have had a chance to observe their meticulous monogomy.

When the jurors of *The Society of Independent Artists* fairly rushed to remove the bit of sculpture called the *Fountain* sent in by Richard Mutt, because the object was irrevocably associated in their atavistic minds with a certain natural function of a secretive sort.

"Buddha of the Bathroom," by Louise Norton. From *The Blind Man*, No. 2 (1917), pp. 5–6. Reprinted by permission of the author.

Yet to any "innocent" eye how pleasant is its chaste simplicity of line and color! Someone said, "Like a lovely Buddha"; someone said, "Like the legs of the ladies by Cézanne"; but have they not, those ladies, in their long, round nudity always recalled to your mind the calm curves of decadent plumbers' porcelains?

At least as a touchstone of Art how valuable it might have been! If it be true, as Gertrude Stein says, that pictures that are right stay right, consider, please, on one side of a work of art with excellent references from the Past, the *Fountain*, and on the other almost anyone of the majority of pictures now blushing along the miles of wall in the Grand Central Palace of ART. Do you see what I mean?

Like Mr. Mutt, many of us had quite an exhorbitant notion of the independence of the Independents. It was a sad surprise to learn of a Board of Censors sitting upon the ambiguous question, What is ART?

To those who say that Mr. Mutt's exhibit may be Art, but is it the art of Mr. Mutt since a plumber made it? I reply simply that the *Fountain* was not made by a plumber but by the force of an imagination; and of imagination it has been said, "All men are shocked by it and some overthrown by it." There are those of my intimate acquaintance who pretending to admit the imaginative vigor of Mr. Mutt and his porcelain, slyly quoted to me a story told by Montaigne in his *Force of the Imagination* of a man, whose Latin name I can by no means remember, who so studied the very "essence and motion of folly" as to unsettle his initial judgment forevermore; so that through overmuch wisdom he became a fool. It is a pretty story, but in defense of Mr. Mutt I must in justice point out that our merry Montaigne is a garrulous and gullible old man, neither safe nor scientific, who on the same subject seriously cites by way of illustration, how by the strength simply of her imagination, a white woman gave birth to a "black-a-moor"! So you see how he is good for nothing but quotation, M. Montaigne.

Then again, there are those who anxiously ask, "Is he serious or is he joking?" Perhaps he is both! Is it not possible? In this connection I think it would be well to remember that the sense of the ridiculous *as well as* "the sense of the tragic increases and declines with sensuousness." It puts it rather up to you. And there is among us to-day a spirit of "blague" arising out of the artist's bitter vision of an over-institutionalized world of stagnant statistics and antique axioms. With a frank creed of immutability the Chinese worshipped their ancestors and dignity took the place of understanding; but we who worship Progress, Speed and Efficiency are like a little dog chasing after his own wagging tail that has dazzled him. Our ancestor-worship is without grace and it is because of our conceited hypocrisy

that our artists are sometimes sad, and if there is a shade of bitter mockery in some of them it is only there because they know that the joyful spirit of their work is to this age a hidden treasure.

But pardon my praise for, sayeth Nietzsche, "In praise there is more obtrusiveness than in blame"; and so as not to seem officiously sincere or subtly serious, I shall write in above, with a perverse pen, a neutral title that will please none; and as did Remy de Gourmont, that gentle cynic and monkey without a tail, I, too, conclude with the most profound word in language and one which cannot be argued —a pacific Perhaps!

IN ADVANCE OF
WHOSE BROKEN ARM?

George Heard Hamilton

If ever there were a watershed—some probably think of it more as a trough—between the artistic past and whatever the present is turning out to be, it was Duchamp's snow shovel, that quite unprepossessing object which in 1915 left the safety of a shelf in a hardware shop on upper Broadway for the perilous pleasures of the world of art. What an odd fare for something so commonplace! It was never to be quite the same thing again, nor, which is more mysterious, were we. For of what other object, man-made and mass-produced (*pace* the plane and the bomb), can it be said that, because of one man's decision, the course of Western culture was altered?

This didn't happen all at once. The "original" snow shovel, the one Duchamp first selected in the shop, paid for, and took home where he inscribed it with the mystifying title, *In Advance of the Broken Arm*, was seen in New York only once or twice. Those were the days, so blithe in retrospect, when America was still "too proud to fight" in the First World War, when Prohibition was still a few years away, and Walter and Louise Arensberg were keeping open house for the bright young men—Duchamp, Picabia, Gleizes, and Jean Crotti among them—who had somehow managed to get from Europe to Manhattan. One was amused by the shovel, and a little startled to read in the paper that a man had actually broken his arm shovelling snow, thereby proving the truth, not only of Duchamp's title, but of Oscar Wilde's remark that nature does too, imitate art. But then the shovel was lost, for almost thirty years quite forgotten.

That is, by all but Duchamp's friend, the American artist Kath-

"In Advance of Whose Broken Arm?" by George Heard Hamilton. From *Art and Artists*, Vol. 1, No. 4 (July, 1966), 29–31. Reprinted by permission of the author.

erine S. Dreier who had been so excited by abstract painting when she first saw it at the Armory Show in New York in 1913 that she became an abstract painter herself, somewhat in the style of Kandinsky (her best painting is an abstract "portrait" of Marcel, now in the Museum of Modern Art in New York). In 1920, Miss Dreier, with Duchamp's assistance, founded the Société Anonyme, Inc. (the pun was Man Ray's), a sort of impermanent museum with which for ten years she did as much as any other American to make the country safe for modern art by exhibiting the paintings and sculptures she and Duchamp had collected for that purpose. The Depression curtailed her activities and the foundation of the Museum of Modern Art in 1929 eclipsed them. But in 1941, she and Duchamp presented the collection of the Société Anonyme to Yale University, thereby establishing the first archive for the study of the modern movement in an American educational institution.

In 1945, we decided to hold at Yale a retrospective exhibition of the work of the three Duchamp brothers—Jacques Villon, Raymond Duchamp-Villon, and Marcel Duchamp—borrowing a few items as best we could, for the times were not auspicious but there seemed no reason to wait, to round out the materials available in the Société Anonyme. On that occasion the snow shovel reappeared in the world of art, not the "original" but a new one, another actual shovel, carefully lettered like the first. (I brought it back on the train from New York one balmy April evening, startling the commuters who thought I must have heard a dire report about our fickle New England weather.)

Now, and this is of perhaps some interest for cultural history, when the shovel was put on exhibition, nothing happened. Nobody came to see it—the papers were too taken up with the fall of Berlin—and it just dangled from the ceiling in an empty hall. Miss Dreier had insisted that, since it really wasn't a painting or a piece of sculpture, it couldn't be hung on a wall or placed on pedestal. And how right she was! Even standing it in a corner wouldn't do, for then it suddenly became a shovel again. And, as Gertrude Stein might have said, "If it wasn't a shovel, what was it?" (That was hard to say, art and life being what they are. When our little exhibition went on a tour, a janitor at a Museum in Minnesota the next winter mistook it for a shovel, as well he might, and went to work on a snowdrift, doing Duchamp's inscription no good.)

Twenty-one years have passed, the time it takes one legally to come of age, and what has happened to the snow shovel? What vote has it cast, for or against all the art towards which it stands in so ambiguous a relationship?

Some of us have never had any doubts about what the snow

shovel was, but we had to have Duchamp's help if we were to help others to understand it. And we had to disencumber it from two concepts which had arisen since it first appeared. These were the romantically psychological overtones clustering around the Surrealists' "found objects," and the formal aesthetic developed for evaluating mass-produced, machine-made objects which were thought to possess a kind of functional beauty. With the absolute formal perfection of a steel ball-bearing, for example, or the magical associations of a bit of driftwood, the snow shovel has never had anything whatever to do. In itself even, and this was the hub of the argument, it had nothing to do with art. No wonder that at first we were so baffled, because the structure of the ordinary American snow shovel is not even particularly functional, any more than the work it enables one to perform is agreeable. On the contrary, if the shovel is to take its place at all in an artistic context, and it has, historically, then the reasons for its transformation must be sought somewhere other than in itself.

The argument lay close at hand, buried among the notes for the great *Bride Stripped Bare by Her Bachelors, Even* [Fig. 17] (the Glass picture, now in the Philadelphia Museum) which Duchamp had had reproduced in impeccable facsimile in 1934. Eventually I was to have the privilege of translating them with his help, for Richard Hamilton's brilliant typographical facsimile which we published in 1960. There, at the end of one of the notes, was the clue, one of Duchamp's private words, a new word, even in French: *cervellités,* meaning "brain facts" (from *cervelle,* French for "brains, minds").

Now we knew. The snow shovel, like its ominous title, is a brain fact. Not the shovel itself, of course, for it is of no consequence, but the decision which took it out of the shop and put it right down in the middle of our lives. The decision itself had occurred in the mind; the shovel was the outward and visible embodiment of that decision. If this was so, as it certainly seems to have been, then many other matters fall into place. Every work of art whatsoever has always been a "brain fact," nothing less, and perhaps not even anything more. With one stroke, with one decision taken in a hardware shop (Why there rather than elsewhere? Perhaps because such shops sell "durable" goods?) Duchamp had annihilated all that haughty aesthetic talk about empathy, pure painting, significant form, etc. Art is what one decides it shall be. We do not so much find it, or make it, as determine it. Consequently it has no value whatsoever except in so far as it exists in the context of a mental event.

This was difficult to understand, and even harder to accept. Has the work of art no absolute value at all, no "beauty" existing over against us? Are we alone in this inhospitable world, even in our aesthetics? The prospect is bleak, and would be dreadful were it not

warmed by Duchamp's kindness, patience, and wit. But we cannot prove him wrong, any more than we can prove the opposite point of view right.

The snow shovel, then, was the ultimate insult, far worse than the urinal or *Mona Lisa's* moustache. They were bad enough, but they only offended our prudery and our cult of the old masters, and that was part of the fun. The snow shovel has never been fun, or funny. Like some gauche and tiresome stranger it seems never to have been meant to be liked. But now we cannot do without it. From now on we know that every work of art whatever, prehistoric or Pop, must be seen in its own terms, as part of a human, all-too-human situation—the triumph of consciousness over matter and, what is more important for us in this century, of will over taste. Maybe only one unfortunate shoveler may have broken his arm, but Duchamp has twisted every one else's.

Fig. 1
Duchamp, Marcel.
Portrait of the Artist's Father, 1910.
Oil on canvas,
36 ⅜" x 28 ⅞"
Philadelphia
Museum of Art
The Louise and Walter
Arensberg Collection

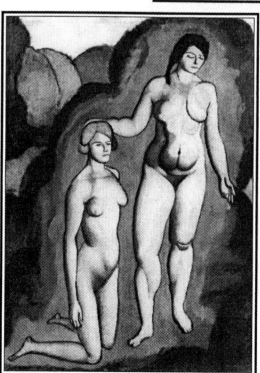

Fig. 2
Duchamp, Marcel.
The Bush [also known as *The Thicket*], 1910–11.
Oil on canvas,
50 ¼" x 36 ³⁄₁₆"
Philadelphia Museum of Art
The Louise and
Walter Arensberg Collection

Fig. 3
Duchamp, Marcel.
Sonata, 1911.
Oil on canvas,
57 ⅛″ x 44 ⅝″
Philadelphia Museum
of Art
The Louise and Walter Arensberg
Collection
Photograph by
Graydon Wood

Fig. 4
Duchamp, Marcel.
*Yvonne and Magdaleine Torn
in Tatters*, 1911.
Oil on canvas,
23 ¼″ x 28 ⅞″
Philadelphia Museum of Art
The Louise and Walter Arensberg
Collection
Photograph by Eric Mitchell

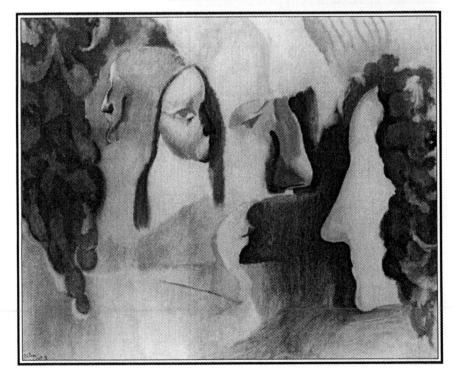

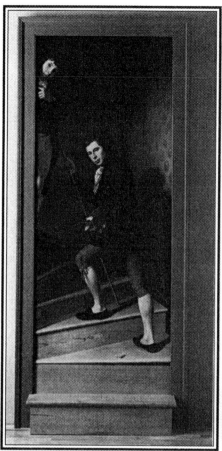

Fig. 5
Peale, Charles Wilson.
*Staircase Group (Portrait of Raphaelle
Peale and Titian Ramsey Peale)*, 1795.
Oil on canvas,
89 ½" x 39 ⅜",
with frame and wooden step
Philadelphia
Museum of Art
The George W. Elkins
Collection

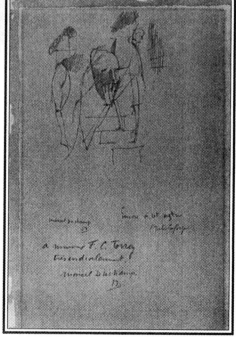

Fig. 6
Duchamp, Marcel.
*Study for Nude Descending a Staircase
(Encore à cet astre
[Once More to This Star])*, 1911.
Pencil on paper,
9 ¾" x 6 ½"
Philadelphia
Museum of Art
The Louise and
Walter Arensberg Collection
Photograph by
Lynn Rosenthal

Fig. 7
Duchamp, Marcel.
Nude Descending a Staircase,
No. 1, 1911.
Oil on cardboard,
37 ¾" x 23 ½"
Philadelphia
Museum of Art
The Louise and
Walter Arensberg Collection
Photograph
by Graydon Wood

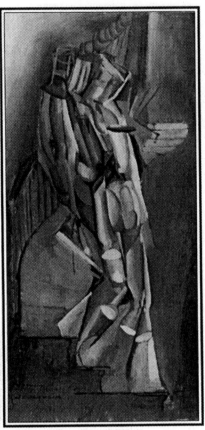

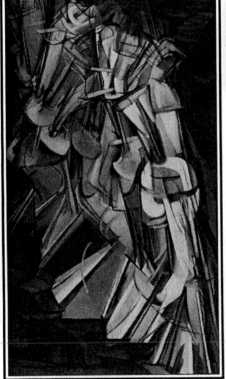

Fig. 8
Duchamp, Marcel.
Nude Descending a Staircase,
No. 2, 1912.
Oil on canvas,
57 ⅞" x 35 ⅛"
Philadelphia
Museum of Art
The Louise and Walter
Arensberg Collection
Photograph
by Graydon Wood

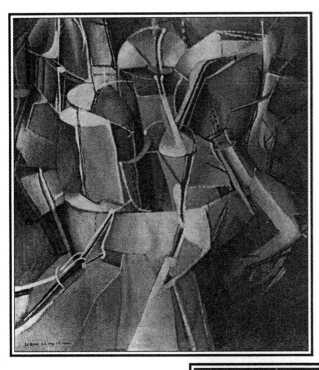

Fig. 9
Duchamp, Marcel.
The Passage from Virgin to Bride. Munich,
1912 (July–August).
Oil on canvas,
23 ⅜″ x 21 ¼″ (59.4 x 54 cm).
The Museum of Modern Art, New
York. Purchase.
Photograph ©2001 The Museum of
Modern Art, New York.

Fig. 10
Duchamp, Marcel.
The Bride, 1912.
Oil on canvas, 35 ¼″ x 21 ¾″
Philadelphia Museum of Art
The Louise and Walter
Arensberg Collection

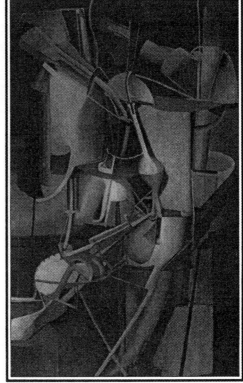

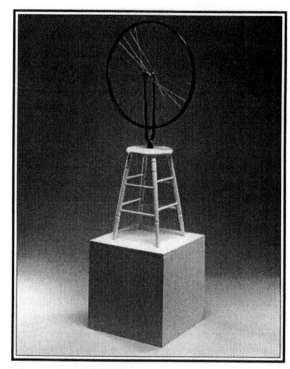

Fig. 11
Duchamp, Marcel.
Bicycle Wheel [1913], replica, 1964.
Bicycle wheel mounted on painted
wooden stool
Philadelphia Museum of Art
Gift of the Schwarz Galleria d'Arte
Photograph by Graydon Wood

Fig. 12
Duchamp, Marcel.
*Study for Cemetery of Uniforms and
Liveries*, 1913.
Pencil on paper, 12 ⅜″ x 15 ¾″
Philadelphia Museum of Art
The Louise and Walter
Arensberg Collection

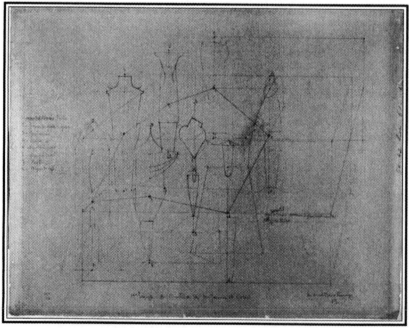

Fig. 13
Duchamp, Marcel.
3 *Stoppages Étalon*. 1913–14.
Assemblage: three threads glued to three painted
canvas strips, 5 ¼" x 47 ¼" (13.3 x 120 cm), each
mounted on a glass panel, 7 ¼" x 49 ⅜" x ¼"
(18.4 x 125.4 x .6 cm); three wood slats,
2 ½" x 43" x ⅛" (6.2 x 109.2 x .2 cm),
2 ½" x 47" x ⅛" (6.1 x 119.4 x .2 cm),
2 ½" x 43 ¼" x ⅛" (6.3 x 109.7 x .2 cm),
shaped along one edge
to match the curves of the threads;
the whole fitted into a wood box,
11 ⅛" x 50 ⅞" x 9"
(28.2 x 129.2 x 22.7 cm).
The Museum of Modern Art, New York.
Katherine S. Dreier Bequest.
Photograph ©2001 The Museum
of Modern Art, New York

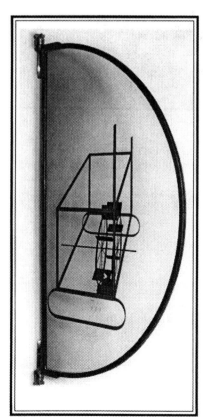

Fig. 14
Duchamp, Marcel.
Water Mill within Glider [also known as *Glider
Containing Water Mill in Neighboring Metals*],
1913–15.
Oil and lead wire on glass, 60 ¼" x 33"
Philadelphia Museum of Art
The Louise and Walter Arensberg Collection
Photograph by Graydon Wood

Fig. 15
Duchamp, Marcel.
Network of Stoppages (Réseaux de Stoppages).
Paris, 1914.
Oil and pencil on canvas,
58 ¼" x 6' 5 ⅝" (148.9 x 197.7 cm).
The Museum of Modern Art, New York.
Abby Aldrich Rockefeller Fund
and gift of Mrs. William Sisler.
Photograph ©2001 The Museum of
Modern Art, New York.

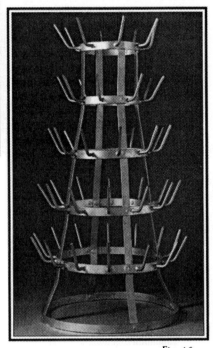

Fig. 16
Duchamp, Marcel.
Bottle Rack, 1963 (replica of 1914 original).
A readymade bottle-dryer of galvanized iron,
28 ¾" h, 14" diameter at base
Norton Simon Museum, Pasadena, CA
Gift of Mr. Irving Blum, in memory of
the Artist, 1968.

Fig. 17
Duchamp, Marcel.
The Bride Stripped Bare by Her Bachelors, Even
(*The Large Glass*), 1915–23.
Oil and lead wire on glass, 109 ¼" x 69 ⅛"
Philadelphia Museum of Art
Bequest of Katherine S. Dreier
Photograph by Graydon Wood

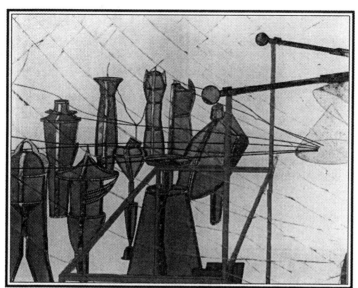

Fig. 18
Detail of
Fig. 17

Fig. 19
Rodin, Auguste.
The Secret, 1910.
Bronze, 33 ½" x 10" x 15 ½"
Rodin Museum, Philadelphia
Gift of Jules E. Mastbaum, 1929
Photograph by Murray Weiss

Fig. 20
Duchamp, Marcel.
With Hidden Noise, 1916.
Metal and twine, 5" x 5" x 5 ¼"
Philadelphia Museum of Art
The Louise and Walter Arensberg Collection
Photograph by Graydon Wood

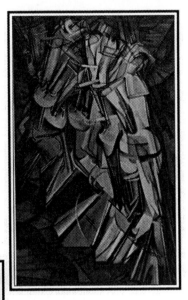

Fig. 21
Duchamp, Marcel.
Nude Descending a Staircase, No. 3, 1916.
Watercolor, ink, crayon and pastel over
photographic base, 58" x 35 ½"
Philadelphia Museum of Art
The Louise and Walter
Arensberg Collection
Photograph by Graydon Wood

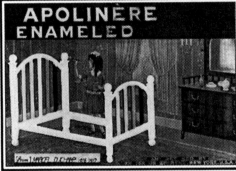

Fig. 22
Duchamp, Marcel.
Readymade, Girl with Bedstead [also known
as *Apolinère Enameled*], 1916–17.
Painted tin advertisement, 9 ¼" x 13 ¼"
Philadelphia Museum of Art
The Louise and Walter
Arensberg Collection
Photograph by Graydon Wood

Fig. 23
Duchamp, Marcel.
*To Be Looked At (From the Other Side of the Glass)
with One Eye, Close To, for Almost an Hour.*
Buenos Aires. 1918.
Oil paint, silver leaf, lead wire and magnify-
ing lens on glass (cracked), 19 ½" x 15 ⅝"
(49.5 x 39.7 cm); mounted between two
panes of glass in a standing metal frame,
20 ⅛" x 16 ¼" x 1 ½" (51 x 41.2 x 3.7 cm);
on painted wood base, 1 ⅞" x 17 ⅞" x 4 ½"
(4.8 x 45.3 x 11.4 cm); overall height, 22"
(55.8 cm).
The Museum of Modern Art, New York.
Katherine S. Dreier Bequest.
Photograph ©2001 The Museum of Modern
Art, New York.

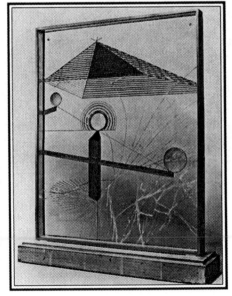

Fig. 24
Duchamp, Marcel.
Monte Carlo Bond. Paris, 1924.
Photocollage on colored
lithograph, 12 ¼" x 7 ¼"
(31.1 x 19.7 cm).
The Museum of Modern Art,
New York.
Gift of the artist.
Photograph ©2001 The
Museum of Modern Art,
New York.

Fig. 25
Duchamp, Marcel.
Rotoreliefs, 1935.
Color lithograph on six card-
board disks (each c. 8" in
diameter), with holder
Philadelphia Museum of Art
The Louise and Walter
Arensberg Collection

Fig. 26
Boite-en-Valise (Box in a Valise), 1941.
Philadelphia
Museum of Art
The Louise and Walter
Arensberg Collection

Fig. 27
Duchamp, Marcel.
Wedge of Chastity (Coin de chasteté). 1954.
Plaster in two sections, partly painted, 2 ¾" x 3 ⅞"
x 2 ½" (6.9 x 10 x 6.1 cm).
The Museum of Modern Art, New York. Gift of
Mr. and Mrs. Solomon Ethe.
Photograph ©2001 The Museum of
Modern Art, New York.

Fig. 28
Duchamp, Marcel.
Etant Donnés: 1ᵉ La chute d'eau, 2ᵉ Le gaz d'éclairage, 1946–66 (detail).
Mixed media assemblage,
95 ½" x 70"
Philadelphia Museum of Art
Gift of the Cassandra Foundation
Photograph by Grayson Wood

NATURAL ART AND CULTURAL ART: A CONVERSATION WITH CLAUDE LÉVI-STRAUSS

Georges Charbonnier

GEORGES CHARBONNIER: Claude Lévi-Strauss, before we leave the comparison between the art of primitive societies and that of contemporary Western societies, I would like to remind you of an observation you made to me on one occasion: we were talking about the function of art in general and about the fact that the elaboration of an additional reality is the characteristic effect of a work of art, and that it is through this effect that we can recognize a work of art. I had made a possibly rash remark: I had asked if it was the function of the artist to secrete reality. You pointed out to me that the expression "to secrete reality" was at once too simple and ambiguous, and that any daub or scribble and, more generally speaking, any activity adds fresh reality to reality, without necessarily being a thing of beauty. Then you added: "However, I must admit that the attitude of the Surrealists in this respect was disturbing." What did you mean by this?

CLAUDE LÉVI-STRAUSS: I remember once having a long correspondence with André Breton on the subject. Is an absolutely original document automatically a work of art, because of its originality, or must there be something more to it? In so far as the work of art is a sign of the object and not a literal reproduction, it reveals something that was not immediately present in our perception of the object, and that is its structure, because the peculiar feature of the language of art is that there exists a profound homology between the struc-

"Natural Art and Cultural Art: A Conversation with Claude Lévi-Strauss (editor's title). (Original title: "Natural Art and Cultural Art.") From Georges Charbonnier, *Conversations with Claude Lévi-Strauss*, translated by John and Doreen Weightman. Translation copyright © 1969 by Jonathan Cape, Ltd. Reprinted by permission of The Viking Press, Inc., and Jonathan Cape, Ltd.

ture of the signified and the structure of the signifier. In this respect, articulate language can signify in any way it chooses; there is no homology between the words and the objects to which they relate, or if we were to suppose there is, we would have to revert to those old ideas belonging to the philosophy of language, according to which liquid semi-vowels are particularly suited to the description of physical bodies in the liquid state, and we use very open vowels for heavy objects, and so on.

G.C.: So you believe that the Surrealists were absolutely right to objectivize the object and turn it into a work of art? The chair which becomes an object by relinquishing its function as a chair is, then, a perfect realization of the coincidence between object and work of art.

C.L.-S.: At any rate, this seems possible in so far as the work of art, in signifying the object, succeeds in creating a structure of signification which is in relation to the structure of the object.

G.C.: So, coincidence, by definition, is implied in objectivization?

C.L.-S.: The structure of the object to which I am referring is not present in immediate perception, and consequently the work of art makes it possible to achieve an advance in knowledge.

G.C.: Is this progress achieved through objectivization or is it not? Things would be too easy, if the effect were achieved in advance!

C.L.-S.: It is not necessarily achieved by objectivization, but it can be . . . ; for instance, the very great painters like Ingres—it seems to me that Ingres's secret is that he could give the illusion of a facsimile (we need only think of his Cashmere shawls reproduced with all the most minute details of design and shades of colour) while at the same time the apparent fac-simile reveals a signification which goes far beyond perception and even extends to the structure of the object of perception.

G.C.: I think the Surrealists really played a very important part in this connection and, as regards the plastic arts, I think they had an equally important idea when they thought of what they called "ready-mades": take, for instance, this microphone in front of me. I can decide that it is a piece of sculpture; it is ready made and it was deliberately created for a purpose, but I can decide that it is a work of art.

C.L.-S.: And yet the feature of the "ready-made"—you will correct me if I am wrong—seems to me to have been that it was very rarely reducible to a single object: in order to make a "ready-made," there must be at least two objects.

G.C.: A single object can be enough . . . the famous bottle-drainer which Marcel Duchamp used, for instance [Fig. 16].

C.L.-S.: Even in this instance, it is not true, because it is not the same draining rack as it was in the cellar or the store-cupboard. . . .

G.C.: Yes, of course, but that is what I mean!

C.L.-S.: All right! You stand it on a piece of furniture, in a drawing-room. . . .

G.C.: My aim is, precisely, to isolate it.

C.L.-S.: . . . and consequently it only becomes a work of art in the new context in which it is placed.

G.C.: Quite, and because I have decided that it should be so.

C.L.-S.: That's right.

G.C.: In other words, it seems to me that, in this case, the opposite is happening: I am separating the signified from the signifier.

C.L.-S.: No.

G.C.: I am not juxtaposing two structures.

C.L.-S.: Yes you are!

G.C.: It seems to me that I am separating one structure from another.

C.L.-S.: I don't agree with you at all! The bottle-drainer in the cellar is a signifier of a certain signified: in other words, it is a device used for draining bottles. If you put it on a drawing-room mantelpiece, you obviously break and explode the relationship between signified and signifier. . . .

G.C.: Bottles don't come into it any more!

C.L.-S.: In doing this, you are bringing about a semantic fission.

G.C.: Yes, that is what I mean.

C.L.-S.: But the semantic fission helps to produce a fusion since, when you set the object alongside other objects, you bring out certain structural properties that it already possessed—properties of harmony or balance, or perhaps weirdness or aggressiveness—if it looks like the bony skeleton of a fish—you bring to light properties which were latent in it.

G.C.: I quite agree, but by separating the signifier and the signified.

C.L.-S.: But the separation serves to create an unexpected fusion between another signifier and another signified.

G.C.: That I am quite prepared to accept, but nevertheless I began by separating them.

C.L.-S.: You are thereby effecting, if you will allow me to use a pretentious expression, a different equalization of the relationship between signifier and signified, an equalization which existed in the realm of the possible but was not overtly expressed in the original situation of the object. You are therefore, in a sense, adding to human knowledge, you are discovering in the object latent properties

which were not perceptible in the initial context; this is what the poet does every time he uses a word or an expression in an unusual way.

G.C.: Of course. But, this being so, I am led to wonder whether, when he had this idea, Marcel Duchamp did not open up a limitless prospect. Who is to prevent me objectivizing any object whatever? Who is to prevent me considering any object as a "ready-made"? Is this not a new way of arriving at reality by magnifying each thing so that it acquires the function of an art object?

C.L.-S.: It should be stated, however, that not any object used any how will do; objects are not necessarily all equally rich in these latent possibilities; we are referring to certain objects in certain contexts.

G.C.: Might it not be possible to generalize still further and say: any object in the widest possible context?

C.L.-S.: Of course, I am perfectly convinced that it is possible to generalize and if I wanted—not, however, as an anthropologist—to predict what the painting of the future might be like in terms of my personal preferences, I would forecast that it will become anecdotal and extremely figurative (but cannot these terms, in one sense, be applied to as perfect a work as Poussin's *Funérailles de Phocion?*)— that is, a kind of painting which, instead of trying to escape completely from the objective world which is, after all, the only world which interests us as human beings, or to be satisfied with the objective world in which modern man has his being and which does not strike me as very satisfactory either for the senses or for the mind, would, by using all the technical applications of the most traditional kind of painting, endeavour to recreate around me a more viable universe than the one in which I am living, not. . . .

G.C.: Ah! you are preserving the work of art, whereas I was supposing that if it were to disappear, it would be replaced by reality itself.

C.L.-S.: Yes?

G.C.: In the last analysis, if the artist disappears, the lesson to be learnt is perhaps that reality itself is a work of art; that no object has a special function nor is to be considered in a particular context.

C.L.-S.: I am stressing the point because I think we are on the verge of what would be an extremely dangerous confusion: it is not every object in itself which is a work of art, but certain arrangements, or patterns, or relationships between objects. It is exactly the same thing as with the words of a language—in themselves they have very uncertain meanings, they are almost devoid of significance and only acquire a sense from their context; words such as "flower" or

"stone" refer to an endless series of very vague objects and only take on their full meaning inside a given sentence. In the case of "ready-mades"—whether those who invented them were fully aware of the fact or not (I believe they were aware of it, because the Surrealists were always vigorous theoreticians), it is the "sentences" made with objects which have a meaning and not the single object in itself, in spite of what some people have tried to do or say. The "ready-made" is an object within a context of objects, and of course, it would be possible to imagine the extreme case of a civilization that was completely imprisoned, as it were, within its technical and material universe, and which would. . . .

G.C.: —would consider it as a work of art?

C.L.-S.: . . . would, in the end, order it according to several different styles: one or more styles might be utilitarian and scientific, while others would be gratuitous and artistic, the difference between the two depending solely on the arrangement of the elements. A seashell is not the same thing in one of the rooms of the Natural History Museum as it is when in the possession of a curio-collector . . . in the same way, certain curves are equations for the mathematician, or marvellous objects.

G.C.: Yes, the sculptor exploits the fact.

C.L.-S.: But. . . .

G.C.: But I was wondering if it would not be possible to reach a point of coincidence, a point at which the two arrangements coincided absolutely?

C.L.-S.: I do not believe that once this course were embarked upon— and I could easily imagine Western civilization going that way— it would be possible to succeed in checking and arresting it at the point you envisage, which would be characterized by a simple and literal redistribution of the elements. The movement would go further and further in the direction of division and recomposition, and where would it end? Perhaps in very detailed figurative painting in which the artist, instead of standing in front of a landscape and giving a more or less transposed and interpreted vision of it, would set about making super-landscapes as Chinese painting has, in fact, always done; it is along these lines that I would expect a solution to the present contradiction to be found: in a kind of synthesis of representativeness, which could once again be carried to extremes, with non-representativeness, which would operate on the level of the free combination of elements.

G.C.: Well, I would like to see coincidence between representativeness and non-representativeness in relation to reality, for each individual.

C.L.-S.: But I can perfectly well imagine myself being able to live with some large landscape, I can think of one or two examples . . . you will perhaps be shocked because I am about to quote minor painters who, curiously enough, as it happens, are now the only ones for whom I still have some feeling: take for instance, Joseph Vernet's large pictures of the seaports of eighteenth-century France which are on display in the main hall of the Musée de la Marine and which are among the few pictures which I always find deeply moving. I can well imagine myself living with these pictures so that the scenes they depict become more real for me than those of real life. For me, their value lies in the fact that they allow me to relive the relationship between sea and land which still existed at that time; a port was a human settlement which did not completely destroy, but rather gave a pattern to, the natural relationships between geology, geography and vegetation, and thus offered an exceptional kind of reality, a dream-world in which we can find refuge.

G.C.: In that case, I ought to admit that you are right on all levels, and that I am going off on the wrong tack.

C.L.-S.: I believe we are both moving in the same direction, but that we do not have exactly the same view of the concrete way in which this orientation or reorientation of painting . . . of the point it might eventually reach. I think it might lead, frankly, to genre painting.

G.C.: I would be prepared to envisage the possibility of all art disappearing completely and reality itself being accepted by man as a work of art.

C.L.-S.: Oh! man would very quickly get fed up with that situation, since, after all, the combinations we were talking about, the rearrangement of objects in order to bring out their latent properties, are perfectly conceivable but rather limited; after a while, all the possibilities would be exhausted, and I think the best proof of this is the fact that this is not the first time in our history that something of the kind has occurred. Interest in the "ready-made" (correct me if I am wrong) appeared with Benvenuto Cellini who, in his memoirs, relates how he used to walk along the shore picking up shells and objects carved into shapes by the sea, and how he found inspiration in such things. . . .

G.C.: Yes. In this sense, we can consider other periods in history. . . .

C.L.-S.: In the years preceding the French Revolution, there was also a great vogue for collecting objects. People would buy minerals or shells and give them as presents instead of ornaments. We are again living through a similar period.

G.C.: Yes, but the "ready-made" is not often taken from nature. Nowa-

days, we use the manufactured object in preference to the natural object.

C.L.-S.: Yes, I know, and the manufactured object. . . .

G.C.: There is a preference for scrap-iron rather than . . . say, roots.

C.L.-S.: Yes, but from this point of view, nature is so much richer than culture; one very quickly exhausts the range of manufactured objects as compared with the fantastic diversity of the animal, vegetable and mineral worlds . . . in short, the novel character of the "ready-made" presents a kind of last resort, before the return to the main source.

G.C.: Yes, but it must be remembered that the "ready-made" we are talking about now is not the same as the one we were talking about a short while ago.

C.L.-S.: I agree.

G.C.: It is not the same thing at all. When I referred to the generalizing of the function of the "ready-made," it never occurred to me to limit it to objects manufactured by man, or to such objects when they have been altered by rusting or some other form of damage.

C.L.-S.: I quite understand.

G.C.: I was thinking of anything that might occur in the natural world.

C.L.-S.: Yes, but we would then relapse into an already well-known situation, which has never existed except for very short periods, because man soon gets bored even with what might be called natural art, and begins to yearn again for human art.

THE READY-MADE

Octavio Paz

The "ready-mades" are anonymous objects which the gratuitous ges-
ture of the artist, by the simple act of choosing them, converts into
"works of art." At the same time this gesture dissolves the notion of
work. Contradiction is the essence of the act; it is the plastic equiva-
lent of the pun: the latter destroys meaning, the former the idea of
value. The "ready-mades" are not anti-art, like so many of the creations
of Expressionism; they are *an-artistic*. The wealth of commentaries on
their meaning—some of them would no doubt have made Duchamp
laugh—reveals that their interest is not plastic but critical or philo-
sophical. It would be stupid to discuss them in terms of their beauty
or ugliness, as much because they transcend beauty and ugliness as
because they are not works but rather question-marks or signs of nega-
tion that oppose the idea of works. The "ready-made" doesn't postulate
a new set of values: it is a spanner [U.S., monkey-wrench] in the works
of what we call "valuable." It is active criticism: a contemptuous dis-
missal of the work of art seated on its pedestal of adjectives. The
critical action unfolds in two stages. The first serves the purpose of
hygiene, an intellectual cleanliness: the "ready-made" is a criticism
of taste; the second is an attack on the notion of the work of art.

For Duchamp good taste is no less harmful than bad. We all
know that there is no essential difference between them—yesterday's
bad taste is the good taste of to-day—but what is taste? It is what
we call pretty, beautiful, ugly, stupendous, marvellous without having
any clear understanding of its raison d'etre: it is execution, construc-

"The Ready-Made," by Octavio Paz (editor's title). From "Duchamp's Ready-
Mades," in *Marcel Duchamp, Or the Castle of Purity,* translated by Donald
Gardner (London: Cape Goliard Press, 1970). Reprinted by permission of the
author and Jonathan Cape, Ltd.

tion, style, quality—the distinguishing characteristics of a work. Primitive people don't have any idea of taste; they rely on instinct and tradition, that is to say: they repeat almost instinctively certain archetypes. Although the Middle Ages and Antiquity formulated aesthetic canons, they had no knowledge of taste either. The same is true of the East and of Precolumbian America. Taste was probably born in the Renaissance and didn't become self-conscious until the Baroque period. In the eighteenth century it was the courier's mark of distinction and later, in the nineteenth, the sign of the parvenu. To-day, since popular art is extinct, it tends to propagate itself among the masses. Its birth coincides with the disappearance of religious art and its development and supremacy are due, as much as anything, to the open market for artistic objects and to the bourgeois revolution. (A similar phenomenon, though it is not identical, can be seen in certain epochs of the history of China and Japan.) "There's no law about tastes," says the Spanish proverb. In fact, taste evades both examination and judgment: it is a matter for samplers. It oscillates between instinct and fashion, style and prescription. As a notion of art it is skin-deep both in the sensuous and in the social meaning of the term: it titivates and is a mark of distinction. In the first case it reduces art to sensation; in the second it introduces a social hierarchy which is founded on a reality as mysterious and arbitrary as purity of blood or the colour of one's skin. The process has become accentuated in our time: since Impressionism painting has been converted into materials, colour, drawing, texture, sensibility, sensuality—ideas are reduced to a tube of paint and contemplation to sensation.[1] The "ready-made" is a criticism of "retinal" and manual art: after he had proved to himself that "it was the craft that dominated," Duchamp denounced the superstition of craft. The artist is not someone who makes things; his works are not pieces of workmanship—they are acts. There is a possibly unconscious echo in this attitude of the repugnance Rimbaud felt for the pen: *Quel siècle a mains!*

In its second stage the "ready-made" passes from hygiene to the criticism of art itself. In criticizing the idea of execution Duchamp doesn't claim to dissociate form from content. In art the only thing which counts is form. Or, to be more precise, forms are the transmitters of what they signify. Form projects meaning, it is an apparatus for signifying. Now, the equipment that "retinal" painting uses to signify is insignificant: it consists of impressions, sensations, secretions, ejaculations. The "ready-made" confronts this insignificance with its neutrality, its non-significance. For this reason it cannot be a beautiful

[1] According to Duchamp all modern art is "retinal"—from Impressionism, Fauvism and Cubism to abstract art and op-art, with the exception of Surrealism and a few isolated instances such as Seurat and Mondrian.

object, or agreeable, repulsive or even interesting. Nothing is more difficult than to find an object that is really neutral: "anything can become very beautiful if the gesture is repeated often enough; this is why the number of my 'ready-mades' is very limited. . . ." The repetition of the act brings with it an immediate degradation, a relapse into taste—a fact which Duchamp's imitators frequently forget. Detached from its original context—usefulness, propaganda or ornament —the "ready-made" suddenly loses all significance and is converted into an object existing in a vacuum, into a thing without any embellishment. Only for a moment: everything that man has handled has the fatal tendency to secrete meaning. Hardly have they been installed in their new hierarchy, than the nail and the flat-iron suffer an invisible transformation and become objects for contemplation, study or irritation. Hence the need to "rectify" the "ready-made": injecting it with irony helps to preserve its anonymity and neutrality. A labour of Tantalus since, when significance and its appendages, admiration and reprobation have been deflected from the object, how can one prevent them from being directed towards the author? If the object is anonymous, the man who chose it is not. And one could even add that the "ready-made" is not a work but a gesture and a gesture which only an artist could realise and not just any artist but inevitably Marcel Duchamp. It is not surprising that the critic and the discerning public find the gesture "significant," although they are usually unable to say what it is significant of. The transition from worshipping the object to worshipping the gesture is imperceptible and instantaneous: the circle is closed. But it is a circle which binds us to ourselves: Duchamp has leapt it with agility; while I am writing these notes he is playing chess.

One stone is like another and a corkscrew is like another corkscrew. The resemblance between stones is natural and involuntary; between manufactured objects it is artificial and deliberate. The fact that all corkscrews are the same is a consequence of their significance: they are objects that have been manufactured for the purpose of drawing corks; the similarity between stones has no inherent significance. At least this is the modern attitude to nature. It hasn't always been the case. Roger Caillois points out that certain Chinese artists selected stones because they found them fascinating and turned them into works of art by the simple act of engraving or painting their name on them. The Japanese also collected stones and, as they were more ascetic, preferred them not to be too beautiful, strange or unusual: they chose ordinary round stones. To look for stones for their difference and to look for them for their similarity are not separate acts: they both affirm that nature is the creator. To select one stone among a thousand is equivalent to giving it a name. Guided by the

principle of analogy, man gives names to nature: Rocky Mountains, Red Sea, Hell Canyon, Eagles' Nest. The name—or the signature of the artist—causes the place—or the stone—to enter the world of names; or, in other words, into the sphere of significances. The act of Duchamp uproots the object from its significance and makes an empty skin of the name: a bottle-rack without bottles. The Chinese artist affirms his identity with nature; Duchamp, his irreducible separation from it. The act of the former is one of elevation or praise; that of the latter, a criticism. For the Chinese, the Greeks, the Mayans or the Egyptians nature was a living totality, a creative being. For this reason art, according to Aristotle, is imitation: the poet imitates the creative gesture of nature. The Chinese artist follows this idea to its ultimate conclusion: he selects a stone and signs it. He inscribes his name on a piece of creation and his signature is an act of recognition; Duchamp selects a manufactured object; he inscribes his name as an act of negation and his gesture is a challenge.

The comparison between the gesture of the Chinese artist and that of Duchamp demonstrates the negative nature of the manufactured object. It is worth looking at the point a bit more closely. For the ancient world nature was a goddess and, what is more, a creator of gods—manifestations in their turn of vital energy in its three stages: birth, copulation and death. The gods are born and their birth is that of the universe itself; they fall in love (sometimes with our own women) and the earth is peopled with demigods, monsters and giants; they die and their death is the end and the resurrection of time. Objects are not born: we make them; they have no sex; nor do they die: they wear out or become inserviceable. Their tomb is the dustbin or the recasting furnace. Technology is neutral and sterile. Now, technology is the nature of modern man: it is our environment and our horizon. Of course, every work of man is a negation of nature; but at the same time it is a bridge between nature and us. Technology changes nature in a more radical and decisive manner: it throws it out. The familiar concept of the return to nature is proof that the world of technology comes between us and it: it is not a bridge but a wall. Heidegger says that technology is nihilistic because it is the most perfect and active expression of the will to power. Seen in this light the "ready-made" is a double negation: not only the gesture but the object itself is negative. Although Duchamp doesn't have the least nostalgia for the paradises or infernos of nature, he is still less a worshipper of technology. The injection of irony is a negation of technology because the manufactured object is turned into a "ready-made," a useless article.

The "ready-made" is a two-edged weapon: if it is transformed into a work of art, it spoils the gesture by desecrating it; if it preserves

its neutrality, it converts the gesture into a work. This is the trap that the majority of Duchamp's followers have fallen into: it is not easy to juggle with knives. There is another condition: the practice of the "ready-made" demands an absolute disinterest. Duchamp has earned derisory sums from his pictures—he has given most of them away—and he has always lived modestly, especially if one thinks of the fortunes which a painter accumulates to-day as soon as he enjoys a certain reputation. Harder than despising money is resisting the temptation to make works or to turn oneself into a work. I believe that, thanks to irony, Duchamp has succeeded: the "ready-made" has been his Diogenes' barrel. Because, in the end, his gesture is a philosophical or, rather, dialectical game more than an artistic operation: it is a negation which, through humour, becomes affirmation. Suspended by irony, in a state of perpetual oscillation, this affirmation is always provisional. It is a contradiction which denies all significance to object and gesture alike; it is a pure action—in the moral sense and also in the sense of a game: his hands are clean, the execution is rapid and perfect. Purity requires that the gesture should be realised in such a way that it seems as little like a *choice* as possible: "The great problem was the act of selection. I had to pick an object without it impressing me and, as far as possible, without the least intervention of any idea or suggestion of aesthetic pleasure. It was necessary to reduce my personal taste to zero. It is very difficult to select an object that has absolutely no interest for us not only on the day we pick it but which never will and which, finally, can never have the possibility of becoming beautiful, pretty, agreeable or ugly. . . ."

The act of selection bears a certain resemblance to making a rendez-vous and, for this reason, it contains an element of eroticism—a desperate eroticism without any illusions: "To decide that at a point in the future (such and such a day, hour and minute) I am going to pick a 'ready-made' . . . What is important then is chronometry, the empty moment. . . it is a sort of rendez-vous." I would add that it is a rendez-vous without any element of surprise, an encounter in a time that is arid with indifference. The "ready-made" is not only a dialectical game; it is also an ascetic exercise, a means of purgation. Unlike the practices of the mystics, its end is not union with the divinity and the contemplation of the highest truth: it is a rendez-vous with nobody and its ultimate goal is non-contemplation. The "ready-made" occupies an area of the spirit that is null: "this bottle-rack which still has no bottles, turned into a thing which one doesn't even look at, although we know that it exists—which we only look at by *turning our heads* and whose existence was decided by a gesture I made one day. . . ." A nihilism which gyrates on itself and refutes itself: it is the enthroning of a nothing and, once it is on its throne,

denying it and denying oneself. It is not an artistic act, this invention of an art of interior liberation. In the *Large Sutra on Perfect Wisdom*[2] we are told that each one of us has to endeavour to reach the blessed state of being a Boddhisattva while knowing that Boddhisattva is a non-entity, an empty name. This is what Duchamp calls the *beauty of indifference*. Or, to put it another way: freedom.

[2] Translated by Edward Conze, London 1961.

DIMENSION AND DEVELOPMENT IN *THE PASSAGE FROM THE VIRGIN TO THE BRIDE*

Lawrence D. Steefel, Jr.

for Meyer Schapiro with affectionate regards

Marcel Duchamp's art operates on more than one level of meaning and in more than one dimension of form. Disliking the exoteric, Duchamp's esoteric mind created images which would open upon hidden perspectives beyond the merely visible. He has characterized his work as being the *n-l* dimensional projection of an *n* dimensional form.[1] With characteristic irony, he argues that, if two-dimensional shadows are cast by three-dimensional objects, three-dimensional objects may well be shadows of fourth-dimensional forms. The locus of this fourth-dimensional world is unspecified, but one may begin by assuming it lies behind the two-dimensional rendering of three-dimensional forms which are the visual materials of his painting. Such an assumption leads to unexpected discoveries, warning us not to look at his work superficially, for it contains more than meets the eye. I propose to discuss Duchamp's *Le Passage de la Vierge à la Mariée*** as a problem of dimensional readings moving from its surface into its depths, and these dimensions include not only spatial factors but iconographic ones as well. My inspection of the image has discovered a hidden double

"Dimension and Development in *The Passage from the Virgin to the Bride*" (editor's title). From Lawrence D. Steefel, Jr., "The Art of Marcel Duchamp: Dimension and Development in *Le Passage de la Vierge à la Mariée*," *Art Journal*, XXII, No. 2 (Winter 1962–63), 72–79. Some footnotes have been deleted. Reprinted by permission of the author and *Art Journal*/College Art Association.

* [*The Passage from the Virgin to the Bride* (Fig. 9)—Ed.]

[1] Interview with Duchamp, 1956. [For the following remarks on third- and fourth-dimensional form, see Robert Lebel's monograph *Marcel Duchamp*, New York, 1959, p. 278. The interested reader is also referred to the original of this essay for slightly more extensive footnotes than can be reprinted here.—Ed.]

imagery in the depths of the work which lies beneath the abstract, sensuous surface and has important implications for our interpretation of *Le Passage* as an individual painting and also for our understanding of important aspects of Duchamp's use of art.

As a pattern of abstract form, *Le Passage* is perhaps the most beautiful, sensuous, and refined piece of work Duchamp ever produced. As Robert Lebel has claimed, *Le Passage* is "Duchamp's masterpiece as a painter." It was shortly after completing this image that Duchamp radically altered his style lest he be seduced by the elegance of his own taste and the facile cuisine of his technical means. The small canvas is an intricate web of dissected flaps, tubes, filaments, and nodules which blossom across a fluid field of glowing color in a rococo network of sensitively spaced waves and distensions. The image is painted with a velvety touch, the pigment having been kneaded by hand to a consistency of immaculate smoothness comparable to the frictionless constancy of flawless motion which pervades the work as a whole. As an abstract pattern of rhythmic fluency, *Le Passage* resembles the anatomy of an exotic flower whose fleshy petals tremble in a stream of distilled sensuality, the product of a perfected alchemy which transmutes motion into a kind of visual perfume and canvas and paint into pure lubricity. The eye can delight in scanning the forms which bend over the picture plane without distraction, so that *La Passage,* in this aspect of its appearance, seems a paradigm of Duchamp's formula of *"peinture de precision; beauté d'indifference."*

The effects just described can only be experienced in the presence of the work itself. Reproductions do not transmit the sensuous surface of the work. A reproduction will, however, render salient aspects of the work which exist in the original but which are masked by the quality of cuisine. These elements, which are traces of figurative imagery and other representational cues, invite a reading of the image which fractures the abstract surface coherence of the work. The title of the work plays an important role here, for if it is taken seriously, it will lead most of us to look for an actual virgin becoming a bride within the flow of forms. One may well be satisfied, at least for a long time, with the assumption that Duchamp has created a poetic equivalent of sexual pleasure by the lubricity of his abstract patterns, their fleshy color, and their pervasive texture of mucous membrane. For the viewer who is not fully "educated" to reading abstract form as disengaged from representational imagery, however, the rectangular format and the modelling of shapes may provoke a temptation to look at the painting as a window into space in which an action occurs. To be sure, this reading too can be abstract, but sooner or later certain forms will begin to organize themselves as cues which are more specifically anatomical than a purely surface reading will tolerate with-

out disturbance. If this occurs, and if there is some curiosity about how Duchamp derived his forms (whether they are abstracted from natural forms or whether they are purely constructed forms), then the eye may begin to attempt an organization of the image according to the rules of traditional perspective representation.[2]

One may object that this would be the application of a wrong approach to such an image. Modern criticism has warned us again and again against applying traditional notions to modern art. In a painting like *Le Passage,* however, this posture of indifference to distracting cues or mixed modes of form construction is not easy to maintain, and Duchamp is notorious for his practice of mixing categories of interpretation and classes of forms to produce contexts of paradox which create problems for the viewer. The viewer may suppress those elements which tempt him to disrupt the surface of the work, but once they have come to mind, the suppression of them requires an increasing effort of indifference which, as an act of attention, subverts the passive contemplation of the work. What at first seems irrelevant will thus become a relevant aspect of the work and force us to question the quality of pleasure the work at first seemed to symbolize. As the eye begins to probe and scan the work, inadvertently in the beginning, but soon with an increasing tempo of attraction and rejection, the forms fluctuate and throb into depth and separateness and the image becomes disturbingly alive.

One may try to fix the forms so that they will not move, but this cannot be done without a violent short circuit of attention. If one applies a perspective formula to the work which would focus its forms as an array of bodies in a unified spatial field, the forms begin to collapse back to the surface. The intricate elisions, interpenetrations, and convergence of pattern conflict with the distinctions between parts, while the range of modelling and shape prevents a homogeneous texture from emerging once the surface has been ruptured. One may hope that a penetration of the depth of the image may result in a break through the ambiguities of its three dimensional structure, but this is obstructed by the dense web of substance which lies between us and any horizon we can imagine or construct. To really go beyond the work and its problems to a free realm beyond the situation we now see, requires an abolition of the image as image and demands we transform the painting into a kind of blank. So radical a decision seems impossible as long as we assume that the image is the object with which we are concerned. To go beyond means that we must really move into the field of our own imagination as if we had closed

[2] For the use of cues in reading imagery, see E. H. Gombrich, "How to Read a Painting," *The Saturday Evening Post,* vol. 234, no. 30, July 29, 1961, pp. 20f; and Gombrich, *Art and Illusion,* New York, 1960.

our eyes, and this, curiously enough, brings us out of the picture when we wanted to be both in front of and behind.

The intercourse between ourselves and the image becomes a frustrating rhythm of thrust and withdrawal into and out of the work. This rhythm, of course, can be interpreted as Duchamp's way of constructing an "image" of intercourse of a kind relevant to the title of the work. The perceptual action is assimilated to the dramatic action which the title promises we shall find in the work. Having once found it in this mode, we may understand how Duchamp can develop a dimension of psychological action out of the painting's abstract forms which demonstrates Duchamp's concern with what his subject matter does as opposed to how it looks. Once realized, however, the problem of consummating the act, both perceptual and erotic, will still be with us, and we will probably be driven to seek a fixing of depth as depth once more or a return to surface and innocence.

There is a configuration which can be constructed which will fix the depth, at least it will fix it more firmly for a moment than one might at first expect. There are perhaps other configurations which might be constructed, but this one, for all its arbitrary nature, has important links to Duchamp's earlier work and also to works which follow *Le Passage*.[3] This configuration is composed of a group of curiously grotesque figures who play a strange game indeed, enacting a kind of ritual vivisection whose psychological impact is as disturbing and arresting as is its visual effect. Note the robot-like voyeur who seems to peer into the viscera of what I take to be the bride.[4] Her

[3] See below, notes 4, 5, 37. For an eruptive double imagery of violent eroticism behind a masking surface, see Duchamp's *Portrait* (1911), Lebel, Pl. 36. See also *Portrait de Joueurs d'Echecs* (1911), Lebel, Pl. 43.

[4] The voyeur seems to me to be a logical development of robotism in Duchamp's figure style from *Portrait de Joueurs d'Echecs* (1911), Lebel, Pl. 43, through *Jeune Homme triste dans un Train* (1911), Lebel, Pl. 48; *Nu Descendant un Escalier*, No. 1 and No. 2, (1911 and 1912), Lebel, Pls. 50–51; the king and queen of *Le Roi et la Reine entourés de Nus vites* (1912), Lebel, Pl. 55. The female figure lies on a diagonal axis comparable to the flow of nudes in *Le Roi et la Reine traversés des Nus en vitesse* (1912), Lebel, Pl. 54. This figure is foreshadowed as a form by the nudes tunneling into the right hand figure of *Le Roi et la Reine traversés par des Nus vites* (1912), Lebel, Pl. 57; and it has common characteristics found in the drawing, *Vierge*, No. 2 (1912), Lebel, Pl. 59, which resembles a mechanistic Kwan Yin figure, with the right leg raised. The rather obvious arm mechanism of the odalisque with the nose and eyebrow to the right of the elbow are major anatomical cues. For images with a related format, which are *ex post facto*, analogies to these forms, but bear, perhaps, a common quality of sadistic or Narcissistic interpretation of the female figure, see "Didactic Anatomy," in William S. Heckscher, *Rembrandt's Anatomy of Dr. Nicholaas Tulp*, New York, 1958, Pl. IV–8, and Ingres' "Odalisque with Slave," now in the Walters Art Gallery, Baltimore, reproduced in Maurice Raynal, *The Nineteenth Century: Goya to Gauguin*, Geneva, 1951, p. 33. Paul Klee's *Obsessed Lover*, reproduced in

body spreads across the canvas from lower left to upper right. Her
skirts are the coulisses at the lower left, her chest cavity is formed out
of the metallic vessel shape above the robot's head, and her arm is
flung across an indistinct face at the upper right corner. The bride
is posed in a variation on the odalisque pose made famous by Ingres
and Matisse, except that here she is a victim who flinches in terror and
agony rather than being an exhibitionist beauty who displays her
charms.

These forms are the easiest to recognize, but there are two others
which complete the ensemble with which I am concerned. The hieratic
figure in the upper left of the painting seems to preside over the rites,
while a looming mask juts out in the upper center of the image.[5] These
hallucinatory forms throb within the vitals of the work, emerging vio-
lently in a spasm of arresting tension, only to flicker away in the
matrix of smaller parts when our attention relaxes or we evade their
threatening presence. The shock of the hidden drama becoming overt
crystallizes the ominous undertones of the painting which we begin
to sense as soon as the surface is initially broken. This shock reduces
the mystery of the image at the same time it reveals its human roots
of passion and perversion.[6] With these exposed, it may seem impossible
to return to any pleasurable relationship with the surface now that its
underlying source of power has been revealed, but it is precisely this
kind of problematic pathos that Duchamp wishes to transmute and
escape from in the creation of his art. Having recognized what it is
he is transforming we may be able to accept the transformation and
repress or ignore the hidden problem by returning to the surface as
an act of will. This, I believe, is what Duchamp himself has done in

James Thrall Soby, *The Prints of Paul Klee*, New York, 1945, is a related image.
For the context of eroticism which lies behind Duchamp's imagery, see Mario
Praz, *Romantic Agony*, London, 1933.

[5] The hieratic figure has a facial resemblance, though schematized even further, to
the "most descended" position of the nude in *Nu descendant un Escalier*, No. 2,
Lebel, Pl. 51, and to the general position of the left hand figure in the King and
Queen series, Lebel, Pls. 53, 54, 55, and 57. The looming mask, which becomes
part of *La Mariée* (1912), Lebel, Pl. 62, and *La Mariée mise à nu par ses Céli-
bataires, même* (1915–1923), Lebel, Pl. 100a, is an assemblage of motifs from
the same sources as the other figures, with special links to the drawing which post-
dates the painting of the same name, *Les Joueurs d'Echecs* (1911), Lebel, Pl. 38.
See also Heckscher, *op. cit.*, Pl. X-13b, for "Knight Attending the Ceremonial
Anatomy of a Female," which has a group of spectators and a bending figure in
the center of the work, which is useful for orientation of the double imagery, but
is not claimed as a source.

[6] For Duchamp's personal relations and mood at this time, see Lebel, *op. cit.*,
Chaps. I and II (Chapter I is titled "Bonds and Breaks") and Gabrielle Buffet-
Picabia, "Some Memories of Pre-Dada: Picabia and Duchamp," in *The Dada
Painters and Poets* (Robert Motherwell, ed.), New York, 1951, pp. 255–257.

his art as a whole, and it helps to explain why he will not call images like *Le Passage* "abstract art." [7]

To summarize the situation as it has been developed above, the problem is as follows. When we discover that there is both a surface and a depth in this painting, we may try to focus on one or the other. When we consciously focus on the surface, the depth becomes apparent and gets in the way. When we try to focus on the depth, the surface becomes apparent and gets in the way. Although this gives dynamic vitality to the work and seems to offer us important options in our response, it raises more problems than it solves. One seeks to fix the surface and the depth, each in its place, or else one tries to ignore surface at the expense of the depth, or the depth at the expense of the surface. Once the double imagery of the four figures is discovered, is there not a fourth and preferable option, in which one returns to a state of innocence, or what Duchamp calls "dada blankness," and in which, nevertheless, one is aware of the fact that one has chosen the option? If this is done, a series of destructions have produced a negative dichotomy out of a superficial positive unity which one then chooses to return to as a positive solution to an unwanted problem. Because the return has been "earned" through experience, the reestablishment of innocence differs in quality from the original innocence before experience. The quality of this "dada blankness" is worth examining. [8]

To Duchamp, "the blankness of dada was very salutary. It was a metaphysical attitude, a way of getting free, a way of finding out one was not as blank as one thought one was." [9] Duchamp's approach

[7] Interview, 1956.

[8] For "dada blankness," see Duchamp's interview with James Johnson Sweeney, "Eleven Europeans in America," *Museum of Modern Art Bulletin*, XIII, No. 4–5, New York, 1946. See also, Tristan Tzara, "Dada Manifesto 1918," *The Dada Painters and Poets*, pp. 76–82, especially sub-sections "Dada Means Nothing" and "Dadaist Disgust" and Tzara, "Lecture on Dada," *The Dada Painters and Poets*, pp. 246–51.

[9] Duchamp, *MOMA Bull.*, p. 20. Compare Tzara's statements: "After the carnage we still retain the hope of a purified mankind." (p. 77); "Let each man proclaim: there is a great negative work of destruction to be accomplished. We must sweep and clean. Affirm the cleanliness of the individual after the state of madness, aggressive complete madness of a world abandoned to the hands of bandits, who rend one another and destroy the centuries." (p. 81) "Dada is not at all modern. It is more in the nature of a return to an almost Buddhist religion of indifference. Dada covers things with an artificial gentleness. . . . Dada is immobility and does not comprehend the passions. You will call this paradox, since Dada is manifested only in violent acts. Yes, the reactions of individuals contaminated by *destruction* are rather violent but when these reactions are exhausted, annihilated by the Satanic insistence of a continuous and progressive 'What for?' what remains, what dominates is *indifference*." (p. 247) Duchamp's beauty of indiffer-

to the blankness of Dada was both willed and involuntary. He wished to destroy Romantic sentiment, as he understood it, and "dehumanize" art. He wished to decompose naturalism and what for him were its deterministic implications. He wanted to transcend "physicality" (materialism) and make art a product of "gray matter" (mind). His work previous to *Le Passage* shows the pattern of stylistic reconstruction and humoristic approach by which this dismantling of the past was accomplished. By a kind of perverse antilogic, he logically reduced the human and natural in his art into the mechanistic and inhuman, but he found that destruction could lead to a new freedom from restrictive categories of responsibility and action.[10] The blankness with which he had begun was replaced by a new kind of blankness; the blankness of a fertile void in which things might exist without names as aspects of a process which could be characterized as "pure operation without objective or consciousness." [11]

The automatism of this blankness in which one was free to rest or create was a curious mixture of intellectual narcissism and almost physiological release.[12] Its solipsism was tempered by the effort of reduction of alien objects of the outer world into instruments of the artist's transcendence of them. As Duchamp himself has written, the creative process involved the artist acting like "a mediumistic being who, from the labyrinth beyond space and time, seeks his way out to a clearing." This notion is paradoxical if we assume that Duchamp is moving from the conditional world of men and things into an interior world of purely fictional and imaginary autonomy but, for him and for us faced with the problems of *Le Passage*, the escape into the blankness of pure contemplation was a concrete experience of integration out of fragmentation. By achieving a condition in which, "by being sufficiently still, by becoming exactly identical with ourselves, we

ence is closely linked to his irony of indifference, which is an "irony of affirmation," as noted by Lebel, p. 8.

10 For the role of humor carried to the absurd as a methodical changing of signs, see Roger Shattuck, *The Banquet Years*, New York, 1958, pp. 27–28. Shattuck's study of poetic structure and ideas, using Jarry and Apollinaire as central figures, not only analyzes poetry which influenced Duchamp, but also ways of life reflected in art which are directly applicable to Duchamp's concerns. Rather than using Henri Rousseau in his book, Shattuck would have done better to have chosen Duchamp.

11 This phrase is taken from Sidney and Harriet Janis, "Marcel Duchamp: Anti-Artist," *The Dada Painters and Poets*, p. 310.

12 One thinks of Valery, in this connection, especially of his Monsieur Teste. See Elizabeth Sewell, *Paul Valéry: The Mind in the Mirror*, Cambridge, 1952. See also, Frank Kermode, "Poet and Dancer before Diaghilev," *Partisan Review* XXVIII, No. 1, January–February, 1961, pp. 48–75, for a discussion of "dehumanization" in art as a mode of approaching a fusion of self and world.

can allow the universe to move around us," a new ground for self-affirmation in the world was established by the paradox of withdrawal from it.

Duchamp has said that, for him, problems are nonsensical.[13] They are human inventions, or the result of human interventions, as exemplified in the experience of *Le Passage* where we, as spectators, sought out a human aspect in the work and were temporarily shipwrecked by our success. At the same time, Duchamp has also stated that his works are projected fantasies of aggression and obsession, which he prefers to direct towards art rather than towards persons.[14] He achieves an obvious catharsis from his art, yet he insists that it is more than mere self-expression undisciplined and untransmuted into a sublimated and ultimately different form. In dealing with this matter, Duchamp will quote T. S. Eliot's "Tradition and the Individual Talent," saying that "the more perfect the artist the more completely separate in him will be the man who suffers and the mind which creates; the more perfectly [then] will the mind digest and transmute the passions which are its material."[15] The doctrine of impersonality in art, as Eliot says, is meaningful only to the person with strong personality who can understand what it means to escape from this burden.[16] Translated into Duchampian terms, the escape from personality, which through its strength encounters problems in the world, acknowledges the struggle and deformity which makes for suffering, but chooses to transcend suffering by aesthetic ecstasy.[17]

[13] See Rudi Blesh, *Modern Art U.S.A.* New York, 1956, p. 76.

[14] Interview, 1956.

[15] See Lebel, *op. cit.*, p. 77. Duchamp feels that Eliot's essay presents his own feelings as well or better than he himself has ever done in writing (discussion with Duchamp, 1961).

[16] See T. S. Eliot, "Tradition and the Individual Talent," *Selected Essays 1917–1932*, New York, 1932, p. 10; "Poetry is not a turning loose of emotion, but an escape from emotion; it is not the expression of personality but an escape from personality. But, of course, only those who have personality and emotions know what it means to want to escape from these things." Yet, as Kermode, remarks *op. cit.*, p. 74, "In Mr. Eliot, in Valéry, we surely are aware of what Stevens called 'the thing that is incessantly overlooked: the artist, the presence of the determining personality,' and this presence is consistent with impersonality."

[17] See Alex Comfort, *Darwin and the Naked Lady*, New York, 1962, especially pp. 100–118, for a discussion of the erotic as a form of ecstasy. Comfort writes, p. 107, "Sexual orgasm is the only ecstatic phenomenon in common experience, and does involve a death-like loosening of our grip on personal identity. The Indian mystics, like the European Adamites, disgusted our ancestors by introducing sex under cover of esoteric experience—we might now be more inclined to wonder whether the boot is not on the other foot—whether we have not been talking esoteric prose all our lives, and whether religion and philosophy which pursue ecstatic states are not in search of substitutes for, or sophistications of, the physiological version."

At the time he painted *Le Passage*, Duchamp was still seeking a creative posture which would gain for him the freedom of true indifference. *Le Passage* is not as comprehensive in its solution of the problem of separating pathos and art emotion as he would have liked it to be. The title of the painting refers not only to the *rites de passage* of its theme but also to the transitional role of the work between the drawings *Vierge No. 1* and *Vierge, No. 2* and the painting *La Mariée* which bracket *Le Passage*. In this period Duchamp was trying to "decompose" the world, as we see him doing in the *Vierge* drawings and also moving from externals inwards to a deeper probing of the expressive possibilities of his art.[18] One is tempted to assimilate the anatomy of the tortured bride in *Le Passage* to the anatomy of his art in which the hidden vivisection produces the surface integration at a terrible cost to its "background."[19] Just as Apollinaire saw in Picasso

[18] See Duchamp, "Eleven Europeans in America," *MOMA Bull.*, p. 20.

[19] Duchamp has not specifically equated his mythical personae with the work of art as an object of pursuit, but the following quotations are suggestive in this context and need further research to develop fully. The first reference is to a passage from Albert Aurier, the symbolist critic, reprinted in Sven Lövgren, *The Genesis of Modernism*, Uppsala, 1959, p. 127. "L'oeuvre d'art est la traduction, en une langue spéciale et naturelle, d'une donnée spirituelle, de valeur variable, au reste, laquelle est comme minimum un fragment de la spiritualité de l'artiste, comme maximum cette entière spiritualité de l'artiste plus la spiritualité essentielle des divers êtres objectifs. L'oeuvre d'art complète est donc *un être nouveau*, on peut dire absolument *vivant* puisqu'il a pour l'animer une âme, qui est même la synthèse de deux âmes, l'âme de l'artiste et l'âme de la nature, j'écrirais presque l'âme paternelle et l'âme maternelle. Cet être nouveau, quasiment divin, car il est immuable et immortel, doit être estimé susceptible d'inspirer à qui communie avec lui certaines conditions, des émotions, des idées, des sentiments spéciaux, proportionnés à la profondeur de son âme. C'est cet influx, ce rayonnement sympathétique ressentis à la vue d'un chef-d'oeuvre, que l'on nomme le sentiment du beau, l'émotion esthétique, et le sentiment de cette émotion, ainsi expliquée par la communion de deux âmes l'une inférieure et passive, l'âme humaine, l'autre supérieure et active l'âme de l'oeuvre, apparaitra sans doute, à qui voudra de bonne foi approfondir, très analogue à ce qu'on nomme: l'Amour, plus vraiment même l'Amour que l'Amour humain toujours maculé de boueuse sexualité. Comprendre une oeuvre d'art, c'est en définitive l'aimer d'amour, la pénétrer, dirai-je au risque de facile railleries, d'immatériels baisers." The imagery of this passage is particularly relevant to the iconography of Duchamp's *La Mariée mise à nu par ses Célibataires, même*,° but it is the kind of imagery which Duchamp would delight in parodying. The second quotation is from Kermode, *op. cit.*, p. 75, speaking of dancers who "are always striving to become, like poems, machines for producing poetic states; 'they labor daily,' as Levinson says, 'to prevent a relapse into their pristine humanity.' Only when the body is objectified in this way does it function, in the words of Whitehead, as 'the great central ground underlying all symbolic reference.' Also, it dies, and in so far as it is permitted to appear like something that does, it cannot represent victory over *hasard*, perfect being, the truth behind the deceptive veil of intellect. How is this

° [*The Bride Stripped Bare by Her Bachelors, Even* (Fig. 17)—Ed.]

a surgeon of art, so too we may see in Duchamp an anatomist of expressive form.[20] His disciplined violence and intensity in this formal decomposing of the three-dimensional normative perception of the Renaissance tradition is not unlike the paradoxically impersonal and sadistic vivisection by the bachelors of the virgin-bride of *Le Passage*.[21]

In the Renaissance tradition, the world was the locus of the viewer's self-realization. The space of art was continuous with the spectator's space and stretched before him towards a horizon which held a vanishing point, defined as the point at infinity where parallels meet. One can see this system as a spectrum, with the viewer or self at one end, the world as the middle section, and the horizon as the place where one encounters whatever ultimate this world contains or by which it is organized.[22] The self, in its subjectivity, stands before

to be overcome? 'Slash it with sharp instruments, rub ashes into a wound to make keloid, daub it with clay, paint it with berry juices. This thing which terrifies us, this face upon which we lay so much stress, is something they have always wanted to deform, by hair, shading, every possible means. Why? To remove from it the terror of death, by making it a work of art.' So William Carlos Williams on primitive ways into the artifice of eternity." One thinks here of the "discountenancing" of Duchamp's mother in *Sonate*, 1911, Lebel, Pl. 37; of his sisters in *Yvonne et Magdaleine* déchiquetées,° 1911, Lebel, Pl. 47; of the Nudes descending the Staircase, of the Kings and Queens traversed and surrounded by swift nudes, and the drawings *Vierge*, 1 and 2, which precede *Le Passage*.

20 "The resolve to die came to Picasso as he watched the crooked eyebrows of his best friend anxiously riding his eyes. Another of his friends brought him one day to the border of a mystical country whose inhabitants were at once so simple and so grotesque that one could easily remake them. And then after all, since anatomy, for instance, no longer existed in art, he had to reinvent it, and carry out his own assassination with the practised and methodical hand of a great surgeon." Guillaume Apollinaire, *The Cubist Painters*, New York, 1949, p. 22–23.

21 By "the normative perception of the Renaissance tradition," I mean the internal coherence of object forms set against a clearly distinguishable field or ground, the illusion of three-dimensional space filled by objects or empty space, and the unity of that space based on perspective construction. This tradition had been continuously developed until the twentieth century either as a form of naturalism or as a regulative principle which underlay stylistic contradictions of it, as in Mannerist works of the 16th century. With Cézanne and Cubism, this tradition was transformed, although it still is a ground against which variations, paradoxes, and contradictions are constructed to show the artists rejection of the tradition.

22 I am indebted to President Douglas M. Knight, of Lawrence College, for this image of a spectrum. It was developed to characterize the situation of contemplation and action in the late nineteenth and twentieth centuries which faced such diverse figures as Kierkegaard, Nietzsche, Gerard Manley Hopkins, Van Gogh, and Cézanne. Whereas the middle ground of nature and the operational conventions of society was the focus of nineteenth century orthodoxy, the increasing concern with the subjectivity of the self and its existential tensions lead to a rediscovery of ultimate encounters at the limits of nature or ethics or utilitarian religious views. The urgency of these encounters disturbed or destroyed

° [*Yvonne and Magdaleine Torn in Tatters* (Fig. 4)—Ed.]

the world which is focused by its unified consciousness and powers of perception, but the world which submits to this focus also contains the vanishing point which is both a projection of the self and a transcendent point beyond it. In this system and relationship, the world becomes a mediating realm between self and ultimate and objectifies both the subjectivity of the viewer and the ineffable quality of the ultimate. From the sixteenth century on, this system of coherence of the world portrayed, is threatened by the increasingly precarious position of the observer and the increasingly remote distance of the ultimate.[23] By the year 1912, as in *Le Passage* regarded as a Renaissance picture, the relationship between self and ultimate can no longer move serenely through the world, but must either try to penetrate the barrier of the world by a leap over the world or get lost in the world which becomes a labyrinth of impenetrable opacity. Since the depth of the painting is incoherent and the focus of a perspective is wholly disrupted by the structure of the forms, a projected double imagery or a return to a surface organization of forms seem to be the only alternatives.

This, I propose, is the consequence of Duchamp's dilemma in encountering the world in a traditional way.[24] Because it will no

the traffic patterns of the middle range and showed them to be conventional, rather than natural or given, thus transforming the world into a field of transformation involving the double action of self and transcendent which structured or shaped the middle ground. The painting *Landscape with Ploughed Fields*, reproduced in Meyer Schapiro, *Van Gogh*, New York, 1950, p. 115 shows the tensions which this situation sets up between "the self and its goals." See also Schapiro's commentary on *Crows over the Wheat Field*, *op. cit.*, pp. 34 and 130. One can interpret the three roads in the Van Gogh as "the familiar perspective network of the open field . . . now inverted; the lines converge towards the foreground from the horizon, as if space had suddenly lost its focus and all things turned aggressively on the beholder," (Schapiro, p. 130); or as three divergent paths to the horizon which tear apart the self who seeks to move in multiple directions of impulse at the same time. In discussing this painting with Schapiro in 1955, he felt that its problems were relevant to those of Duchamp.

23 For an interesting, brief background for this statement, see Douglas M. Knight, "History of Ideas and the Creative Writer," *The Review of Metaphysics*, Vol. V, No. 2, December 1951, pp. 269–280.

24 For Duchamp's encounter with "the arbitrariness and falseness of our poor creation, the world," see Gabrielle Buffet-Picabia, *op. cit.*, pp. 255–7, summarized (p. 255) as follows: "After the self-satisfied rationalism of the nineteenth century, an ebullience of invention, of exploration beyond the realm of the visible and the rational in every domain of the mind—science, psychology, imagination —was gradually breaking down the human, social, and intellectual values which up to then had seemed so solid. All of us, young intellectuals of that period, were filled with a violent disgust at the old, narrow security; we were all conscious of the progressive decline of reason and its experience, and alert to the call of another reason, another logic which demanded different experience and different symbols."

longer organize itself for him "automatically," he seeks to break up its opacity in hopes of moving violently, by short circuit perhaps, to a focus beyond it.[25] At the same time, he is unable to accept any focus which does not have the immediacy of his most intimate experience of himself. This too is a problem because the immediacy of his experience of himself, in its deepest meaningfulness, is filled with the same opacity that the world of non-self exhibits to him.[26] The traces of object figures in the depth of *Le Passage* surely refers to the liquidation of this opacity, but it is also significant that we move back to the immediacy of the surface rather than moving on to a "fourth dimension" beyond the work. The surface has the consummatory qualities of the Duchampian "fourth dimension," but it is not yet within the deepest levels of the work.[27] It was only in *La Mariée*, the painting of 1912 which came just after *Le Passage*, that Duchamp says he first glimpsed this "fourth dimension" within his work.[28]

In *Mariée*, forms somewhat like those found in the depths of *Le Passage* are brought forward as a screen of structured sculptured shapes which stand in front of a mysterious and fluid depth. In *La*

[25] Buffet-Picabia, *op. cit.*, p. 256, writes: "May I confess that the first supposedly abstract paintings that I saw left me in a state of perplexity? . . . Some of these works, which then struck me as incomplete and uncertain, assume at present an extraordinary magnitude and precision; they speak eloquently of a will to abandon the obsolete formulas of imagination and expression, of a determination to *reconstruct on a new plane,* of an unremitting and *painful quest* in the domains both of thought and technique. It was a strange period of gestation and adaptation; *new works brought nothing but doubt, dismay, anxiety, until minds could adjust themselves and corresponding new reflexes could be created.*" (italics mine).

[26] *Ibid.*, p. 256. Speaking of Duchamp in 1910, Buffet-Picabia writes: "Though very much detached from the conventions of his epoch, he had not found his mode of expression, and this gave him a kind of disgust with work and an ineptitude for life. Under an appearance of almost romantic timidity, he possessed an exacting dialectical mind, in love with philosophical speculations and absolute conclusions. . . . In that period . . . Duchamp enclosed himself in the solitude of his studio . . . this was a time of escape into himself. . . ." For a rich account of the contemporary will to metamorphosis of the self and its relations with the world of things, machines, and values, see Marcel Raymond, *From Baudelaire to Surrealism,* New York, 1950, especially pp. 217–227 and pp. 269–283.

[27] The "fourth dimension" should, logically, be the dimension behind the painting, since three-dimensional forms are the "shadows cast by four-dimensional forms." (Duchamp, interview, 1956.) For Duchamp, the fourth dimension is a plane of consummation, analogous to or exemplified by the sexual act, "since he considers the sexual act the pre-eminent fourth-dimensional situation. Thus he completely parts company with the Cubist painter who, as subject, dominates the object spread upon the canvas while, in erotic terms, Duchamp achieves the fusion of subjects (the subject of the painting and the subject as perceiver) in a single entity: the couple magnetized on all surfaces" (Lebel, p. 28).

[28] Statement by Duchamp, interview, 1956.

Mariée, the lubricity of the surface of *Le Passage* is contained and spatialized as depth, "canned" and preserved behind the tense but explicitly solid forms of the foreground.[29] There are ambiguities and double imageries among these forms, but however paradoxical or complex one may make them, there is always the glowing depth which invites us to move beyond and submerge ourselves in the vitals of the work. Robert Lebel has commented on the interior body imagery of *Le Passage* and *La Mariée,* noting that Duchamp was exploring the visceral unconscious as a source of power in these works. He writes, "as a matter of fact, they [these paintings] constitute the first incursion of modern art into the domain of intersubjective relations. By introducing, as Apollinaire so magnificently wrote, "traces of beings," Duchamp established a state of communication which had been forbidden to the new painting. According to the formula which Matta later adopted, and with reference moreover to Heidegger, at that moment Duchamp was the painter of *being with.*"

This idea of "being with" applies in *Le Passage* primarily to the self with itself, while in *La Mariée* the "being with" relates the self to a focus beyond itself, though this focus is primarily a projection of the self.[30] But, however narcissistic this relationship might be, however personal its focus and however slight a real escape from the Duchamp who suffered was achieved here by the action of the mind which created, the direction Duchamp moves in is out from himself, seeking to master himself by mastering forces which lay beyond him.[31] If he could encounter the force he calls the "fourth dimension" within the image he creates, then that image could be both a vehicle for this

[29] For a specific analysis of this painting, see my unpublished dissertation, The Position of *La Mariée mise à nu par ses célibataires, même* (1915–1923) in the Stylistic and Iconographic *Development of the Art of Marcel Duchamp,* Princeton, 1961, pp. 145–50.

[30] I base this on George Herbert Mead, "Perspectives," in *The Philosophy of the Present,* Chicago, 1932, p. 168. "In the process of communication the individual is an other before he is a self. It is in addressing himself in the role of other that his self arises in experience." This notion is developed by Mathew Lipman, "The Aesthetic Presence of the Body," *Journal of Aesthetics and Art Criticism,* XV, June, 1957, p. 431, who writes: ". . . to symbolize something artistically is, in a very pertinent sense, to symbolize oneself experiencing that something, and so one comes not only to a better knowledge of the defining characteristics of the thing, but also to a better knowledge of oneself." Lipman's article is a superb essay on the role of the body and body imagery in art and the social symbolism of body imagery.

[31] Compare Meyer Schapiro, *Paul Cézanne,* New York, 1952, p. 10. "In this complex process, which in our poor description appears too intellectual, like the effort of a philosopher to grasp both the external and the subjective in our experience of things, the self is always present, poised between sensing and knowing, or between its perceptions and a practical ordering activity, mastering its inner world by mastering something beyond itself."

encounter and a world in which the artist and his ultimate are reflected.[32] To be sure, this constructed world was arbitrary, artificial, paradoxical and full of mechanisms of a dubious sort, yet we can agree, I think, with Lebel when he writes that Duchamp here was "frankly advocating an art which, over and above an esthetic formulae, was concerned with everyone's fundamental preoccupations. There was nothing more elementary, more generalized, more popular, if you will, than the complex problems he had set himself to solve." [33]

While Duchamp's art is hardly an art for everyone, and his problems may not be those of *everyone*, after all, they are surely problems which have been central in the work of modern poets and painters in their concern with self-definition, self-discovery, and self-affirmation over against a faltering tradition and a disintegrating world.[34] The

[32] In discussing dimension, beginning with two- and three-dimensional development, Duchamp suddenly shifted to the statement, "I want to grasp ideas the way the female encloses the male organ in intercourse." The development of dimensions from two to four and the shift from objects to ideas, feelings, and self as objects is characteristic of Duchamp. "What he wanted, we might say, was not a painting *of* something, but painting as something, painting which should not only represent an object but be in itself an idea, even as the object represented might not be actual in the phenomenal sense but rather a mental image. As he said in 1945: 'I wanted to get away from the physical aspect of painting . . . I was interested in ideas—not merely in visual products. I wanted to put painting once again in the service of the mind,'" (George Heard Hamilton, "Inside the Green Box," in Marcel Duchamp, *The Bride Stripped Bare by Her Bachelors, Even*. If the image (*La Mariée*) created by the unconscious process of the mind contains (grasps) the fourth dimension, the fourth dimension becomes the consummatory object (subject matter) which Duchamp (the perceiving subject) recognizes when he has worked his way out to a clearing through the creative process as creator and which we penetrate as spectators by deciphering and interpreting the inner qualifications of the work of art.

[33] Lebel, *op. cit.*, p. 15. Apollinaire writes of Duchamp aspiring to "an art directed to wresting from nature, not intellectual generalizations, but collective forms and colors, the perception of which has not become knowledge. . . ." (*Cubist Painters*, p. 47). It was this unconscious perception which Apollinaire saw as the energy which would produce works of a strength so far undreamed of which might "even play a social role" (p. 48).

[34] The search for an autonomous and autotelic art, "art, nameless, radiant . . . a homogeneous and complete place . . . indefinable, absolute . . . a fire above all dogmas." (Kermode, *op. cit.*, p. 49) as the product of an alchemy of complex fusions which would restore the primordial unity of being which had been sundered by the rise of consciousness was a common concern of Duchamp's generation. Buffet-Picabia writes, *op. cit.*, p. 258 "It would seem . . . that in every field, the principal direction of the 20th century was the attempt to capture the 'non perceptible.' Which justifies and illuminates the poetic and plastic hermeticism of the arts which illustrate our age." See Marcel Raymond, *op. cit.*, for a full history of this interest among the poets, and Roger Shattuck, *op. cit.*, for the syntax and motivations of art in Duchamp's generation. Duchamp's allegiance to poetry, especially that of Mallarmé, as a model for his own transcendence of the physical and the restoration of ideas to painting is well known.

awareness of a dimension of resolution beyond the surface of *La Mariée*, which, following Duchamp, we may discover in the depths of the work, takes us into a depth which is obscure and undifferentiated, unconscious, dark, like a primordial womb.[35] In *La Mariée*, however, this dimension is still visceral, physical, brute in its texture compared to what Duchamp would like to achieve. His next step will be to attempt a purely mental encounter with the fourth-dimension which will be purged of the turgidity of *La Mariée*.

This next step may be seen, I believe, in the great glass assemblage, *La Mariée mise à nu par ses Célibataires, même* [Fig. 17]. Here we find the surface qualities of *Le Passage* crystallized into a pane of glass. The glass surface is both transparent and opaque, both solid and void.[36] Forms are silhouetted against the glass panel in an antiseptic array, but when one becomes familiar with their icono-

[35] This is not the only aspect this encounter can have. Unless the viewer responds to the four-dimenisonal idea as a process of trasmutation, the world of *La Mariée*, and of *Le Passage* too, may resemble the world of primordial thingness described by Mathew Lipman, "The Physical Thing in Aesthetic Experience," *Journal of Aesthetics and Art Criticism*, XV, September, 1956, p. 38. This would be the world of things before the communicative act between the self and itself as an object occurs. "Prior to the emergence of consciousness, prior to the elaborate mechanisms of social integration, the organism exists merely as a brute physical thing. But in this dim, primordial world, lumps of bone and flesh have no preferential status. They are solids, tangible surds, shaped and wrought and driven through all their surroundings. Here is to be found things of all kinds, things porous, opalescent, granular, luminous, fleshy, things slimy, brittle, impenetrable. There is no communication here, no intelligibility, only a terrifying unknowableness. In such a world, it has been said, there can be no communion, only tentative and erratic movements, which seek to pierce the oppressive darkness, as insects feel, with painfully sensitive antennae, along a cold moist wall." In its horror, this is the world of Kafka (untransformed into the structure of bureaucracy and the bourgeois interior), the world of Lautréament (a Duchamp favorite), perhaps the world of the schizophrenic who becomes a thing. For Jacques Maritain, *Creative Intuition in Art and Poetry*, New York, 1953, pp. 211–215, who reproduces *Mariée* (f. p. 216), Duchamp fails in his attempt at "integral to transmutation" for he cannot "proceed in an angelic or demonic manner" to evoke the spark of illumination from the unnatural "thing" he has constructed. But Lipman (p. 38) suggests that in moments of crisis we may need to establish roots in the depths of this primordial world of thingness "worshipping the impersonal world which is a proof of some existence other than ours." The depths of *La Mariée* have this character, in the context of Duchamp's art, and correspond also to the roots of "terror and joy of obscure primitive ground from which modern poets draw strength for their archaic art" (Kermode, *op. cit.*, p. 75). Much the same thing can be said of *Le Passage*, except that in *La Mariée* a new continuity of motion out and away has been established.

[36] By finding a "ready-made" equivalent of this surface, Duchamp reduces its attraction as a consummatory plane, for the glass is a materialization of sheer lubricity and transparency. In the effort to transform the physical appearance of the glass as a solid substance, the viewer is led beyond the surface as well as being attracted to it.

graphic background they are clearly related to both the forms in the depth of *Le Passage* and the iconography of that work.[37] In the *Glass* [Fig. 17], the forms are organized in a perspective system with a single vanishing point, although this perspective, which is delineated and formulated in a drawing, is unformulated and implicit in the *Glass*. Here the frustrating drama between bachelors and bride, their interaction of mutual arousal and rejection, lies on the surface of the work, but the iconographic implication of reading a disjointed, but provocative narrative into the visual forms, leads us beyond the surface either to frustration or to a reconstructed imaginary vanishing point. There are strong incitements to move beyond the barrier of surface into the void of the depth by a selective organization of depth cues on the surface of the *Glass*, aided by a simultaneous abolition of interferences that get in our way. If this can be done, then we find that we have constructed a "moment of arrest" which is a relationship of self-reflexiveness within the depths of the *Glass*. This self-reflexiveness, insofar as it "realizes" the focal power of a perspective on a paradoxical world of symbols within the work of art, constructs this perspective against the background of the world of actuality seen through the transparency of a pane of glass. One is then free either to enjoy the resolution of a problematic image by the contemplation of a structured and focused void or one can use this focus to move out into the world of human space and time with the assurance of an experience of integration which self-reflexiveness has achieved.

If this pattern of dimensional development can be followed from *Le Passage* to the *Glass*, from the "fourth dimension" as a surface phenomenon to its embodiment in an imaginary three-dimensional vision behind the *Glass*, we can understand better both the discontinuities and continuities which distinguish Duchamp's development in his art. As we might expect, the transformations which occur between *Le Passage* and the *Glass* in a stylistic and structural pattern correspond precisely to his aesthetic intentions after 1912. These were to objectify and abstract his techniques and concepts and to intellectualize his art. There is less of the man who suffers and more of the mind which creates in the *Glass*, but this will become evident only

[37] The voyeur in *Le Passage* becomes "The Oculist Witnesses" on the *Glass*; the hieratic spectator of *Le Passage* becomes the "Moules Mâlics" of the *Glass*; the central mask may be equated with the "Chocolate Grinder" of the *Glass*, as well as with the forms of "pendu femelle" of the upper panel; and, finally, the odalisque bride of *Le Passage*, which is literally detached from the grasp of the bachelors, becomes the bride machine of the upper panel of the *Glass*. As Lebel notes, p. 73, the forms on the *Glass* may be seen as the Platonic projection of ideas "behind" the *Glass*. They are to be "grasped" in the same way that the poetic essence of the true self of Apollinaire is to be discovered in the white field of the paper in the mirror calligrame reproduced in *The Cubist Painters*, p. 6.

if one moves beyond the surface conflict of its pattern and narrative to the construction of a dimension beyond what we see. The focus by which we measure ourselves against the *Glass* is a construct we have provided, but once we construct it it no longer belongs only to our own efforts and our point of view. Magically, but significantly, the vanishing point with which we orient our relationship becomes a bridge to futurity and "the lighthouse of the Bride." No one who has had the experience of encountering the intellectual and emotional illumination which this focal point provides can doubt that its hallucinatory presence has both form and substance and reality for the world of the mind. Since it is the world of the mind and the imagination that Duchamp values as real, as opposed to what he calls the "physicality" of things, what are called an imaginary focal point and an imaginative relationship become real forms in a real dimension which can only cast obscure shadows in a material world. Without the challenge of this material world, however, represented by the forms on the surface of the *Glass*, we would not be provoked into the effort of transcending them to the higher values which lie beyond. It is no accident, I believe, that after abandoning the *Glass* in 1923, Duchamp moved into the world itself, carrying his own focus within him and projecting its mysterious but compelling perspective as the "Radiant Myth of 'Marcel'—A Masterpiece even more arresting than the *Nude Descending a Staircase*" [Fig. 8].

DUCHAMP'S GLASS, *LA MARIÉE MISE À NU PAR SES CÉLIBATAIRES, MÊME,* AN ANALYTICAL REFLECTION

Katherine S. Dreier and Matta Echaurren

The Renaissance brought to human consciousness the full awareness of the organic image of man's own body—the visible structure of Man and the natural world. The whole chain of association was controlled by the physical phenomena, and the interest in natural sciences was stimulated and began to grow. In contrast to natural sciences, phenomenology, which is the science of the transcendental consciousness as indicated by Kant, now helps us to realize the structure of the human spirit.

The essential principles of human consciousness cannot be grasped until we abandon the psychological attitude of conceiving the image as a petrified thing or object; the result of emphasizing the external vision, which is rarely related to perception. The image is not a thing. It is an act which must be completed by the spectator. In order to be fully conscious of the phenomenon which the image describes, we ourselves must first of all fulfill the act of dynamic perception.

Marcel Duchamp was the first to paint the image per se, to be completed by an act in consciousness on the part of the spectator. Prior to this, the artist spoke and the onlooker listened, for he was not called upon to complete the work of art by his own conscious act. It was a statement—now it is a dialogue!

In Duchamp's most important work: *La mariée mise à nu par ses célibataires, même* . . . (machine agricole)—we do not find any bride nor agricultural machine, but a disturbing plastic conversation. This, the human spirit can only understand by means of poetic reason-

"Duchamp's Glass, *La Mariée mise à nu par ses célibataires, même;* An Analytical Reflection," by Katherine S. Dreier and Matta Echaurren (New York: Société Anonyme, Inc., 1944). Reprinted by permission of the Yale Collection of American Literature, Beinecke Rare Book and Manuscript Library.

ing, which demands an intentional conscious act on our part. Through this poetic reasoning, the spirit per se realizes the reality of the object in place of only recognizing it. It is the first attempt to bring to consciousness the image of the essence—which is the essential image of the object. This cannot be completed except through the conscious participation of the onlooker.

Painting—glass—mirror—these are the three substances in dynamic interrelation to the final image of the *Glass* [Fig. 17]. While we gaze upon the bride—there appears through the glass the image of the room wherein we stand and on the radiation of the mirror design lives the image of our own body.

This dynamic reality, at once reflecting, enveloping and penetrating the observer, when grasped by the intentional act of consciousness, is the essence of a spiritual experience. To put our force of imagination into action is the most important goal which the art of the present day can achieve. The spectator is no longer an onlooker—he is an actual participant. It must however be realized that the liberation from outworn modes of experiences comes in proportion to the sensitivity, as well as to the intensity of the act of consciousness on the part of the onlooker.

We quote from Marcel Duchamp writing about his *Glass*, that: "Through perspective or through any other conventional means, the lines of design are forced, and lose all their inherent possibilities. It is the more ironic because the artist himself has chosen the body or primitive object, which inevitably takes shape according to the law of perspective—rather than by virtue of his, the artist's own will."

Duchamp's images are brought to serve the human spirit by simply disregarding the common use attributed to the object, thereby liberating the power of vision. He has constructed a small glass on which he inscribed the following: "A regarder d'un oeil de près, pendant presque une heure" [Fig. 23].

Humor, which is the violent reaction to something unknown, will be the only experience that we will get out of a *Glass* by Duchamp, if we refuse to follow him into his "monde en jaune."

In Cézanne's *Apples*, consciousness is awakened. But in Duchamp's *Glass*, reality is created by the artist himself, for the use of the spirit. Art which is the means whereby to place in focus the human consciousness, has changed from the representational—exploitation of the object or subject—to dynamic action, causing a direct shock through which to free the spirit. Duchamp has found the key whereby to liberate the images from their common meaning and to represent the object by an image which is pliable to the mechanism of sight and expands the consciousness. He has broken the association between the object and the onlooker and in breaking down these limitations, frees the spirit of man.

Once we understand that the objects are but the instruments the artist selects to use, in search of the Spirit—it is of no interest to remain on the surface of that which we see. The sensuous shock should transport the nerve tissues of the fingertips, the calming functioning of the retina—and then beyond! It is for this that the "moule malique" and the "chocolate grinder" are presented in a sensuous contrast—open to the same kind of speculation that turpentine and oil surfaces give—only a sensuousness on glass has an achievement whereby all accomplishments through manual accidents are eliminated. Besides a new technique has been evolved. What magic has Duchamp used that the weight of the lead and the paint stay in their place on so slippery a surface as glass?

In Duchamp's mural *Tu m'*, the emotion is obtained by the contrast of the corkscrew shadow, like candle smoke—and a sign painter's hand, actually done by a sign painter. To have presented on one and the same canvas the difference between the two attitudes towards one's work, demonstrates clearly the mental and spiritual approach of the artist, in contrast to that of the commercial ·painter, whose attitudes differ so widely, the one from the other. Something which should be obvious, but is not!

Through his marvelous technique and sense of order, Duchamp carries the onlooker into the deep philosophical truths which underlie all his works and which are especially emphasized in these two great examples—the mural—*Tu m'* and the big glass—*La mariée*. In the mural he emphasizes the philosophical idea that nothing has value until it passes through some mind which creates the value. Thus Duchamp chose only discarded objects—a discarded corkscrew—a bicycle wheel—old bedsprings—color-samples, etc.—and through the placement of these objects—in juxtaposition to each other—through his great sense of space as related here to time and motion—he created a balance of action and reaction—of flight and repose—which makes it one of the most remarkable pictures of our day. While through his *Glass—La mariée*—he causes one to realize the futility of trying to possess that which does not belong to the material world. For the moment one wants to possess and grasp at it—that moment it eludes one and like smoke, it vanishes into thin air!

Our relationship to the outer and the inner world is thus proved. Our relationship can be addressed to the outer world and its natural phenomena—or to the inner world—the world of the Spirit or the finer vibrations. The greatest of all phenomena is the phenomenon of Man. What Man thinks and makes. And what is revealed to us on entering this realm of Man's imagination is as mysterious as the stars in the firmament and as solid. "Condition d'un langage. Rechercher des mots premiers—divisibles seulement par eux mêmes et par l'unité." (*Duchamp*).

THE GREEN BOX

Jasper Johns

Finally, all the notes from the *Green Box* are published in English, and Richard Hamilton has arranged them typographically so one may follow the chronological development of the invention of the Bride and her bachelors.

The fascinating layout of the erotic machinery may be over-balanced in the book by the revelation of the extraordinary qualities of Duchamp's thinking, and in the final unfinished *Large Glass* (1915–23) [Fig. 17] as well it seems less the machines' True-Story capacities for romance than the capacity of the work to contain Duchamp's huge precisions of thought-in-art that is conveyed by its vitality.

The force of the externality of the multi-dimensional work seems taken for granted in the notes. However, when the bachelors "shoot," once each, this "Hilarious" glass house is pierced through—and the signs of this action are joined some years later by more haphazard breakage.

Like "The Clock *in profile*," from the rear or side, the *Glass* "no longer tells the time." But it is Marcel Duchamp's "*Inspector* of Space" participating and, at times, getting lost in its environment. The walls of the Philadelphia Museum show through it, attack it, are absorbed or reflected by it. It is "painting of precision, and beauty of indifference"; allowing the changing focus of the eye, of the mind, to place the viewer where he is, not elsewhere.

The lavish care and constant readjustment-toward-precision (De-

"The Green Box," by Jasper Johns. This review of Richard Hamilton, ed., *The Bride Stripped Bare by Her Bachelors, Even; Typographic Version*, trans. George Heard Hamilton (London: Lund Humphries; New York: George Wittenborn, Inc., 1960) is from *Scrap*, December 23, 1960, p. 4. Reprinted by permission of the author.

light in the necessity of the artist's hand is left unexplored, as though the best operation would leave no souvenir of the Surgeon) . . . not only in the imagined machine, but in the true physicality of the work (The glass is mirrored and scraped away; dust is allowed to settle on the "sieves" for 3 or 4 months and is then fixed to the glass—"just as good today as it was 30 years ago" [1]) . . . are countered by Duchamp's curious frugality. The carbon paper used to transfer the image of the *Oculist Witnesses* onto the glass becomes a drawing in itself; the machined readymades *serve* as works of art and *become* works of art through this service; and the aristocratic decision to work little or not at all is made.

Duchamp's wit and high common sense ("Limit the no. of rdymades yearly"), the mind slapping at thoughtless values ("Use a Rembrandt as an ironing-board"), his brilliantly inventive questioning of visual, mental and verbal focus and order (the beautiful Wilson-Lincoln system, which was never added to the glass; "lose the possibility of identifying . . . 2 colors, 2 laces, 2 hats, 2 forms"; the vision of an alphabet "only suitable for the description of this picture") inform and brighten the whole of this valuable book.[2]

[1] This remark about the dust was made by Duchamp in conversation. All other quotations are from the book.

[2] In reviewing this book, I searched for the cartoon whose caption was, "O. K., so he invented fire—but what did he do after that?" but could not find it.

THE NEW PIECE

William Copley

My relationship to Marcel Duchamp was largely personal and amicable. I do not consider myself an intellectual as a painter and so never really got involved in the intellectual analyses of the *Large Glass* [Fig. 17] or the notes that accompanied it. Duchamp's influence on me as a painter was enormous but strictly poetic, having to do with what I assumed to be my understanding of his humor and his philosophy as expressed through his personality.

I would like these few words to be considered as sheer speculation or as nonsense. Otherwise it would not be fun to write and probably no fun to read.

I insist that I understand why he perpetrated the myth that he long ago stopped working. I will oversimplify this here. It must have seemed to him the most direct way to insure himself the privacy he needed to continue working in the light of what was already becoming an exaggerated reputation, because, "Yes, Virginia," there is a final monumental work which occupied him for approximately the last twenty years of his life.

Only a detail of the exterior is reproduced here; the interior will not be photographed. To begin with, the work must be viewed through two peepholes like eyes in a Halloween mask. No other method of viewing it should be considered—no walking around it or touching it, or admiring it sculpturally. The piece is to be merely experienced. Marcel Duchamp was always an ardent supporter of happenings and had what was to me a prodigious patience in lending his time to them. This piece is in many ways a happening, but a short glimpse of it makes its effect for a lifetime.

"The New Piece," by William Copley. From *Art in America*, LVII, No. 4 (July–August 1969), p. 36. Reprinted by permission of *Art in America* and the author.

The *Large Glass,* too, because of the materials chosen and the specially invented perspectives, was intended to convey an experience other than merely looking at a picture. There can be little doubt that Marcel intended this new piece to be an extension of the unfinished *Large Glass.*

The title of the *New Piece* is as enigmatic as that of the *Large Glass*:

> *Large Glass:*
> Etant Donnés: 1. *La Chute d'Eau*
> 2. *Le Gaz d'Eclairage*
> *MD 1966* °

It is equally as "frank" in the sense that it is a monument to certain actions between men and women that some editors still delete if called by a certain four-letter word. But we are willing to use a four-letter word, *life,* and wink slyly.

The Bride and the machinery that makes her female are represented carefully and symbolically in the *Large Glass.* In the *New Piece* she and her moving parts are represented with disarming frankness. In the *Large Glass* her partner in *life* is represented in multiple by the Bachelors, the complex of all men. In the *New Piece* she is holding her man in a gesture that is (again) disarmingly frank, but what she is holding is the lamp of illuminating gas. The illuminating gas was represented in the *Large Glass* as emanating from her.

The illuminating gas and the waterfall (or the "falling of water" as the reading in French allows) are the basic elements of the activity between men and women that the two pieces are concerned with ("Eau et Gaz sur Tous les Etages"). The falling of water achieving the symbolic splash in the *Large Glass* is represented in the *New Piece* by what appears to be an actual waterfall contrived by Duchamp with a Rube Goldberg-like machine disturbing a painted postcard landscape, thus achieving, as in the *Large Class,* the symbolic aspect of the falling of the water. The isolation of the all-important symbols—falling water and illuminating gas—remains a constant in the two great pieces.

Another speculation I am drawn to make concerns the game of perspective that Duchamp plays with himself in the two works. Richard Hamilton has explored with final expertise the aspects of perspective in the *Large Glass.* These seem to function totally in reverse in the *New Piece.* The nude ceases to exist where vision cannot reach, channeled as it is through an oval hole in an inner brick wall. I will not comment on the significance of this as I have not fathomed it be-

° [*Givens: 1st, the Waterfall, 2nd, the Illuminating Gas, MD 1966* (Fig. 28) —Ed.]

yond the obvious. Nor have I fathomed the faggots upon which the nude is reclining; here the obvious seems too dangerous, and perhaps one does not have to look at all. But I know these branches were collected lovingly by Duchamp in expeditions to the country. I might speculate, however, on the two different kinds of precision involved (precision being typical of Marcel and time never being of the essence). The tense precision of the *Large Glass* is replaced by a more relaxed precision in the *New Piece*. The nude herself in the *New Piece* recalls his painstaking work on the *Glass*. He built her skeleton, he stretched her flesh, he bought her wig. The similarity stops there.

The door through which one peeps was cut down from familiar doors in Cadaques, Spain, where Duchamp summered for so long. The bricks that surround the door were filched from building sites. The intricate waterfall is housed in a cookie tin. The whole thing is set on a checkered linoleum mat—room for further speculation, I guess, for chess buffs.

But I cannot intellectualize on this piece of Marcel's; I can only feel it. I have experienced it. I can close my eyes and see it in detail anytime I choose. Both pieces I'm sure were motivated by Marcel's need to be busy—or, better perhaps to say quietly, his positive feelings about life. The materials for both pieces came from daily experience, endless and random. The work was an enjoyment of patience; the difference between the two techniques might represent the difference between spring and fall—which may finally explain the autumn branches on which the nude reclines. The work was signed "MD 1966." Does this mean that the *Large Glass* was finally finished? I do not think so, but I do think its implication was restated with finality.

J'ACCUSE MARCEL DUCHAMP

Thomas B. Hess

Precarious balance between seriousness and pretense is an unmistakable and integral part of culture.

HUIZINGA

Marcel Duchamp over the years brilliantly has consolidated a position that is practically invulnerable to serious criticism.

On one flank, he is the yearning vanguard's blue-eyed pride. A mild pun from his pen, scribbled on a bit of note paper, recently and typically was enshrined by a New-Realist assemblager as a catalogue preface; Duchamp's imprimatur was handled with the reverence that a devout Sister might tender a Vatican postcard touched by the Pope.

For his avant-garde audience of the past fifty years, Duchamp has embodied in a charming smile, soft conversations farced with needles and in his disarming cynicism all that has seemed youthful, independent, buoyant, attractive—in a word, "Fun"—to the modernist sensibility. To attack him is to be, *a priori*, stuffy.

On the other flank, Duchamp is a favorite whipping-boy of the philistines. The citizen-patriots who want to jail Lennie Bruce, ban Lawrence, boost the Bomb, who know that Picasso is a Jew-Communist practical-joker and that Pollock's technique is excremental smearing, the reactionaries who have fought every new idea and every radical gesture, all unite in hating the painter whose *Nude Descending a Staircase*, No. 2 [Fig. 8] shocked Teddy Roosevelt in 1913. To attack Duchamp is, *a priori*, to join the know-nothings.

"J'accuse Marcel Duchamp," by Thomas B. Hess. From *Art News*, LXIII, No. 10 (February 1965), 44–45, 52–54. Copyright © 1965 ARTnews LLC, reprinted courtesy of the publisher.

In the past few years, however, Duchamp's work has been re-
moved somewhat from controversy through both the venerability of
the artist (he is now 77) and a number of enterprising surveys: the
Arensberg holdings are on public view at the Philadelphia Museum;
other major works, from the Dreier bequest, are shown at Yale; the
Guggenheim and Pasadena museums, the Fried gallery in New York
and the Schwarz gallery in Milan, have helped make visible an œuvre
that usually was jealously hidden by initiates to the cult of M.D. Texts
by R. Lebel and by G. H. and R. Hamilton as well as exhibition cata-
logues also have clarified the situation. The most recent exhibition,
accompanied by a book in the deluxe format that is standard obbligato
to a Duchamp appearance, is at the Cordier-Ekstrom gallery, New
York [to Feb. 13], whence it will then go on a national museum tour.
Over 100 items are displayed: paintings, drawings, notes, original
ready-mades, reproductions in limited editions of other ready-mades,
memorabilia, typographies, snapshots from all periods in the artist's
career (the exhibition is subtitled "not seen and/or less seen, 1904–
64"). So now it is possible to get a less encumbered view of Duchamp
than ever was available before and to attempt a preliminary assay of
his accomplishments while remaining disengaged from his enemies
and champions.

Point 1: Marcel Duchamp was a second-rate painter.

Counterpoint 1: He did two or three of the masterpieces of mod-
ern art.

Point 1: Duchamp's early provincial, academic pictures evince a
gift for delicate, caricatural draftsmanship—exactly the sort of dainty
talent that a wise art student would be on guard against exploiting, a
precaution Duchamp seldom exercised. His first conversion to modern
art resulted in a soft, dappled Fauvism that relies on, while largely mis-
understanding, the contributions of Matisse. Duchamp's color tends to
the superficially garish; his modeling, to the illustrative.

Indeed Duchamp as a Fauve most resembles the German Ex-
pressionists in his preoccupation with allegory and anecdote, his ham-
fisted distortions, his sculpturesque idea of space. Duchamp's next
switch was to a Futurist inflection of Cubism, but he confused Picasso's
theses as badly as he had misread Matisse's. Duchamp piled Cubist
planes on academically modeled figures as a costume designer might
hang shoulder-pads on an actor. Literary anecdotal subject matter
keeps precedence over pictorial content. Most of Duchamp's Cubist
pictures read, with a minimum of translation, like Pre-Raphaelite
genre. And a similar end-of-the-century attenuation informs both man-
ners. As he entered his ultimate conversion, to his own version of Dada
painting and construction-making, Duchamp continued to process any

bits and pieces of available modernist painting for his own literary preciosity. He animated the Cubist drawing in much the same way that Walt Disney animated the mouse. Facets become flippers. The plane is a screen upon which to project simple experiments in applied calculus, mechanical drawing, optics, etc. His penchant for "fine" lines and pretty "passages" of paint remains to the end. Duchamp, like his brother Jacques Villon, never could resist the temptations of Paris *cuisine* picture-making: the juicy impastoes and chocolate-cream shadows that finally choked a whole tradition. (It is possible that Duchamp gave up painting not as an exemplary act of will, but out of fatigue and disgust with an over-indulged talent that kept producing the paint that cloys.)

As a painter, Duchamp deserves a little room, with a representative cross-section, in the Municipal Museum of his native village, Blainville—well, maybe of the nearby big town, St. Lo.

Counterpoint 1: *The Big Glass, Network of Stoppages* [Fig. 15], and *Tu m'* are extraordinary accomplishments. B painting the first one on glass, he was able to constrain his virtuosity and let the strength of his forms come through. In *Network*, by working with scraped-over pictures, he combined three intellectual exercises into a palimpsest whose layers of meaning miraculously lock into coherence. In *Tu m'*, he mimicked craftsmen methods; in fact a sign-painter was hired to execute a central detail (this idea is directly borrowed from the poet Raymond Roussel, who deeply influenced both Duchamp and Picabia). Again he avoided the *patisserie* effect and was able to concentrate on what was happening on the surface of his elaborate image. In a strict sense, these masterpieces are not paintings at all (one recalls Willem de Kooning's remark, "Duchamp is no art-lover"): they are marvels, like the amazing objects that used to be collected in princely *Wunderkammer* where unicorn horns and bits of meteorite were prized alongside illuminated manuscripts and Renaissance panels. Modern art (as will be noted later) has a weakness for excessive purity; Duchamp's great works are monuments to the perils of simplification.

Point 2: Duchamp organized and agitated a middle-brow cult of anti-art.

Counterpoint 2. In order to remain creative, modern art needs a critical destructive side.

Point 2: Anti-art, as promulgated by Dada in war-beset Zurich, stayed within the anti-style tradition that goes back to Courbet in the history of modern art. Dada was nihilistic, radical, idealist. It attacked esthetic conventions, mannerisms and customs and, beyond them, the whole rotten official establishment. It was outraged at injustice, at a middle-class leadership that was proving itself bloodthirsty in war and

corrupt in government. "Savage indignation" lacerated the Dada breast. On the other hand, Marcel Duchamp's own brand of home-made Dada giggles at art in cahoots with the artist's chosen audience.

Duchamp's "ready-mades" are a product of his "flair" (to quote R. Hamilton) for the object. He has that interior-decorator's eye which spots beautiful items in the dingiest flea-market. When Duchamp sent a commonplace or despicable object to an art exhibition (the hat rack or the urinal), it was an anti-art gesture at modern sculpture, but the additional twist for his fan-club was that the object really *is* beautiful in itself. And probably better executed technically than much contemporary modernizing art. In this sly irony, Camp Art was born. (Some readers may not have kept track of recent discussions on "Camp" in fashion and literary circles. The term originated in homosexual slang and denotes a man who, say at a party, will act more effeminately than he usually does, making an insiders' joke with the other homosexuals in the room. Its more general usage applies to any art in which the artist exaggerates his own traits, in conspiracy with his audience. For example, an eight-hour "underground" movie by Andy Warhol is boring, but his friends are delighted to understand that Warhol meant it to bore. Or a young writer announces a poem called *Chic Death* and his intimates know beforehand that it will be so bad that it's good. Or a fashion-designer will have an elephant's foot for an umbrella-stand in his salon. There is also heterosexual Camp: Thomas Benton's Wild-Midwest, Chagall's Riviera *shtetl*. Marcel Duchamp is, I believe, the first artist to enter into this kind of compact with his audience. Two generations of Surrealists, Beats and Pop-Artists have followed his lead.)

Camp Art is the perfect expression of the artist as a man of the world. It is trivial because of its reliance on a built-in audience; it exists in the smirk of the beholder.

Counterpoint 2: Dada anti-art, in its very ambition, overshot the artists' world. No matter how nobly they may be shredded, paper collages, sad to say, topple no governments. Duchamp's anti-art zeroed in on Art—at the paintings and sculptures being done by his colleagues. He served the vital function of adding vinegar.

Modern art, in Duchamp's lifetime, became increasingly separate from all classes of society. Artists concentrated on the spectacular discoveries of events unfolding on the picture plane and within their psyches and the inter-connection new insights might suggest. In a half-century of immensely creative production, modern painting broke with its past and exploited new ideas at a breakneck pace. In the process, the artist became his own hero, and some of the hymns to himself sounded more sentimental than convincing. Minor artists became

guardian-priests of artist-heroes; cults and dogmas were propagated. Art became Holy—a thing in a temple.

Duchamp grasped the fact that the avant-garde would have to be led by an anti-hero, a Voltaire for the new religions. His ready-mades are catalysts to precipitate the baloney-content out of High Art. *Mona Lisa* needed that mustache. Duchamp mocked the pompous metaphysics of geometric abstraction, the decorative pretensions of Synthetic Cubism, the ersatz lyricism of School-of-Paris brushwork. "Sure, I like Duchamp," a senior modern painter remarked recently, "he's been our enemy all my life!" But Duchamp the In-Art-We-Trust-Buster has helped every young painter. This, probably, is what de Kooning meant when he said that he didn't know where he was going, but it was on the same train as Marcel Duchamp.

If New-Realist assemblager Arman wants a Duchamp sentence in facsimile as his catalogue foreword (it reads: *La vache à lait lêche Arman, songe-je"*—or, "I think the milch-cow is licking Arman—with possible puns around *La Vache! Allez légèrement*—"Damn it, go slowly"—or *Mensonge*—"Lie," etc.), Duchamp supplies a cocked snoot which exposes the tedium of the art-critical bowings and scrapings that usually mark such pages.

Without destructive criticism, art could smother in its own drek.

Point 3: Duchamp disastrously has confused art with life. He stopped painting, but stuck to the art-world. He tries to turn himself into a masterpiece, and through his example, has been a corruptor of youth.

Counterpoint 3: Duchamp expresses the independence of a pellucid French temperament. He has every right to do as he pleases and cannot be blamed for the stupidities of his epigones. After all, one of his pseudonyms is "Sélavy" ("that's life").

Point 3: When Rimbaud gave up poetry, he went to Africa, made a new life as an explorer and gun-runner. He gave a profound meaning to his decision. When Duchamp in 1923 renounced art for chess (Rimbaud as well as Roussel must have been on his mind at this time), he proclaimed that painting was bankrupt, but he never quit the company of art patrons. On the contrary, he became his own priest —and everybody's pal. He arranged art exhibitions, lectured at art conferences, served on art juries. He re-edited his own expensive limited art editions. He designed art magazine covers and art gallery announcements. Art, art, art, art, art. He made little doodles, cutouts and objects—one or two a year—and gave them to friends as seriously as John D. Rockefeller, Sr. presented dimes to caddies. Certainly one of the less attractive compulsions of Duchamp is his inability to let

anything get lost. He clasps each scrap he has marked in narcissistic passion. The result has been a massive accumulation of bric-a-brac and ephemera which Duchamp-lovers comb through and croon at with campy pedantry. If, in the future, he becomes St. Duchamp, his nimbus should be represented by an infinity of footnotes.

After abandoning art, he also insisted on remaining an Artist with the prerogative of naming anything he chooses to become "his" art. Following this example, hundreds of young and not-so-young artists have involved themselves with exhibitions of numb found-objects, with Happenings that never happen, with feeble protests in the form of subversive bon-mots at gallery openings. All these lost, grey souls, who hope that some day their life, too, will turn into a masterpiece, creep through a limbo made to the specifications of Marcel Duchamp. If Tolstoy were God in Heaven, Duchamp would be condemned to fry.

Counterpoint 3: Duchamp chose to become a leader of the avant-garde, and with the proud analytical intelligence that marks the great Frenchmen of his generation, he acted for a lifetime on his decision. Evolving his concepts with Joycean silence, exile and cunning, he has had the courage to push to the limits, but always in terms of the tact and cultivation that mark his sensibility. He reminds one of André Gide —who also was concerned with the gratuitous act. During the Nazi occupation of France, Gide studied the nuances of French grammar. He was sharpening his tools. Marcel Duchamp, in the same debacle, refined his complete works down to a size that would fit ingeniously into a small leather valise. There is nobility in such intellectual commitments, in these professional, unswerving stares at the logic of History.

Socrates, too, was accused of corrupting the youth, and he was given hemlock for using too much reason.

Duchamp is not responsible for the errors of his followers because they should have known that only Duchamp can be his own work of art. When Duchamp did it first, he did it last. That is his lesson. Those who have understood him make the same point: In the Beginning is—Originality.

Ten years ago, this writer discussed Jackson Pollock's recent pictures with Duchamp, who complained that Pollock still uses "paint, and we finished that," thus Pollock "never will enter the Pantheon!"

"Pantheon" seems a surprising goal for this celebrated agnostic, but if he wants it, probably his three masterpieces are more than sufficient reason for an apotheosis. And when they are invoked, future generations will also honor the free intelligence which they express. But no consecration can ever disguise how much excess-baggage this immortal will have to leave behind.

MARCEL DUCHAMP AND/OR
RROSE SÉLAVY

Donald Judd

Rrose Sélavy is all right, but I don't know about Duchamp. Johns is quoted in the catalogue quoting a *New Yorker* cartoon—"O.K., so he invented fire—but what did he do after that?" Duchamp invented several fires but unfortunately didn't bother with them. He hasn't been entirely quiet but has done very little since 1923. The work Duchamp does have is of course highly interesting, but its a mistake not to have developed it. His work and his historical importance are different things. It's to other people's credit to have developed his or related ideas. Good beginnings are fairly abundant; they aren't enough; the developed thing counts. Neither Duchamp's retirement nor his role as conservator of his own work is so admirable. This show isn't of all his work. It's the Mary Sisler Collection. It includes some original pieces and some from the Schwarz editions. There are also fifty early drawings and paintings—to 1911. Duchamp was born in 1887. These are done from the public domain; the drawings resemble Lautrec's and Manet's, and the paintings are influenced by Cézanne and the Fauves. *La Mariée Mise à Nu par Ses Célibataires Même* is dated July, 1912.* After that Duchamp is remarkable. The roto-reliefs and the ready-mades and assisted ready-mades are fine.

"Marcel Duchamp and/or Rrose Sélavy," by Donald Judd. This review of an exhibition at the Cordier and Ekstrom Gallery, New York City, is from *Arts Magazine*, XXXIX, No. 6 (March 1965), 53–54. Reprinted by permission of the Estate of Donald Judd.

* [*The Bride Stripped Bare by Her Bachelors, Even* (Fig. 17)—Ed.]

COUNTER-AVANT-GARDE

Clement Greenberg

*Das Gemeine lockt jeden: siehst du in
Kürze von vielen
Etwas geschehen, sogleich denke nur:
dies ist gemein.*

Goethe: *Venetian Epigrams*

The case of what passes nowadays for advanced-advanced art has its fascination. This isn't owed to the quality of the art; rather it has to do with its very lack of quality. The fascination is more historical, cultural, theoretical than it is esthetic. Not that no advanced art of superior quality is being produced at this time. It is, in the usual relatively small quantities. But it's not that kind of art that I call advanced-advanced art. Nor does superior art, in any case, have the kind of fascination I'm speaking of, which offers far more challenge to understanding than to taste. Here, understanding requires going to origins.

As we know, the production of art in the West divided itself over a century ago into advanced or avant-garde on one side and academic, conservative, or official on the other. All along there had been the few artists who innovated and the many who didn't. And all along the highest qualities of art had depended in crucial part on the factor of newness or originality. But never before the 1860's in France had the difference between decided newness and everything else shown itself so strikingly in high art. Nor had innovation ever before been resisted so stubbornly by the cultivated art public.

"Counter-Avant-Garde," by Clement Greenberg. From *Art International*, XV, No. 5 (May 20, 1971), 16–19. Reprinted by permission of Janice Van Horne. This is a revised and much expanded version of an Adolph Ullman Lecture given at Brandeis University, in Waltham, Massachusetts, on May 13, 1970.

That was when the present notion of the avant-garde was born. But for a while this notion did not correspond to a readily identifiable or definable entity. You might paint in imitation of the Impressionists or write verse like a Symbolist, but this did not mean necessarily that you had joined something called the avant-garde. It wasn't there definitely enough to join. You could join bohemia, but bohemia antedated the avant-garde and meant a way of life, not a way of art. The avant-garde was something constituted from moment to moment by artists— a relative few in each moment—going towards what seemed the improbable. It was only after the avant-garde, as we now recognize it, had been under way for some fifty years that the notion of it seemed to begin to correspond to a fixed entity with stable attributes. It was then that the avant-garde came into focus as something that could be joined. That was also when it first began to look like something really worth joining; by then enough people had awakened to the fact that every major painter since Manet, and every major poet since Baudelaire (at least in France), entered the maturity of his art as a "member" of the avant-garde. At this point, too, innovation and advancedness began to look more and more like given, categorical means to artistic significance apart from the question of esthetic quality.

The Italian Futurists may not have been the very first individuals to see the avant-garde and advancedness in this light, but they were the first to make the avant-garde, as seen in this light, a viable, ongoing notion and classification. They were the first to think in terms of avant-garde*ness*, and to envisage newness in art as an end in itself; and they were the first group to adopt a program, posture, attitude, stance that was consciously "avant-garde."

It was no accident (to talk as Marxists used to) that Futurism became the first manifestation connected with the avant-garde to win public attention more or less immediately, and that "Futuristic" became the popular adjective for modernist art. The Futurists announced, spelled out, and illustrated their intention of pursuing the new as no intention associated with avant-garde art had ever been before. (The sensation made at the New York Armory show in 1913 by Marcel Duchamp's *Nude Descending a Staircase* [Fig. 8] which resembles Futurist versions of Analytical Cubism, is a case in point: this work gave people enough cues to permit them to watch themselves being startled by the "new"—as they could not do with Picasso's, Braque's, Léger's, or even Matisse's newnesses in that same exhibition.)

The Futurists discovered avant-gardeness, but it was left to Duchamp to create what I call avant-gard*ism*. In a few short years after 1912 he laid down the precedents for everything that advanced-advanced art has done in the fifty-odd years since. Avant-gardism owes

a lot to the Futurist vision, but it was Duchamp alone who worked out, as it now looks, every implication of that vision and locked advanced-advanced art into what has amounted to hardly more than elaborations, variations on, and recapitulations of his original ideas.

With avant-gardism, the shocking, scandalizing, startling, the mystifying and confounding, became embraced as ends in themselves and no longer regretted as initial side-effects of artistic newness that would wear off with familiarity. Now these side effects were to be built in. The first bewildered reaction to innovative art was to be the sole and appropriate one; the avant-gardist work—or act or gesture—was to hold nothing latent, but deliver itself immediately. And the impact, more often than not, was to be on cultural habits and expectations, social ones too, rather than on taste. At the same time newness, innovation, originality itself was to be standardized as a category into which work, an act, a gesture, or an attitude could insert itself by displaying readily recognizable and generally identifiable characteristics or stimuli. And while the conception of the new in art was narrowed on one side to what was obviously, ordinarily, or only ostensibly startling, it was expanded on the other to include the startling in general, the startling as sheer phenomenon or sheer occurrence.

All along the avant-garde had been accused of seeking originality for its own sake. And all along this had been a meaningless charge. As if genuine originality in art could be envisaged in advance, and could ever be attained by mere dint of willing. As if originality had not always surprised the original artist himself by exceeding his conscious intentions. It's as though Duchamp and avant-gardism set out, however, deliberately to confirm this accusation. Conscious volition, deliberateness, plays a principal part in avant-gardist art: that is, resorting to ingenuity instead of inspiration, contrivance instead of creation, "fancy" instead of "imagination"; in effect, to the known rather than the unknown. The "new" as known beforehand—the general look of the "new" as made recognizable by the avant-garde past—is what is aimed at, and because known and recognizable, it can be willed. Opposites, as we know, have a way of meeting. By being converted into the idea and notion of itself, and established as a fixed category, the avant-garde is turned into its own negation. The exceptional enterprise of artistic innovation, by being converted into an affair of standardized categories, of a set of "looks," is put within reach of uninspired calculation. Avant-gardism was not all there was to Futurism, Dada, or Duchamp—even to the post-1912 Duchamp. It's far from being all there was to Surrealism either, though Surrealism did more even than Futurism to popularize avant-gardism. But it's doubtful whether even in Surrealism's heyday, in the latter 1920's and in the 1930's, avant-gardism took hold in artistic practice as thoroughly as it had among

a few adventurous or would-be adventurous artists at the time of Dada. For all the designed "aberrations" of Surrealist art, there was hardly a Surrealist artist of consequence who sacrificed his *taste* to the sole effect of the innovative.

In the latter 1940's and in the 1950's, when Abstract Expressionism and *art informel* were in the ascendant, avant-gardism receded even further from actual artistic practice. The worst of the artists caught up in these tendencies (and they were legion) as well as the best (they were a handful) were genuinely avant-garde, not avant-gardist, in aspiration, whether they knew it or not. They wanted their works to function as art in the "traditional" sense that avant-gardism often professed to repudiate.

This may sound surprising to some people. If so, it's because they haven't looked closely enough at Abstract Expressionist or *informel* painting and/or because they've taken on faith too much of what's been written and said about them. (The very term, *art informel*, expresses and forces a misunderstanding, not to mention "Action Painting.")

Almost all new manifestations of art get misunderstood in the first attempts to explain them, and usually they stay misunderstood for a good while after. This was so long before the avant-garde appeared, but it has become ever so much more so since then. With avant-gardism, however, there has come *forced* misunderstanding—aggressive, inflated, pretentious misunderstanding. Avant-gardism, even today, is planted deeper and more broadly in the talk and writing about art than in its practice. And it planted itself in the talk and the writing earlier, appearing in Apollinaire's art criticism before it ever did in Futurist practice or attitudinizing. What Apollinaire wrote on behalf of Cubism foretold in many respects what was later written on behalf of Dada, Surrealism—and Abstract Expressionism. The palaver of the 1950's about absolute spontaneity, about the liberation from all formal constraints, and about breaking with the whole past of art—all this wasn't just part of the ordinary muddlement that has affected talk about art ever since people first tried to account for it. It emerged, as *applause*, only with avant-gardist rhetoric. Maybe the most constant topic of avant-gardist rhetoric is the claim made with each new phase of avant-garde, or seemingly avant-garde, art that the past is now being finally closed out and a radical mutation in the nature of art is taking place after which art will no longer behave as it has heretofore. As it happens, this was already said more or less about Impressionism in its time, and it was also said about every next step of modernist art—but it was said then only in condemnation and opposition. Not till around 1910 did the same thing begin to be said in praise and welcome. Again—as with the business of pursuing originality for its

own sake—it was as though avant-gardism were trying deliberately to confirm a standard charge against the avant-garde.

A key figure in the Abstract Expressionist situation was Jackson Pollock. I mean a key figure—aside from the value of his art—as looked back at in the light of what has most conspicuously happened in art since Abstract Expressionism. Pollock's all-over "drip" paintings of 1947–50 were in their time taken for arbitrary effusions by his fellow-Abstract Expressionists as well as by almost everybody else. These fellow-artists may have basked in avant-gardist rhetoric about total "liberation," and they may have indulged in that kind of rhetoric themselves, but—as I've said—at bottom they still believed in, and acted on, painting as a discipline oriented to esthetic values. Because they could discern little or nothing of these in Pollock, they did not consider him to be a "real" painter, a painter who *knew* how to paint, like a de Kooning, a Kline, or a Rothko; they saw him, rather, as a freakish apparition that might signify something in terms of cultural drama but hardly anything in those of art proper. The younger artists who in the 1960's displaced the Abstract Expressionists on what's called the "scene" likewise saw Pollock's middle-period painting as freakish and inartistic, but instead of deploring that, they hailed it. They could no more "read" Pollock than their predecessors could, but they admired him all the more precisely because of that. And as the 1960's wore along and art went further and further out, Pollock's reputation became more and more a hallowed one, second only to Duchamp's in the pantheon of avant-gardism.

The conclusions the avant-gardist artists of the 1960's drew from their inability to grasp the art in Pollock got acted on in much the same way as those which Duchamp had drawn almost fifty years earlier from his inability to recognize the whole of the art in Cubism. He would seem to have attributed the impact of Cubism—and particularly of Picasso's first collage-constructions—to what he saw as its startling difficulty; and it's as though the bicycle wheel mounted upside down on a stool and the store-bought bottle rack he produced in 1913 were designed to go Picasso one better in this direction. Young artists in the 1960's, reasoning in a similar way from their misconception of Pollock's art, likewise concluded that the main thing was to look difficult, and that the startlingly difficult was sure to look new, and that by looking newer and newer you were sure to make art history. To repeat: it wasn't Abstract Expressionist art as such that helped bring on the great resurgence of avant-gardism in the 60's, but the misconceptions of it propagated by avant-gardist rhetoric and welcomed and maintained by younger artists of retarded, academic taste.

"Academic" is an unhelpful term unless constantly re-defined and

re-located. One of the notable things done by Charles W. Millard, in an article called "Dada, Surrealism, and the Academy of the Avant-Garde" which appeared in *Hudson Review* of Spring 1969, was to define and locate academicism as an aggressive tendency inside the precincts of the avant-garde, and not just a matter of imitativeness or belatedness. Mr. Millard specifies Dada and Surrealism as being in part an effort to "modify modernism, to make it 'easier,' and to reintroduce literary content." I would add that Dada and Surrealism, insofar as they were avant-gardist (Mr. Millard doesn't use this label), constituted a first attempt not just to modify, but to capture the avant-garde—from within as it were—in order to turn it against itself.

Academic qualms are omnipresent, like mold spores in the air. They arise from the need for security, which artists feel as much as other human beings do. Until recently any kind of art in which this need predominated declared itself more or less openly as academic. There were, of course, degrees and degrees; and it never was, and never will be, easy to distinguish among them. Yet when we look back it seems that it used to be easier to do so than it is now, when so many sheep have taken to wearing wolf's clothing.

In the 1950's old-time, self-evident academic art began to be pushed from the current foreground of the larger art public's attention by Abstract Expressionism and *art informel*. It was left to Pop art, however, to finish the job, in the early 1960's, and Pop art was able to finish it because it was more essentially, and viably, academic than Abstract Expressionism had ever been, even in its last and worst days. The current foreground was the natural habitat of academic art, and it was a habitat, moreover, that wouldn't tolerate any other kind of art. Having been thrust from that habitat in all its old guises, academic art rushed back in new ones. This marked the beginning of the present revival of avant-gardism. In the meantime the public attracted by whatever could be considered advanced art had grown enormously, so that by the early 60's it had come to coincide to all intents and purposes with the public for contemporary art in general. But this public, while it had a great appetite for the look of the advanced, turned out to have no more real stomach for the substance of it than any previous art public had.

Like Assemblage and Op, Pop art remained too tamely artistic, too obviously tasteful, to maintain for long the advanced-advanced look that avant-gardist art needed in order to be plausible. If academic sensibility were to continue to disguise itself effectively it would have to wear a much more physically, phenomenally new look, a more opaque and "difficult" one. Innovation was not supposed to be all that easy on taste. Again Duchamp was consulted, this time less for his "Pop" irony than for his vision of the all-out far-out—art beyond art,

beyond anti-art and non-art. This was what the past triumphs of the classic avant-garde, from Manet to Barnett Newman, had now—with help from avant-gardist rhetoric—prepared a new middlebrow consciousness for.

Academic sensibility has taken to cavorting in ways that seem to defy and deny all past notions of the academic. Doesn't the academic depend, always, on the tried and proven, and isn't every sort of untried and unproven thing being adventured with here? Well, just as there's almost nothing that can't (under sufficient pressure of both taste and inspiration) be turned into high and original art, so there's almost nothing that can't be turned immediately into academic (or less than academic) art: nothing that can't be conventionalized on the spot, including unconventionality itself. It's one of avant-gardism's great theoretical services to have demonstrated that the look, at least, of the unconventional, the adventurous, the advanced, can be standardized enough to be made available to the tritest sensibility.

But you can still wonder exactly why it is that all the phenomenal, configurational, and physical newness that abounds in art today should evince so little genuinely artistic or esthetic newness—why most of it comes out so banal, so empty, so unchallenging to taste. In the past phenomenal newness used almost always to coincide with authentic artistic newness—in Giotto's or Donatello's case, really, as much as in Brancusi's or Pollock's. Why does the equation between phenomenal and esthetic newness no longer seem to hold today?

In some part this question resolves itself into one of context. All art depends in one way or another on context, but there's a great difference between an esthetic and a non-esthetic context. The latter can range from the generally cultural through the social and political to the merely sexual. From the start avant-gardist art resorted extensively to effects depending on an extraesthetic context. Duchamp's first Readymades, his bicycle wheel, his bottlerack, and later on his urinal, were not new at all in configuration; they startled when first seen only because they were presented in a fine-art context, which is a purely cultural and social, not an esthetic or artistic context. (It doesn't matter in this connection that the "influence" of Cubism can be detected in the choice of the bicycle wheel and the bottlerack.) But of "context" art, more a little later.

There are, however, other varieties of avant-gardist art that do not rely on extrinsic context, and which do aim at intrinsic visual or situational originality: Minimal art (which is not altogether avant-gardist), technological, "funky," earth, "process," "systems," etc., etc. These kinds of art more emphatically pose the question of why phe-

nomenal novelty, and especially spectacular phenomenal novelty, seems to work nowadays so differently from the way it used to.

Among the many things that highly original art has always done is convert into art what seems to be non-art. Avant-garde art called attention to this supposed conversion in more obvious and striking ways than any art before it had—at least any urban art. It was as though the line between art and supposed non-art receded faster for the avant-garde, and that at the same time the latter had to push harder and harder against that line. As I've already said: to most people at the time, the first full-blown Impressionist paintings seemed to break with everything previously considered pictorial art and to remain "non-art" objects; this, the "non-art" reaction, was provoked by every subsequent move of modernist art and, like other such standard reactions to it, was finally adopted by avant-gardism as something to be welcomed.

But Duchamp's Readymades already showed that the difference between art and non-art was a conventionalized, not a securely experienced difference. (As they also showed that the condition of being art was not necessarily an honorific one.) Since then it has become clearer, too, that any thing that can be experienced at all can be experienced esthetically; and that any thing that can be experienced esthetically can also be experienced as *art*. In short, art and the esthetic don't just overlap, they coincide (as Croce suspected, but didn't conclude). The notion of art, put to the strictest test of experience, proves to mean not skilful making (as the ancients defined it), but an act of mental distancing—an act that can be performed even without the help of sense perception. Any and everything can be subjected to such distancing, and thereby converted into something that takes effect as art. There turns out, accordingly, to be such a thing as art at large, art that is realized or realizable everywhere, even if for the most part inadvertently, momentarily, and solipsistically: art that is private, "raw," and unformalized (which doesn't mean "formless," of which there is no such thing). And because this art can and does feed on anything within the realm of conceivability, it is virtually omnipresent among human beings.

This "raw," ubiquitous art doesn't as a rule move anybody more than minimally on the esthetic level, however much it might do so on the level of consolation or therapy or even of the "sublime." It's literally and truly minimal art. And it's able to remain that because in its usual privacy it is sheltered from the pressure of expectations and demands. Art starts from expectation-and-satisfaction, but only under the pressure of heightened expectation—expectation as schooled and heightened by sufficient esthetic experience—does art lift itself out of

its "raw" state, make itself communicable, and become what society considers to be art proper, public art.

Duchamp's "theoretical" feat was to show that "raw" art could be formalized, made public, simply by setting it in a formalized art situation, and without trying to satisfy expectations—at least not in principle. Since Duchamp this formalizing of "raw" art by fiat has become a stereotype of avant-gardist practice, with the claim being made, always, that new areas of non-art are being won for art thereby. All this has actually amounted to, however, is that public attention is called to something that was art to begin with, and banal as that, and which is made no more intrinsically interesting by being put into a recognized art context. New areas are thereby won not for art, but only for bad formalized art. The esthetic expectations to which art by fiat is directed are usually rudimentary. Surprise, which is an essential factor in the satisfaction of more than minimal esthetic expectations, is here conceived of in relation mainly to nonesthetic ones, and derives only from the act of offering something as formalized art that's otherwise taken to be, and expected to be, anything but art—like a bicycle wheel or a urinal, a littered floor, or the temperature multiplied by the barometric pressure in a hundred different places at the same time or at a thousand different times. (Or else the surprise comes from reproducing or representing objects in incongruous materials or sizes, or from affixing incongruous objects to pictures, or from offering reproductions of photographs as paintings, and so on, with the stress being always put on incongruity in the "material mode." And though there's nothing that says that *stressed* incongruity can't be an integral esthetic factor, it has hardly ever managed to be that so far except in literature.)

The issue for art is not merely to extend the limits of what's considered art, but to increase the store of what's experienced as "good and better" art. This is what extending the "limits" of art meant for the classic avant-garde. The issue remains quality: that is, to endow art with greater capacity to move you. Formalization by itself—putting a thing in a public art context—does not do this, or does it only exceptionally. Nor does surprise for the sake of surprise do this. Art, as I've said, depends on expectation and its satisfaction. It moves and satisfies you in a heightened way by surprising expectation; but it does not do so by surprising expectation *in general;* it does what it does best by surprising expectations that are of a certain order. By conforming to these even as it jars them, artistic surprise not only enhances esthetic satisfaction, but also becomes a self-renewing and more or less permanent surprise—as all superior art shows.

Superior art comes, almost always, out of a tradition—even the superior art that comes early—and a tradition is created by the inter-

play of expectation and satisfaction through surprise as this interplay operates not only within individual works of art, but between them. Taste develops *as* a context of expectations based on experience of previously surprised expectations. The fuller the experience of this kind, the higher, the more truly sophisticated the taste. At any given moment the most sophisticated, the best taste with regard to the new art of that moment is the taste which implicitly asks for new surprises, and is ready to have its expectations revised and expanded by the enhanced satisfactions which these may bring. Only the superior artist responds to this kind of challenge, and major art proceeds as one frame of expectations evolves out of, and includes, another. (Need I remind anyone that this evolution, for all its cumulativeness, does not necessarily mean "progress"—any more than the word, "evolution," itself does?)

The superior artist acquires his ambition from, among other things, the experience of his taste, his own taste. No artist is known— at least not where the evidence is clear enough—to have arrived at important art without having effectively assimilated the best new art of the moment, or moments, just before his own. Only as he grasps the expanded expectations created by this best new art does he become able to surprise and challenge them in his own turn. But his new surprises—his innovations—can never be total, utterly disconcerting; if they were, the expectations of taste would receive no satisfaction at all. To repeat in different words what I've already said: surprise demands a context. According to the record, new and surprising ways of satisfying in art have always been connected closely with immediately previous ways, no matter how much in opposition to these ways they may look or actually have been. (This holds for Cavallini and Giotto as well as for David and Manet, and for the Pisanos as well as for Picasso as constructor and sculptor.) There have been no great vaults "forward," no innovations out of the blue, no ruptures of continuity in the high art of the past—nor have any such been witnessed in our day. Ups and downs of quality, yes, but no gaps in *stylistic* evolution or nonevolution. (Continuity seems to belong to the human case in general, not just to the artistic one.)

The academic artist tends, in the less frequent case, to be one who grasps the expanded expectations of his time, but complies with these too patly. Far more often, however, he is one who is puzzled by them, and who therefore orients his art to expectations formed by an earlier phase of art. The unique historical interest of Duchamp's case lies in his refusal, as an academic artist of the second kind, to follow this second way, and in his deciding, instead, to wreak his frustration on artistic expectations in general. As well as by scrambling literary and cultural with visual contexts he tried to disconcert expectation

by dodging back and forth between pictorial and sculptural ones (as he must have thought Picasso was doing in his collage-constructions).[1]

Again, there's nothing necessarily wrong or qualitatively compromising in the juggling of expectations between one medium and another. The classic avant-garde's emphasis on "purity" of medium is a time-bound one and no more binding on art than any other time-bound emphasis. What's been wrong in the avant-gardist juggling of expectations is that the appeal from one frame of expectations to another has usually been away from the most sophisticated expectations working in one medium to less sophisticated ones operating in some other. It's a lesser pressure of literary taste that the Pop artist appeals to as against a higher pressure of pictorial or sculptural taste; it's a lower pressure of pictorial taste that the Minimalist artist appeals to as against a higher pressure of sculptural taste. The invoking of the literary three-dimensional in a two-dimensional context (as in the shaped canvas), and of the two-dimensional in a three-dimensional context (though there are strong exceptions here) has meant, in general, the attempt to evade the highest going pressures of taste, and at the same time to disguise this. Which is maybe the most succinct way of all of describing avant-gardism in any of the arts—those of literature and music and architecture as well as of painting and sculpture.

For good reasons, the drift of avant-gardist medium-scrambling in visual art has been more and more towards the non-pictorial and three-dimensional. Now that utter abstractness is taken for granted, it has become more difficult to approach the "limits" of art in a pictorial context; now everything and anything two-dimensional states itself automatically as pictorial—a stretch of mud (in bas-relief) as well as a blank wall or blank canvas—and thus exposes itself immediately and nakedly to pictorial taste. (Some awareness of this lies behind the recent cry that painting is "finished.") On the other hand, taste, even the best taste, appears to function far more uncertainly nowadays in the area of the three-dimensional than in that of the two-dimensional. The difference between abstract sculpture (or "object"-making) and "non"-art still seems relatively tenuous. Experience of sculpture has not yet produced an order of expectations that would help the eye firmly separate abstract sculpture not only from architecture and utilitarian design, but even from three-dimensional appearances at large. (This may help account for the repeated disappointments of abstract sculpture so far.) Something like a break in the continuity of sculptural taste has

[1] In all fairness to Duchamp as an artist I should point out that he did several things—the "straight" painting, *Network of Stoppages*, of 1914, and the *Glasses* of a little later date—that achieve genuinely large, even major quality, and that are also prophetic in the way that they make a virtue out of their opposition to Synthetic Cubism. In those years, Duchamp could fall into inspiration.

appeared: something that looks, even, like a vacuum of taste. This ostensible vacuum has come in opportunely for academic sensibility that wants to mask itself. Here is the chance to escape not just from strict taste, but from taste as such. And it's in this vacuum that avant-gardist art has produced, and performed, its most daring and spectacular novelties. But this vacuum also explains, finally, why they all come out so un-new, why phenomenal and configurational innovation doesn't coincide the way it used to with the genuinely artistic kind.

Art that realizes—and formalizes—itself in disregard of artistic expectations of any kind, or in response only to rudimentary ones, sinks to the level of that unformalized and infinitely realizable, sub-academic, sub-*kitschig* art—that sub-art which is yet art—whose ubiquitousness I called attention to earlier. This kind of art barely makes itself felt, barely differentiates itself, as art because it has so little capacity to move and elate you. Nor can any amount of phenomenal or configurational novelty increase this capacity in the absence of the control of informed expectations. Ironically enough, this very incapacity to move, or even interest, you—except as a momentary apparition —has become the most prized, the most definitive feature of up-to-date art in the eyes of many art-followers. Some recent art that happens not at all to be avant-gardist in spirit gets admired precisely when it fails to move you and because of what makes it fail to do so.

But to adapt that saying of Horace's again: you may throw taste out by the most modern devices, but it will still come right back in. Tastefulness—abject good taste, academic taste, "good design"—leaks back constantly into the furthest-out as well as furthest-in reaches of the vacuum of taste. The break in continuity gets steadily repaired. Finally it turns out that there has not really been a break, only the illusion of one. In the showdown abstract sculpture does get *seen*, and does get judged. The vacuum of taste collapses.

The inexorability with which taste pursues is what avant-gardist art in its very latest phase is reacting to. It's as though Conceptualist art in all its varieties were making a last desperate attempt to escape from the jurisdiction of taste by plumbing remoter and remoter depths of sub-art—as though taste might not be able to follow that far down. And also as though boredom did not constitute an esthetic judgment.

ROBERT SMITHSON ON DUCHAMP, AN INTERVIEW

Moira Roth

Why did you say you were interested in talking about Duchamp?

Well, for one thing, I think in America we have a certain view of art history that comes down to us from the Armory Show, and Duchamp had a lot to do with that history. There is a whole lineage of artists coming out of the Armory Show. And the notion of art history itself is so animated by Duchamp. The prewar period was dominated by Matisse and Picasso and the post-World War II period was dominated by Duchamp. Hard-core modernism is Picasso and Matisse and T. S. Eliot and Ezra Pound. Then, in the postwar period, we get Duchamp coming on very strong. Duchamp is really more in line with postmodernism insofar as he is very knowledgeable about the modernist traditions but disdains them. So, I think there is a kind of false view of art history, an attempt to set up a lineage. And, I would like to step outside that situation.

There has been a kind of Duchampitis recently, beginning with Duchamp's being rediscovered in Jasper Johns. But Johns is less French and more ratty, you might say. Johns has taken the aristocratic stance and given it a more sordid edge. Then you have this influence pervading Robert Morris' work. But there is no viable dialectic in Duchamp because he is only trading on the alienated object and bestowing on this object a kind of mystification. Duchamp is involved with the notion of manufacture of objects so that he can have his little valise full of souvenirs. I am not really interested in that kind of model making: the reiteration of the Readymades. What I am saying is that Duchamp offers a sanctification for alienated objects, so you get a

"Robert Smithson on Duchamp, an Interview," by Moira Roth. From *Artforum*, XII, No. 2 (October, 1973), p. 47. © *Artforum*, October 1973, "Robert Smithson on Duchamp, An Interview," by Moira Roth.

generation of manufactured goods. It is a complete denial of the work process and it is very mechanical too. A lot of Pop art has to do with this—the transcending in the Readymades. In a sense, Rosenquist is transcending billboards, Warhol is transcending canned goods, and Jim Dine is transcending tools that you buy in hardware stores—Duchamp's influence is quite pervasive on that level. Duchamp is trying to transcend production itself in the Readymades when he takes an object out of the manufacturing process and then isolates it. He has a certain contempt for the work process and here, I think he is sort of playing the aristocrat. It seems that this has had a great deal of effect on New York artists.

Do you think of him as a Dandy in a Baudelairean sense?

Yes, I think there is some of that. I think that it has always had a certain appeal because the artist to a certain extent is always trying to transcend his class, and I think Duchamp is involved in that. At one point, he even said that he would rather kings were patrons, so that he indicated that he considered art fascistic.

You said there was no viable dialectic in Duchamp, is there one in your work?

Yes, I think so. In my early works I was not really Minimal; the works were more related to crystallized notions about abstraction. So there was a tendency toward abstraction, but I never thought of isolating my objects in any particular way. Gradually, more and more, I have come to see their relationship to the outside world, and finally when I started making the Nonsites, the dialectic became very strong. These Nonsites became maps that pointed to sites in the world outside the gallery, and a dialectical view began to subsume a purist, abstract tendency.

I don't think Duchamp had a dialectical view. In other words, I am saying that his objects are just like relics, relics of the saints or something like that. It seems that he was into some kind of spiritual pursuit that involved the commonplace. He was a spiritualist of Woolworth, you might say. He seemed dissatisfied with painting or what is called high art. Somebody like Clement Greenberg is opting for high art or modernism from a more orthodox point of view, but Duchamp seems to want to be playful with that modernism. He doesn't see it as absolute. It is like a mechanistic view. He also strikes me as Cartesian in that respect, and I think he once mentioned in an offhand way that he was. Duchamp seems involved in that tradition and in all the problems of that tradition.

Duchamp was suspicious of this whole notion of mechanism, but he was using it all the time. I don't happen to have a mechanistic view

of the world so I really can't accept Duchamp in terms of my own development. There is a great difference between a dialectical view and a mechanistic view. Andy Warhol saying that he wants to be a machine is this linear and Cartesian attitude developed on a simple level. And I just don't find it very productive. It leads to a kind of Cartesian abyss.

Duchamp's involvement with da Vinci—his putting a moustache on the *Mona Lisa*—seems to be an attempt to transcend another artist who is very close to his view. They both have mechanistic ideas of nature. But in Duchamp's mechanistic view, there is nothing pragmatic or useful in the way it was with da Vinci. In Duchamp, it leads to a kind of Raymond Roussel. Of course, Duchamp was influenced by Roussel and it is more or less taking the mechanistic view to an almost fantasy level. Take the *Large Glass* [Fig. 17] which seems to be an attempt to try and mechanize the sex act in what you would call a witty way.

Conceptual art too is to a certain extent somewhat mechanistic though the whole conceptual situation seems rather lightweight compared to Duchamp. Sol LeWitt coined the term "conceptual" and Sol LeWitt says ideas are machines. So this mechanistic view permeates everything. And it seems that it is just reducing itself down to a kind of atrophied state. A lot of it just evolves into what Mel Bochner might call joke art; playing little jokes like the Dadaists. But you see, the Dadaists were setting up their own religion, thinking that everything was corrupted by commercialism, industry, and bourgeois attitudes. I think it is time that we realized that there is no point in trying to transcend those realms. Industry, commercialism, and the bourgeoisie are very much with us. And this whole notion of trying to form a cult that transcends all this strikes me as a kind of religion in drag. I am just bored with it, frankly. In that, there is a kind of latent spiritualism at work in just about all of modernism. There is the guilt even about being an artist. To return to Duchamp, at bottom I see Duchamp as a kind of priest of a certain sort. He was turning a urinal into a baptismal font. My view is more democratic and that is why the pose of priest-aristocrat that Duchamp takes on strikes me as reactionary.

You said you sometimes talked with Carl Andre about Duchamp?

Yes, Andre's view is more a Marxist one. Andre himself seems to want to transcend the bourgeois order, and Carl more or less sees Duchamp as responsible for the proliferation of multiples and this sort of thing. Where I tend to agree with Andre is when he says that Duchamp is involved in exchange and not use value. In other words, a Readymade doesn't offer any kind of engagement. Once again it is the alienated relic of our modern postindustrial society. But he is just

using manufactured goods, transforming them into gold and mystifying them. That is where alchemy would come in. But I see no reason to extrapolate that in terms of the arcane language of the Cabala.

Then you are not interested in the occult interpretations of Duchamp by Jack Burnham and Arturo Schwarz?

I am just not interested in the occult. Those kinds of systems are just dream worlds and they are fiction at their best and at worst, they are uninteresting. By the way I met Duchamp once in 1963 at the Cordier-Ekstrom Gallery. I just said one thing to him, I said, "I see you are into alchemy." And he said, "Yes."

How do you feel about Duchamp's chess playing?

Well, it has aristocratic connotations. It is also a luxury that I wouldn't really be too inclined to pursue myself, anymore than I would want to sit around and play monopoly.

What do you think Duchamp's attitude toward America was?

I think Duchamp is amused by a certain kind of American naiveté, and he constantly makes references to certain functional aspects, like the statement about his being impressed by American plumbing and that sort of thing. That seems to me a kind of inverted snobbism. And I find his wit sort of transparently French. French wit seems to me very different from an English sense of humor. If the French have any wit at all, I don't really appreciate it. They always seem very laborious, opaque, and humorless so that when you get somebody like Duchamp who is putting forth the whole art notion of the amusing physics or the gay mathematics, or whatever you want to call it, I am not amused. It is a kind of Voltarian sarcasm at best.

JOHNS AND DUCHAMP

Max Kozloff

Achievement in modern art, for better or worse, is invariably meas-
ured in terms of the idea of originality, despite the truism that utter
originality or its opposite can never be attained. Calibrated then by
its initial shock value, the work of Jasper Johns has rocketed high,
and justifiably, on the scale of innovation. And gauged by its wide
impact on the art of American painters even younger than himself,
Johns's production can already be said to have historical stature. With
both these facts I can hardly disagree—precisely because they are
facts. But I do take issue with the standard of originality, of unre-
deemed uniqueness, as applied to Johns, since, like many important
artists, he is, in a major sense, traditional, eclectic, and backward
looking. Indeed, one of the greatest ironies of his recognition has been
his imaginative break-through into the unoriginal.

On the strength of his retrospective at the Jewish Museum (di-
rected effectively by Alan Solomon), one might size up Johns's con-
tribution thus far as the introduction of an anti-rational sensibility
embodied by closed, precise, identifiable forms (an interesting enough
combination) into the great but waning wave of Abstract-Expression-
ism. Yet neither current of Johns's impulse is in the least new. In com-
mon most notably with his brother artist Rauschenberg he tunes his
eye with the reverberations of the great movements of twentieth cen-
tury art: Cubism, Futurism, and Dada. Just as one of the obstacles to
appreciation of these two artists has been their refusal to restrict mean-
ings (in an atmosphere that prides itself on austerity of concept), so
another forms by their subterranean linkage with European main-
stream art. That which in Johns was always thought to be the force

"Johns and Duchamp," by Max Kozloff. From *Art International*, VIII, No. 2 (March 20,
1964), 42–45. Reprinted by permission of the author.

of his rejection of the past is in reality his melding of past ingredients, and his demonstration that the ends of an earlier artist can become *his* means, is his own subtle definition of originality. The man who allowed Johns to realize this is Marcel Duchamp.[1]

It is at first a little difficult to capture the flavor of their relationship. Gorky's admiration for Picasso during the thirties suggests itself as a parallel. But if Gorky's style was a kind of vital carbon of Picasso's, Johns's comment on Duchamp is manifested as an obsessive charade. It is as if Johns had so taken over the contradictory, Pirandello personality of Duchamp that he had no alternative but to outflank and subvert him. In true Dada fashion Johns may be constrained to allude to the older artist, but simultaneously to evade him.

Under no circumstances can he therefore be thought merely to parody or quote his mentor. As Harold Rosenberg defined these activities, allusion is "the true ghostly principle of historical revival, since . . . the thing alluded to is both there and not there; while parody or quotation brings the original work forward either in a distorted form or as a passage in a different work." Since Johns is an "allusionist," he accords very well with Rosenberg's interesting thesis that painting (perpetuated by allusion) may be "the uneasy intuition of this epoch that 'real' art belongs to other times and places . . . but through which is asserted at the same time the counter-intuition that art is deathless and that it actually rises to new heights in becoming nothing else than the artist's experience of it. Allusion expresses both the despondency of modern art and its enthusiasm, its awareness of itself as 'counterfeit' as well as its clarified assurance of the inferior significance of all less history-conscious productions." With Duchamp as model, or at very least, point of greatest affinity, and all the obvious difference of history and background between them, Johns's allusiveness couldn't help but take on profound fascination.

There is, to begin with, some similarity in their precocious dissatisfaction with two great moments in painting—Duchamp's with Cubism, and Johns's with Abstract-Expressionism. From the matrix of these revolutionary visions, both Duchamp and Johns seceded in double time. Though Duchamp's was the more rabid, and Johns's the more wistful, removal, they have in common their main line of attack; the principle of *displacement*. By this one understands the transposition of an idea, motif or object from one context to another. Johns does not undertake a single work without operating by displacement, and attempting to widen its possibilities. The tag of anti-art,

[1] While it is impossible to discount his general familiarity with the more celebrated Duchamps prior to 1959, it was only after the publication of Robert Lebel's book on the artist in that year that Johns could have had detailed knowledge of Duchamp's production.

originally leveled at Duchamp, has here to be seriously rebutted, because a bottle rack or flag cannot be displaced without upholding, even elevating, the sanctity of art. Displacement is not a flat contradiction, but a departure having meaning only in being certified by the original proposal of art itself. And to abuse a spectator's response is also a method of confirming and counting on it. Johns, however, is not prepared to isolate the naked ready-made, e.g. to displace totally, and in this reserves for himself the more flexible strategy. Duchamp, more or less dispensing with painterly execution after 1913, constantly has to change each visible product while fixing the invisible premise of his work; Johns, innately pictorial, slyly alters and undermines the two.

Displacement, however, implies *discontinuity*, the second most important procedure shared by the two artists. Disintegration, divisiveness, fragmentation of a single, organic process of vision and construction, becomes a *modus operandi*. Johns's earliest targets, above which he compartmented plaster casts of dismembered human organs, were almost like an allegory of this situation. And when Leo Steinberg said that "Johns can put two things into a picture and make them work against one another so hard that nothing seems too far fetched to account for the shock received," he merely underlined an incongruity of subject matter, without which the Jewish Museum show would be inconceivable.

But far less familiar than such incongruity of subject (present in innumerable twentieth century artists from de Chirico on) is the discontinuous implementing of form and idea. Like Duchamp, Johns now writes notes and suggestions to himself, which, if they stop short of programming, imply very well that verbal ideas shade his whole mode of inquiry. As an example, one of them concerns attaching an object to a canvas, tracing its outline, and bending the object to reveal its original shape. It is a conception, translated into words, awaiting perhaps embodiment, or contrast by the totally sensuous medium of tangible paint, and then to be reconstituted as a poetic figuration. If the combination of calculated idea and spontaneous execution diverges from Duchamp, Johns's mental frame of mind nevertheless increasingly derives from him. Even in the note mentioned, one detects a Duchamp-like contrariness, and Johns's own stated procedure of thesis and antithesis, of making an inquiry and then seeing if its opposite is possible, has been remarkably adhered to. (For example, the numbers series, where, at one moment he virtually conceals the motifs under quasi-opaque paint, and at another conceals them by making them transparent and compressing them simultaneously in the same space.) Indeed, Johns himself makes us aware that compression can be a form

of discontinuity—if we normally see the objects, or use the processes under scrutiny, separately.

Here a basic distinction arises from the metaphoric disjunctions at work in the two artists. Setting one thing against another, as Roger Shattuck has observed, or one method against another, without supplying the connection, had been the exception until Duchamp. In his work, such contrast focussed all interest upon the element of choice, which perhaps tampered very little with the object, but made it very interesting by subjugating its identity. Johns, on the other hand, constantly invents or supplies unforeseen connections, without associating the objects (which, in his combine paintings at least, are humble and inconspicuous in placement). Duchamp ideates the objects; Johns, ways of seeing them. In Duchamp, the effect is self consuming, and tends to cancel itself out while reverting to a deal level, after shock. In Johns one is bounced back and forth between alternative readings in a self perpetuating experience which is the shock itself. To transubstantiate the picture into an object, as Johns does, and then to paint over the included objects (as in *Diver*) is perhaps to cast doubt upon certain conceptions of reality, but to contain that doubt as a visual encounter. In a Duchamp, even in *The Big Glass* [Fig. 17], there is no such containing dialectic, and therefore it purposefully repels that interpretive energy which Johns solicits, if only to fluster. But then, Duchamp merely says that everything in life is a ready-made. . . .

Parallels might be drawn here between sources the artists had immediately at their disposal. Thus Duchamp conceivably launches forth from the Cubist collage; while Johns possibly takes a hint from the imprints of newspapers pasted by de Kooning on wet oil surfaces, both however, as they do so, pulling out the decorative and stylistic wiring of the given materials. It is one of the shared discontinuities of Duchamp and Johns that they should not so much denigrate style as efface any outward manifestation of temperament. Choice and will, they both agree, can only have the desired force by being de-personalized. For only in figuratively eradicating themselves can their operations pretend to the magic timelessness of icons.

At this point in the Dada ethic enters the rather sinister didacticism of *chance*. It is perhaps coincidental, but not insignificant, that Duchamp claims to have chosen his ready-mades under complete anaesthesia, and that Johns fosters the idea that the flags first came to him in a dream. Such mythology underlines their diminishing of the role of consciousness. Duchamp, of course, goes further in his— usually self-destructive—affirmation of chance as a physical factor in his work. One thinks of his *Elevage de Poussière, Dust Breeding*, of 1920, or his acceptance of the breakage of *Le Grand Verre*, 1915–23.

As for Johns, the frame of reference shifts radically. Of this aspect of his work, Alan Solomon in the exhibition catalogue says: "Not that the artist involves himself and his own activity in the painting, but that he gives the world of the picture a potential of change and alteration in its own terms." And Solomon provides examples: "objects are attached loosely with wire so that they may swing, or they hang on magnets, and may be replaced, or the paint has been smeared or might be smeared by the movement of objects or hands." Johns actually has directed himself to "move the canvas against paint-smeared objects." This compares prettily with Duchamp's repugnant idea of the *Reciprocal Ready-Made,* consisting of a Rembrandt as an ironing board.

But perhaps the most salient, certainly a frequent, illustration of a chance technique in Johns is the measuring stick rotated in paint. I have few doubts of the origin of this motif in the substitution of a stick for the string the artist had originally used in drawing a circle; but I am amazed nevertheless at the similarity of the results to Duchamp's *Rotative Plaque Verre* (*Optique de Précision*), 1920. Or rather, the allusiveness of the results, because the Johns device remains the testimony of a past action, rather than the operative present action. In any event, the activated object produces an effect not merely different in kind but unforeseen and chance-ridden, when compared with the immobile object. Johns summarizes two states of being—the movement is there, and not there. (Can we see in both rotations, I wonder, an added allusion to Futurism, as, say, in Carra's *Free Word Painting* of 1914?) Once again, however, one finds Johns characteristically invading and altering paint matter itself, and in this retaining one of the major tenets of Abstract Expressionism. Pollock, after all, used a stick to flip paint upon a canvas surface, and in a manner which everyone understood to strike a bargain with chance. But without relinquishing the expressiveness which was a goal of action painting, Johns de-individualizes and de-sensitizes the whole manoeuvre. This sudden muteness of an automatist element in Abstract Expressionism is an important deflection of the movement towards Dada—but a Dada irrevocably modulated in the process. By the minimum amount of manipulation Johns achieves the maximum amount of variation, not caring, but rather enjoying the fact that the variation is dumb.

Here it will be evident that any effective use of chance depends upon a determined system, the more sophisticated the better. The artist thereby does not control, but specifically characterizes the effect he produces. In this respect, Duchamp was fairly radical, because, while his individual creations were quite anarchic in development and idea, he early envisaged the possibility of reproducing them. The potentialities of the *reproducible,* in fact, constitute the most over arching of his legacies to recent American art (as well as a story incredibly

complex in itself). Doubtless reproduction was a method of demoting the uniqueness of his objects at the same time as promulgating his ideas. His activities here fall into two categories: reincarnations of lost or destroyed objects which are in no sense different from their originals—the bicycle wheel, the urinal; and facsimiles and photographs of his whole production, such as in the *Box in a Suitcase* [Fig. 26], which are different scaled reconstructions and records of the original works. All this makes possible, in a burst of brilliant paradox, the co-existence of allusion (to concepts), and literal quotation, of objects. As for specific treatment of the problem of organized chance, nothing equals Duchamp's *Green Box*, in which he had caused to have mechanically reproduced facsimiles of dozens of torn notes on scraps, and thus weirdly revoked his habitual self destructiveness. The machine manufactures a deliberate accident, and makes the unique commonplace—a singular turn of events. It is a sort of metaphysical transvestism.

Johns counters with those laboriously hand-made versions of the manufactured: flags, targets, and beer cans, in which he is not in the least anxious to conceal the traces and imperfections of brushstrokes. He makes the mass-produced unique. (Not, I should like to add, to make us see a banal object differently or freshly, but to accentuate the play of his imagination and metaphorical ingenuity.) In circumstances such as his *Three Flags*, 1958 (a veritable orgy of superimposed, self enlarging emblems), his individual handling itself seems aleatoric. In fact, one of Johns's extraordinary perceptions has been to present perfectly predictable structures by unpredictable means, so that a surface activity which would have appeared ordered and tame in an Abstract Expressionist painting looks intrusively random here. On other levels too the *Three Flags* is a perfect example of the multiplication of a specified form to achieve chance results. Each flag is a system of measured and fixed relationships which are suddenly lost when their scale is changed, and their placement is staggered in juxtaposition. Their broken continuities suggest Cubism and de Stijl, their patchy brushwork comes out of Abstract Expressionism, and their fascination with systems of chance has strong Dada precedents. The work is a monster of allusion. If one remembers, finally, that these are American flags—reproduced images—the artist will be seen questioning the nature of reality (specifically) by composing such an image with tangible paint strokes, and (generically) by opposing the reproduced and the random, both being compressed, dadaistically, into the same thing.

Johns indicates, however, that neither of these interpretations is enough to complete the statement which is for him the goal of the created work. Rather, the viewer, conventionally enough, is left with

the task of completion itself, but unfortunately also with insufficient visual clues to discharge it. Or perhaps too many. Thus, Johns will paint a map of the United States as if it were a landscape (as Harold Rosenberg suggests), stencil the names of the states as if they were on packing cases, and color the stencils in hues that "jump" or recede uncontrasted in their separate areas. A Johns painting is a series of cancellations as much as it is a sequence of additions. As he himself put it: "I am concerned with a thing's not being what it was, with its becoming something other than what it is, with any moment in which one identifies a thing precisely, and with the slipping away of that moment. . . ." In Johns *the object depicted, the final content, and the visual effect by no means coincide, or even mutually support each other.* With piquant irony he may even caption the instigated conflict with such picture titles as "No" and "Liar." And all this has been brought about by any one of his principles, say displacement or discontinuity, catching fire in a veritable contagion of meanings. (Speaking of displacement, incidentally, Alan Solomon says of the animated enough encaustic medium, that it "does not seem to participate fully in the energy we usually identify with 'action' painting.") Johns develops, unlike Duchamp, by extending the full gamut of his techniques through a single motif—a kind of theme with variations procedure, that might be continued with the next motif, or cross-referenced, but always introducing reproducible processes which have as their final impact the sabotage of all certainties, and the subversion of the mechanical.

Such is a brief sketch of the various issues that are brought up and articulated differently in the dialogue between Duchamp and Johns. Now, without in the least wishing to introduce the game of influence baiting, I do want to indicate the recurrence of less important elements, showing, for all that, how very well knit the continuity between the two artists is. Whether accidental or not, for instance, there are outright iconographical resemblances: the book (Duchamp's *Unhappy Ready-made*, Johns's *The Book*), the thermometer (Duchamp's *Why Not Sneeze*, Johns's *Thermometer*), and the yardstick (Duchamp's *Trois Stoppages-Étalon*° Johns's *Device*, as well as many other canvases employing that object). In addition one finds such mutual practices as the use of interchangeable contours (that is, one edge double-servicing two passages or entities) as in Duchamp's *Portrait*, 1911, and, say, Johns's *The Black Figure 5*. These latter, incidentally, are visual puns, quite echoed by verbal ones. How very Duchampesque, and yet typical, is Johns's notebook dictum *Onesty is the Pest Policy*. And as for Duchamp's idea of painting on the surface of a canvas the shadow

° [*Three Standard Stoppages* (Fig. 13)—Ed.]

cast by an object (the bottle opener in *Tu m'*) Johns recapitulates in *No*, exactly with the word "no." Finally, also in *Tu m'*, is one of the earliest appearances (1918) of that color scale (coming initially, probably, from Duchamp's brother, Jacques Villon) which was to fascinate Johns, Rauschenberg, and Jim Dine.

All these congruences, in themselves, have a great deal to tell about the climate of ideas in Johns's work, but when one considers how those ideas are embodied, their content virulently reverses Duchamp. For one thing, in each instance the object is overpainted, or functions or relates directly to a pictorial passage. Johns, after all, takes the temperature of a painting, not marble blocks, and the episode underlines his perpetual concern with language rather than subject, with a kind of poetry about the creative process rather than sexual or pseudo-scientific innuendo. If one had to choose the most epigrammatically Johnsian subject, my choice would be the *Painted Bronze* Savarin coffee can (1960) with its group of brushes glued in perpetuity, a sensitive nightmare about painting. Johns escalates most of Duchamp's contradictions into allegories of the nature of painting, in which it is necessary to annex objects of the outer world physically as well as conceptually. In his *Viola*, Johns has an inset panel which unhooks, drops down, reveals by its stretchers that it is a small picture, painted even on its back with the same mendacious grey as the larger picture, and then finally falls into place above a fixed fork and spoon, leaving a rectangle of blank wall where it had once occupied the surface. A painting is an object, and an object can be a painting, each a camouflage of the other. But one also has the blank wall as well, something Duchamp refused to acknowledge.

This intuition of nothingness, that is, of anything outside art, informs the disquieting charade which is the work of Jasper Johns. Life only exists for him on the easel, so to speak, and this charges the tissue of encaustic brush marks and veiny turped washes of his pictures with a pathos one would never have expected—as if the rectangle was the limit of personal nuance and sensibility itself. And yet, many of his works provide little crises of attention because they are so divisive thematically, and low-keyed emotionally, because they are so allusive and so abstract, and finally, so mental and so sensuous. One's responsiveness is spread-eagled by the very delicacy with which these factors are kept in solution, vibrating like a visual tuning fork in memory and experience. But it is the paint itself, and the individual way in which it is worked, which gently violates one's consciousness.

Aside from its debt to the *hachures* of Cézanne (particularly in the numbers series), Johns's handling, it seems to me, approximates the ambiance of *fin-de-siècle* Symbolism. Not for nothing had one of his strong admirations been for Philip Guston, a master of the New York

school with deep connections with Symbolism. Each of Johns's strokes is a larval palpitation of pleasure in the liveness of the pigment—a stroke whose morbidezza and cadenced slowness strives to ideate sense itself. Further, Johns can't help recalling the synaesthesia of the 1890's, and all his sculptures, particularly such pieces as the plaster flashlight, evoke the pictorial resonance of Medardo Rosso, just as his painting eschews metaphor and tends to affirm the existence of tangible matter.

One finally has to read back from this symbolism, through Abstract Expressionism, and into his concern with Dadaism, to rediscover the full complexity of Jasper Johns. When compared with Duchamp he appears somewhat conventional in his concentration on the easel picture and lesser attachments thereto. But then, Duchamp, next to Johns, exhibits enormous despair about the capacity of art ever to enhance or enrich our aesthetic life—as evidenced by his release of objects as gobbets of thought, freely and gratuitously ready-made. It is this pessimism of Duchamp, filtered and colored by the optimism of Johns—that is, by his faith in his own imaginative powers of transformation—that has erupted in one of the most vital dialectical tensions in contemporary American art.

MARCEL DUCHAMP (1887-1968)

Jasper Johns

The self attempts balance, descends. Perfume—the air was to stink of artists' egos. Himself, quickly torn to pieces. His tongue in his cheek.

Marcel Duchamp, one of this century's pioneer artists, moved his work through the retinal boundaries which had been established with Impressionism into a field where language, thought and vision act upon one another. There it changed form through a complex interplay of new mental and physical materials, heralding many of the technical, mental and visual details to be found in more recent art.

He said that he was ahead of his time. One guesses at a certain loneliness there. Wittgenstein said that *"Time has only one direction"* *must be a piece of nonsense.*

In the 1920s Duchamp gave up, quit painting. He allowed, perhaps encouraged, the attendant mythology. One thought of his decision, his willing this stopping. Yet on one occasion, he said it was not like that. He spoke of breaking a leg. "You don't mean to do it," he said.

The *Large Glass* [Fig. 17]. A greenhouse for his intuition. Erotic machinery, the *Bride* [Fig. 10] held in a see-through cage—"a Hilarious picture." Its cross-references of sight and thought, the changing focus of the eyes and mind, give fresh sense to the time and space we occupy, negate any concern with art as transportation. No end is in view in this fragment of a new perspective. "In the end you lose interest, so I didn't feel the necessity to finish it."

He declared that he wanted to kill art ("for myself") but his persistent attempts to destroy frames of reference altered our thinking, established new units of thought, "a new thought for that object."

The art community feels Duchamp's presence and his absence. He has changed the condition of being here.

"Marcel Duchamp (1887–1968)," by Jasper Johns. From *Artforum*, VII, No. 3 (November 1968), 6. Reprinted by permission of the author and *Artforum*. © *Artforum*, November 1968, "Marcel Duchamp (1887–1968)," by Jasper Johns.

IN MEMORY OF MARCEL DUCHAMP

Hans Richter

I see Marcel Duchamp—wherever he might be now—playing chess, playing the game with the intense passion of a lover, the way he played it when I first met him nearly fifty years ago—playing it with the delight for its beauty, with the desire to kill his opponent—to win, with the superiority of a master, with the enigmatic personality of a magician.

Nothing can describe him as clearly, as definitely as the infinite moves of the holy game. Wherever chess is played Marcel lives.

Marcel Duchamp invented Dada in the USA in 1915, before it had been "discovered." His contribution to the philosophy of Dada is elementary, practical, and so obvious that it is regarded and accepted in the United States as the Only-True-Dadaistic-Doctrine. He invented what he found "ready-made": bicycle wheels, bottle racks, pissoirs—the ready-made as the latest cry of Art. These objects proclaimed a new reality. With brutal Cartesian logic, these ready-mades were set up against the *Laocoon* and the *Venus de Milo* as a purgative for thoroughly hypocritical times and a society which had led to them.

Marcel Duchamp did not hail "Anti-Art" like the Berlin Dadaists, but rather "Non-Art." And he has lived his creed with a consistency that has made him a mythological figure even during his lifetime. Through him Dada became an intellectual extension of nihilism, an idea of nothingness which could by no stretch of the imagination be brought to suggest meaning.

"Death? There is no such thing as death. When we no longer have consciousness then the world simply stops." Such an acknowledgement of *cogito ergo sum* shattered me. But rendered with the

"In Memory of Marcel Duchamp," by Hans Richter. From *Form* (Cambridge, England), No. 9 (April 1969), pp. 4–5. Reprinted by permission of Marion von Hofacker.

earnestness of Marcel Duchamp, it seemed to solve all the problems of this world. In a mirror which thus no longer reflected anything, only existentialism found, once again, the vague outlines of a human silhouette . . . while Marcel played chess. . . .

Since 1921 no-one has been able to bring him to produce any so-called "art work," or to submit to the "shabby processes" that underlie the art business in order to dispose of them. Walter Arensberg his collector and Dada friend tried it earnestly during the 2nd World War, when Marcel was seriously in need of means of existence, but he failed, as did his friend Roché and all of us who loved Marcel as an artist.

He has remained faithful to his Dada protest, and instead of making art he has decisively submerged himself in the ephemeral, unnegotiable but spiritually as well as aesthetically satisfying world of chess. More than his work, his life sets up an amazing paradigm of morality. The quality of his paintings would be meaningful even without the scandal that *Nu Descendant l'Escalier** called forth in New York in 1912. Here is a man who has allowed his thinking to become such contempt for the so-called material and worldly advantages that both, perforce, have fallen into his lap.

Over his long lifetime, this muscular independence from a world of compromises in the midst of a conformist civilisation has exerted an enormous influence. Those who lack the strength to draw their own conclusions and act upon them have found a special attraction in identifying themselves with the ideas of Marcel Duchamp, who has all the strength they miss.

The temper of the present gives courage to these "Nothing-People." "Nothingness," alas, becomes the insignia of a new snobbism. Is the Romanticism of "Nothingness," which is so welcomed by a disappointed new generation, in danger of turning into a comfortable ideology?

I find the secret of Duchamp's magical force of attraction in the vacuum he created to replace "rejected" moral and artistic attitudes. The reason for its attractiveness lies less in the artistic or in the shock value of the ready-made. It is rather that "Nothingness" provides a home and an affirmation for the suicidal instincts of a generation which has been weakened by our cultural chaos. There are of course others for whom the "belief-in-Nothing" becomes fashionable self-deception. They find a sly security in their self-created spiritual superiority, without which their self-confidence would collapse.

Duchamp's detachment, the first step of his wisdom, permeates his personality and works like a vacuum on fate, pulling things and people toward it. They approach him open-minded and open-hearted

* [*Nude Descending a Staircase* (Fig. 8)—Ed.]

offer him tributes and sacrifices, and he responds with equal generosity. He who seems to want nothing can freely offer advice to others and find fitting words for the petty inevitabilities of everyday life. They are words, though born out of indifference, which express sympathy and oblige gratitude in return.

His studio is a workroom where chess tables are watched over by automatic chess clocks. Every day they fulfill their duties for two hours. Duchamp has added to the already colossal fund of chess literature with his treatise on certain problems of the end game. As vice-president of the Marshall Chess Club—a leading chess club of New York—he won its championship.

I myself was finally sucked into his chess kingdom despite my less than amateur status. For four years I worked on the filming of a chess fantasy 8 × 8, and on a story about the history of chess, *Chesscetera*. I had landed in his vacuum and was able to observe his passion without sharing it. His thoughts, his charm, his words in his impeccable French—are preserved in my film *Dadascope*.

The Dutch philosopher Huizinga traces the development of *homo sapiens* not à la Darwin to "necessity" (in the struggle for survival), but rather to his instinct for play, unpurposeful and not directed toward any kind of practical use. Thus play becomes the most serious of activities, and Duchamp took Dada as a form of play. He takes chess quite as seriously as Dada. *Homo sapiens* never acquired wisdom; why not give *homo ludens* a chance?

Watching, a few days after his death, a film on TV, made several years ago by French TV, a film in which we, his friends, all paid tribute to this rare man, I was stunned and deeply moved by a sentence with which Marcel Duchamp ends the film. It still moves me . . . a kind of "last word," a kind of enigmatic "solution" of the enigma of his life and personality. Smiling like the *Mona Lisa* which he once had decorated with a moustache, he seemed to summon up his philosophy and life endeavour: "We are always alone: everybody by himself, like in a shipwreck."

He prevails upon us to insist, "like in a shipwreck," upon our own uniqueness, upon the originality of man as an individual, at every moment, all the time. That's the way the game should be played. And as we feel, more every day, that the ship is wrecked, Marcel has become the mythological figure of a prophet, whose word counts more than a thousand (painted) images.

JOHN CAGE ON MARCEL DUCHAMP: AN INTERVIEW

Moira Roth and William Roth

When did you first meet Marcel Duchamp?
I met him in the early forties. But I didn't know him except to see him now and then. I didn't want to bother him with my friendship. Then, towards the end of the forties, I wrote the music for his sequence in *Dreams That Money Can Buy*. Afterwards I ran into him on MacDougal Street. He had heard the music and liked it. Then I met him later when he was with Mary Reynolds. The conversation turned toward dope. Someone in the group asked whether he thought that dope was a future problem. He said he didn't think so; it would never be any more serious than the drinking of liqueurs. Marcel took very little alcohol or food; he would simply eat what was given him. No one gave him a lot because everyone knew he didn't eat very much—two or three peas and one bit of meat. But he did smoke cigars.
Did he seem to change much during the time you knew him?
No, I would say not.
So becoming more celebrated in the 1960s didn't affect him?
He must have enjoyed it. When I wrote *A Year From Monday*, I told him I had written about him, but hadn't wanted to bother him with it before the book was published. He said rather plaintively, "But I would have enjoyed it."
Did he say anything about it when it was published?
Very little. I think I asked him once what he thought of the text that has his name in the title, and he indicated that he liked it. But then he was very nice about everything, including what Arturo Schwarz wrote about him. Marcel's attitude was that Schwarz's book wasn't about *him*, it was *by* Schwarz.

"John Cage on Marcel Duchamp: An Interview," by Moira Roth and William Roth. From *Art in America* (November–December, 1973), pp. 72–79. All footnotes have been omitted. Reprinted by permission of the authors and *Art in America*.

Do you feel it doesn't matter what people say about you?

Of course it doesn't matter. Because it is *their* action at that point. I learned very early to pay no attention to criticism. A review of a concert I gave in Seattle was to the effect that the whole thing was ridiculous. I knew perfectly well it wasn't. Therefore, the criticism was of no interest. In fact, it taught me that if people like what I am doing, I should look out. It's important that I live as I did before society became involved in what I am doing.

Do you resent society?

I think society is one of the greatest impediments an artist can possibly have. I rather think that Duchamp concurred with this view. When I was young and needed help, society wouldn't give it, because it had no confidence in what I was doing. But when, through my perseverance, society took an interest, then it wanted me not to do the next thing, but to repeat what I had done before. At every point society acts to keep you from doing what you have to do.

When you say society, you don't mean an audience?

I'm objecting to society as an audience. But I like society as what you might call an ecological fact.

So you are deeply concerned with people and unconcerned with the audience. You want the audience to turn into people.

I'm out to blur the distinctions between art and life, as I think Duchamp was. And between teacher and student. And between performer and audience, etcetera.

Do you think of yourself as teaching?

I like to think of myself as either having graduated or as going on studying, and I like to think of the music that interests me as being "after school." In other words, having no message in it; not teaching but rather celebrating. Or as Duchamp might have said—cerebrating.

Do you think Duchamp had no message?

He was interested in ideas; they recur and permit, with regard to his work, a certain scholarship. This is true of Jasper Johns also.

Do you think you need a lot of scholarship to see Duchamp's work?

I don't feel I need much scholarship to enjoy Duchamp as *I* enjoy him.

How do you enjoy him?

The way I do. Whether the way I enjoy him is the same way he intended, I have no way of knowing. I could have asked questions about that, but didn't.

Because you weren't interested?

No, no. I didn't want to disturb him with questions. Supposing he had not been disturbed by some question I had asked, and had answered it. I would then have had his answer rather than my experi-

ence. Furthermore, he left the door open by saying that observers complete works of art themselves. Nevertheless, there is still something hermetic or inscrutable about his work. It suggests scholarship, questions and answers from the source. I spoke to Teeny Duchamp once about this. I said, "You know, I understand very little about Marcel's work. Much of it remains very mysterious to me." And she said, "it does to me, too."

What questions come to mind when you think about Duchamp?

The things I think about him don't lead me to ask questions, but rather to experience his work or my life. At a Dada exhibition in Düsseldorf, I was impressed that though Schwitters and Picabia and the others had all become artists with the passing of time, Duchamp's works remained unacceptable as art. And, in fact, as you look from Duchamp to the light fixture (pointing in the room) the first thought you have is, "Well, that's a Duchamp." That's what I think, and that doesn't lead me to ask any questions. It leads me to the enjoyment of my life. If I were going to ask a question, it would be one I really didn't want to know the answer to. "What did you have in mind when you did such and such?" is not an interesting question, because then I have his mind rather than my own to deal with. I am continually amazed at the liveliness of his mind, at the connections he made that others hadn't, and so on, and at his interest in puns.

Would he pun when you talked to him?

He tried to every now and then. He liked it in conversation. He was very serious about being amused, and the atmosphere around him was always one of entertainment.

Would he talk to you about your work?

We really never talked about his work or my work.

He talked mainly about chess and food?

And the people we knew. I was very careful to do that. If, for instance, you go to Paris and spend your time as a tourist going to the famous places, I've always had a feeling you would learn nothing about Paris. The best way to learn about Paris would be to have no intention of learning anything and simply to live there as though you were a Frenchman. And no Frenchman would dream of going to, say, Notre Dame.

So you managed to do that with Duchamp, live in Paris and not sight-see?

That was my intention; to be with him as often as circumstances permitted and to let things happen rather than to make them happen. This is also an oriental notion. Meister Eckhardt says we are made perfect not by what we do, but by what happens to us. So we get to know Marcel not by asking him questions, but by being with him.

What happened when you played chess?

I rarely did, because he played so well and I played so poorly. So I played with Teeny, who also played much better than I. Marcel would glance at our game every now and then, and in between take a nap. He would say how stupid we both were. Every now and then he would get very impatient with me. He complained that I didn't seem to want to win. Actually, I was so delighted to be with him that the notion of winning was beside the point. When we played, he would give me a knight in advance. He was extremely intelligent and he almost always won. None of the people around us was as good a player as he, though there was one man who, once in a blue moon, would win. In trying to teach me how to play, Marcel said something which again is very oriental, "Don't just play your side of the game, play both sides." I tried to, but I was more impressed with what he said than I was able to follow it.

He taught like a Zen master?

I asked him once or twice, "Haven't you had some direct connection with oriental thought?" And he always said no. In Zen, the student comes to the teacher, asks a question, gets no reply. Asks a second and third time, but no reply. Finally he goes off to another part of the forest, builds himself a house, and three years later runs back to the teacher and says, "Thank you." Well, I heard recently that a man came to Marcel with a problem he hoped Marcel would solve. Marcel said absolutely nothing. After a while the problem disappeared and the man went away. It's the same teaching method as the oriental one, and it's hard to find examples of it in the West.

So he got it from himself?

There weren't any specific oriental sources. But there may have been other sources; we'd have to know thoroughly in order to decide whether *they* had any connection with the Orient—Emerson, or Thoreau, who said yes and no are lies, or Schopenhauer, who said that the highest use of the will is the denial of the will. The only true answer is that which sets all well afloat, so to speak, free of one's likes or dislikes. Duchamp says he wants to make a Readymade to which he is completely indifferent. That's the same idea. Now in his case, it didn't come from the Orient directly, but perhaps indirectly.

So that was one reason you felt close to Duchamp?

Well, I always admired his work, and once I got involved with chance operations, I realized he had been involved with them, not only in art but also in music, fifty years before I was. When I pointed this out to him, Marcel said, "I suppose I was fifty years ahead of my time."

Was there any difference between his idea of chance and yours?

Oh, yes. I hear from people who have studied his work that he often carefully chose the simplest method. In the case of the *Musical*

Eratum, he simply put the notes in a hat and then pulled them out. I wouldn't be satisfied with that kind of chance operation in my work, though I am delighted with it in Marcel's. There are too many things that could happen that don't interest me, such as pieces of paper sticking together and the act of shaking the hat. It simply doesn't appeal to me. I was born in a different month than Marcel. I enjoy details and like things to be more complicated.

Duchamp wasn't uncomplicated though?

He was less complicated than someone else doing the same thing would have been. I think the difference between our attitudes to chance probably came from the fact that he was involved with ideas through seeing, and I was involved through hearing. I try to become aware of more and more aspects of a situation in order to subject them all individually to chance operations. So I would be able to set a process going which was not related to anything I had experienced before. In the case of Duchamp—and Johns and others—there is something closer to the development of a language which the person is learning to speak. So in both Johns and Duchamp things recur. He would like us to believe, I think that the *Etant Donnés* [Fig. 28] is a translation of the *Large Glass* [Fig. 17]—the same work restated in a way which is very uncomfortable for us, because we had grown to like the transparency for one thing. In *Etant Donnés* he does the exact opposite, imprisoning us at a particular distance and removing the freedom we had so enjoyed in the *Large Glass.*

Etant Donnés was his last work. Did you know about it?

Oh, no! The only thing he said in the last years, and it was almost like a refrain in his conversation, was that he thought it would be interesting if artists would prescribe the distances from which their work should be viewed. He didn't understand why artists were so willing to have their works seen from any position. Of course, he was referring to the *Etant Donnés,* without my knowing that the work existed. He had two studios in New York; the one people knew about, and one next door to it, where he did his work, which no one knew about. That's why people were able to visit his studio and see nothing going on. As he expressed it later, it was a way of going underground.

I am very impressed with his craftsmanship. I recently saw a show by Picabia, who was so close to Duchamp. But though it was a large show, very few paintings were well made, or as beautifully made as a Duchamp. There are no Duchamps which are made poorly. He spoke of the function of the artist as that of an artisan, someone who made things.

How does that go with the idea of letting things happen?

Well, I would say it would keep one from *just* letting things happen. When he did notice things that had already happened, as in

the Readymades, he was extremely cautious. He didn't do what we have since done—extend the notion of the Readymades to everything. He was very precise, very disciplined. It must have been a very difficult thing for him to make a Readymade, to come to that decision. But then later in life, while he was making the *Etant Donnés,* he would sign anything that anyone asked him to.

Why did he change?

I think he thought other people were being just a little bit foolish. I hesitate to say that, because he did it in such good spirits. The only thing I ever asked him to sign (and I asked him to do so twice because of the circumstances) was a membership card. I had become a member of the Czechoslovakian Mushroom Society, and when I received my membership card—there were various signatures —I thought what a pleasure it would be to have Marcel's signature too. And so I gave it to him; it amused him and he signed it immediately and very beautifully. By beautifully, I mean in an interesting place. It looked as though he was one of the Czechs. Then, to raise money for the Foundation for Contemporary Performing Arts, I was able to sell the card for $500 to increase our fund. I regretted selling it, of course. But in the mail, the very same day that it was sold, came next year's membership card. I was delighted. I pointed this coincidence out to Marcel and he said, "There's no problem; I'll sign it too."

Why did he allow the expensive edition of the Readymades done by Schwarz?

In an interview late in life, an interviewer asked the same question: "Why did you permit that, because it looks like business rather than art," and so forth. Marcel admitted it could be so interpreted, but it didn't disturb him. He was extremely interested in money. At the same time, he never really used his art to make money. And yet he lived in a period when artists were making enormous amounts of money. He couldn't understand how they did it. I think he thought of himself as a poor businessman. These late activities were like business. The *Valise* is the rather feeble attempt of a small business man who tries to act in a businesslike way in a capitalist society, who had an idea of how to make a small company, but has no notion of how to become a big corporation. He couldn't understand why, for instance, Rauschenberg and Johns should make so much money and why he should not. But then he took an entirely different life role, so to speak. He never took a job. Both Rauschenberg and Johns, before their paintings were accepted, worked in the field of advertising. Duchamp never did any work. He viewed the bourgeois business of having a job and making money and so forth as a waste of time.

Is it too personal to ask how he lived, if he didn't work?

It would be too personal of me to answer the question. Let me

simply mention that at the beginning of the *Interviews* with Cabanne
he says that his life has always been extremely pleasant and that it
became more and more so as time went on.

Is that true of your life?

I was brought up to worry. I am very good at worrying. I think
if left to myself I wouldn't have much to worry about, but I manage
to connect myself with many other people whose problems worry
me. I'm very worried, for instance, about the Merce Cunningham
Dance Company, because it seems to be almost impossible to make
a physical situation which is reasonable and comfortable for so many
people and to make it work economically.

Did Duchamp also worry about people he loved?

He didn't give that impression. The only time he disturbed me
was once when he got cross with me for not winning a game of chess.
It was a game I might have won; then I made a foolish move and
he was furious. Really angry. He said, "Don't you ever want to win?"
He was so cross that he walked out of the room, and I felt as though
I had made a mistake in deciding to be with him—we were in a small
Spanish town—if he was going to get so angry with me.

He couldn't understand that you wouldn't care about winning?

He thought it was stupid, absolutely stupid. That night I could
hardly sleep. And the next day he was just bubbling over with friend-
ship. I think he had discussed the matter with Teeny, and she had
seen that I had been very hurt and had explained this to Marcel. And
then he went out of his way to be friendly.

Did you subscribe to the belief that he had stopped working?

He never stopped working. He was working constantly all the
time he led us to believe that he wasn't working. And he did just
what he had done with the *Large Glass*; he made a large work and
a number of offshoots from it. He did two works that it was peculiar
to see him doing at the time. But now that I come to think of them,
they were very closely related to the *Etant Donnés*. One was a wind-
break. He had an apartment in Cadaqués with a terrace outside from
which you could look down and see the bay. But the wind, when it
came from the hills, was very unpleasant. So he designed and con-
structed a very ingenious method of breaking the wind with glass and
wood. It was difficult to get it to hold against the wind because there
was no material to which it could be attached. That kind of problem
is no different from those he had to solve in *Etant Donnés*. Then an-
other thing, which was even more peculiar, was his decision to put in
a fireplace (when they moved from one apartment to another). He
designed the fireplace very carefully. It was extremely uninteresting
looking, but it was very detailed and exactly made, and he was de-
lighted when the fireplace was finished. It's not essentially a different

project than the stone wall of *Etant Donnés*, which is absolutely boring. In other words, he continued his work until the end. All he did was go underground. He didn't wish to be disturbed when he was working, so he didn't want anyone to know he was working. And none of us, at the time, connected the fireplace or the windbreak with art.

He made a real distinction between his life as craftsman and artist and his social life?

Yes, you might say that.

But isn't a Readymade supposed to make you feel that this kind of distinction doesn't exist?

I would say so. I rather think, though, when we think of the Readymades, we think of something other than what Duchamp thought of. I'm not sure if my experience is the same as his. Anything I look at is a Duchamp, just anything. I wouldn't say, as he did, that I must be indifferent to it to begin with.

Is the impression of Duchamp saying art and life are one really obtained through people like you?

Yes, but if you put that with the last work, what do you come up with? We have gotten from Duchamp this concern which interests us more than anything else: the blurring of the distinction between art and life. I would say this is true of Rauschenberg and myself more than of Johns. And in this sense, Johns may be closer to Duchamp than Rauschenberg and myself. Because *Etant Donnés* doesn't have any of that fusion of art and life. It has, rather, the most exact separation.

Do you think it is a mistake to see people like yourself and Rauschenberg as the logical heirs of Duchamp's notion of blurring art and life?

I think that if you observe something, and then want to make connections between work now and some other work that preceded it, you can make—if you are clever—any connections you want.

Did you learn anything about the blurring of art and life from Duchamp? Was it all there before you met him?

These are very difficult questions to answer. He is one of the artists whom I admire the most, and whom I had the privilege of getting to know. Another one whom I admired very much was Mondrian, whom I met but didn't know very well. Then in the late forties, I became involved in oriental thought, and in 1960 I collected my writings under the title *Silence*. However, in a recent book which has my name as title, edited by Richard Kostelanetz, you see me in high school at the age of fourteen proposing that the best thing that could happen to the United States in a world sense would be to become silent. That was before I knew anything about Duchamp.

Do you think your idea of silence has anything in common with Duchamp?

Looking at the *Large Glass*, the thing that I like so much is that I can focus my attention wherever I wish. It helps me to blur the distinction between art and life and produces a kind of silence in the work itself. There is nothing in it that requires me to look in one place or another or, in fact, requires me to look at all. I can look through it to the world beyond. Well, this is, of course, the reverse in *Etant Donnés*. I can only see what Duchamp permits me to see. The *Large Glass* changes with the light and he was aware of this. So does a Mondrian. So does any painting. But *Etant Donnés* doesn't change because it is all prescribed. So he's telling us something that we perhaps haven't yet learned, when we speak as we do so glibly of the blurring of the distinction between art and life. Or perhaps he's bringing us back to Thoreau: yes and no are lies. Or keeping the distinction, he may be saying neither one is true. The only true answer is that which will let us have both of these.

Duchamp seems so much less physical in his art than you do.

A contradiction between Marcel and myself is that he spoke constantly against the retinal aspects of art, whereas I have insisted upon the physicality of sound and the activity of listening. You could say I was saying the opposite of what he was saying. And yet I felt so much in accord with everything he was doing that I developed the notion that the reverse is true of music as is true of the visual arts. In other words, what was needed in art when he came along was not being physical about seeing, and what was needed in music when I came along was the necessity of being physical about hearing. However, with *Etant Donnés*, we feel his work very physically, not abstractly, and in a way which can be deeply felt. Music is more complex, I think, than painting, and that's why chance operations in music are just naturally more complicated than they would be for painting. There are more questions to ask about a piece of music than there are about a painting.

Would he come to hear your concerts?

I wouldn't ask him. If he came, that was his concern but I don't think he particularly enjoyed music. He and Teeny performed with me in the chess piece in Toronto. (*Reunion* with David Tudor, Gordon Mumma, David Behrman and Lowell Cross; Lowell Cross constructed a chess board with circuits, so that moves on the board transmitted or cut off sound produced by the several musicians.) I turned to him during the performance. I said, "Aren't these strange sounds?" He smiled and said, "To say the least." The game I played with him, he won quite quickly; then I played with Teeny and he stayed on the stage. The game went on and on; finally about eleven-thirty we looked up and everyone in the audience had left. We continued the game the next morning in the hotel. I lost.

I don't feel in Duchamp any interest in events that are not interesting. What interested him were connections he had not previously noticed or puns that made things glance off in curious directions. He wasn't interested in some elementary aspect of chess. What interested him were the elaborate details. He wrote a fabulous book on the end game. The end game which he chose was simply that with the kings and a few pawns. He made a most elaborate study of this and never tired of trying to explain it to you. It was so complex I never did understand it, even though he gave me the book. When I asked him to write something in it, he wrote: "Dear John, Look out! Another poisonous mushroom."

Our ideas of blurring the distinctions between art and life have led in some instances to works that turn us stupid. But not even children are stupid. I've read that four-year-old children are capable of learning several languages and inventing new ones. Inventing a new language is precisely what would have interested Marcel. We ought to use our ideas not in order to coddle ourselves as though we were infants who hadn't even learned a single language, but in order to stretch ourselves to the limits, both in art and in life.

Did Duchamp ever talk to you about problems aside from art?

Yes, he did. And quite early in the century he proposed the use of private cars for public transportation—people driving cars wherever they liked and just leaving them; other people would take the same cars and drive on. He was opposed to politics. He was opposed to religion as is Zen. He was for sex and for humor. He was opposed to private property. There is a lovely story about this. Before he married Teeny, he went to visit her on Long Island. Bernard Monnier, her future son-in-law, went to meet Marcel at the station. He said, "Where is your luggage?" Marcel reached into his overcoat pocket and took out his toothbrush and said, "This is my *robe de chambre*." Then he showed Bernard that he was wearing three shirts, one on top of the other. He had come for a long weekend.

He must have been a beautiful friend.

Oh yes, his death was a great loss. I notice that Teeny even now frequently uses the present tense with regard to him. She says, "We do this," or "We don't do that," or "Marcel and I always do this."

I can tell you another story about him. Once we were in Cadaqués and we were invited to lunch on a little island off the mainland, just a hop, skip and a jump off the mainland. The hostess was a mediocre painter, but she and her husband owned the island and they were Spanish. Marcel didn't always accept invitations; he was quite choosy about ones he would accept. But he was always willing to go to this house. Well, I had been told the lady was a painter, but there were no paintings on the walls. We had lunch in this bare-walled

room, and afterwards she asked us if we would look at her paintings. She brought them out of the closet, one after another, and put them against the bare wall. I kept wondering what Marcel was going to say, because the paintings were all hideous. I knew he wouldn't say they were hideous, but I just didn't know what he would do. After seeing quite a number, he said, "You should hang them on the wall," and she said she couldn't stand to look at them, and then he said nothing.

He was very friendly with Dali. Isn't that strange? Dali lived in Cadaqués, and if you go into a stationery shop or a post office there, there are postcards showing Dali's house and portraits of him and so on. There were never any postcards of Marcel, to my taste a vastly superior artist and man. The first year I went to Cadaqués, Marcel asked me whether I would like to meet Dali, and I said I would rather not. And so he didn't press the matter. Then, another year, he asked me again, and said he thought I should whether I wanted to or not. So we all drove over to Dali's, and I was astonished to see that Marcel took a listening attitude in the presence of Dali. It almost appeared as if a younger man were visiting an old man, whereas the case was the other way around. Dali, of course, talks all the time, and wants to show what he's doing—absolutely the reverse of Marcel.

He doesn't have a hidden studio?

No, no, he has enormous vulgar paintings. Marcel went in and admired them. There were several other occasions when I was together with Dali and Duchamp, and then, after Duchamp's death, with Dali alone. I haven't changed my mind radically about Dali, but I notice that there is something in his eyes which is very convincing, a very undisturbed honesty in the man, something I had not expected.

And that's what Duchamp saw?

I don't know, but I was looking for something that I could see. An edition of the *Interviews* with Cabanne has been published here. Unfortunately, it is very poorly translated; it includes a ridiculous preface by Dali. At least I find it so. A preface that has the effect of drawing attention to Dali, rather than to Marcel, and yet Marcel in the presence of Dali always sent the attention to Dali. That's an oriental action of self-effacement. Over and over again, at most any point, I find correspondence between Duchamp and the Orient.

THEATER OF THE CONCEPTUAL: AUTOBIOGRAPHY AND MYTH

Robert Pincus-Witten

The posthumous revelation of the diorama *Etant Donnés** gave lie to the canard that Marcel Duchamp abandoned art for chess in 1923, when he left the *Large Glass* unfinished. For 20 years at least (c. 1946–66), Duchamp had been intensely engaged by the continued elaboration of the mythology that had occupied him between 1912 and 1923 —the arcana of the *Large Glass* [Fig. 17]. Duchamp scholars now realize that the imagery of *Etant Donnés* represents a working toward nature from the mechanomorphic elements of the *Large Glass*—empirical representationalism deduced from diagrammatic terms instead of the reverse.

The title *Etant Donnés* as an expression indicates those syllogistic premises that are "given" or "granted" in a logical argument. When we say so and so is "granted," in French we say "etant donné." In *Etant Donnés*, the granted elements are identical to those of the *Large Glass*—the waterfall and the illuminating gas—physical and metaphorical sources of energy.

Significant to the development of *Etant Donnés* are three small erotic objects of 1951, the *Objet-Dard,* the *Female Fig Leaf,* and the *Wedge of Chastity* [Fig. 27]. All the titles of these familiar and curiously ambiguous talismans play with literary conceits and/or outright puns. The pun is the touchstone of Duchamp's thought—a circular process of reasoning that thriftily returns to the same place while releasing fresh insights.

"Theater of the Conceptual: Autobiography and Myth," by Robert Pincus-Witten. From *Artforum,* XII, No. 2 (October 1973), 40–46. © *Artforum,* October 1973, "Theater of the Conceptual: Autobiography and Myth," by Robert Pincus-Witten.

* [*Givens: 1st, The Waterfall, 2nd, The Illuminating Gas* (Fig. 28)—Ed.]

These three sexual objects account for certain inferences that clarify the mode of Conceptual art that deals with autobiography and/or myth. The three objects respectively are male, female, and a binary image—a male-female form. The male object is *Objet-Dard*—in appearance flaccid and vaguely detumescent despite a raised vein-like element running along a curved ridge. This metal object, it seems, was a brace broken away from the mold in which the breast of the violated female nude of *Étant Donnés* had been modeled. *Objet-Dard* is marked by an oval plane at one extremity upon which are incised the words "objet dard." This pun bridges the notion of "art object" and "dart object," the word "dard" in French meaning "dart." The dart aspect of the work, as Duchamp acknowledged, intensifies the explicitly phallic implications of this conundrum.

In my view, the implications inherent to *Objet-Dard* clarify a source of the iconography of early Jasper Johns dating from about 1955, when he first met Duchamp. The appearance of *Objet-Dard*, a work that on Johns' first encounter did not remotely look like an "object of art," led Johns to ask how such an object could have been imagined in the first place. Duchamp's reply, according to Johns, explained the derivation of the object from the mold referred to above.

The secondary meanings of *Objet-Dard* are even more elusive. What is the object of a dart? Clearly the answer is a Target, a central icon associated with Johns' painting from 1955 on. Thus, from the implicitly ironical attitude toward the pun and language in Duchamp's work, Johns made an imaginative leap which further transposed these implications into an oblique, conceptually multivalent iconography wholly different in type from the character of much American abstraction between 1950 and 1955. Johns' insinuating imagery displaced such glyphs as were then based on the prevailing fusion of Willem de Kooning and Franz Kline.

Taking Duchamp's pun literally, at face value, Johns inaugurated an imagery of conceptual ambiguity, one that continues. The Pop artists, working in an ambient situation fed by many sources, were far less hyperbolic than Johns in their approach. To the degree that any were influenced by Johns, they took his work—and Rauschenberg's also—to emphasize primarily an iconography of the commonplace. Granting the nature of Johns' evolution however, it seems that his emphasis points to an iconography of conceptual sets that only incidentally engages the commonplace. But another generation of artists sees that it was the conceptual set that was as crucial as the imagery itself —target, American flag, map, numbers, measuring devices, and orthographic signs that identify primary colors.

The sheer perversity of Duchamp's *Objet-Dard*, shockingly unclassifiable as art to an Abstract Expressionist taste, is even more para-

doxical when the question "what is the object of a dart?" is answered by Johns' Target—an oddly specific response to a hypothetical query.

Johns rejects this iconographic connection. He claims he knew no French, though to mouth the word "dard" surely calls the English word "dart" immediately to mind. More viable is his assertion that he did not know of the three erotic objects until after the early Targets were completed. To be sure, there is the matter of Johns' personal acquaintance with Duchamp, a detail that must be accounted for, or even the access to Duchamp's mind and persona transmitted to Johns through Cage.

Be this as it may, the artist's mind, unlike that of the historian, does not thrive on niggling one-to-one details, but on making imaginative leaps and playing sudden hunches that throw the origins of the feat into relative unimportance. Even were Johns not fully cognizant of the potential of these three erotic objects in 1955, surely he was aware of some of their implications. What better confirmation of his fascination than that by 1960 he had personally acquired these works.

The intention of the cryptic *Female Fig Leaf* becomes clear on learning that it was modeled against the pudenda of the violated female figure of the *Etant Donnés,* upon which Duchamp had worked so long in secrecy. Modeling against anatomy or anatomically suggestive fragments is a central feature of Johns' work that begins in 1955, and continues to this day. The *Target With Plaster Casts,* 1955, for instance, supports a register of boxes filled with colored anatomical fragments—lip, nose, ears, fingers, male sex organ—cast from the body of a friend of the artist.

The use of the body fragment, an essential reliance on graphic values, and an insistent intellectual clutch of paradox indicate that Johns, like Duchamp, evolves from the principles of French Symbolism. As Duchamp was the spiritual heir of Mallarmé, so Johns derives from Odilon Redon, in whose charcoal drawings and lithographs we find both the inspirational matter of Johns—fragments of human imagery, especially the floating or severed head—and his richly self-elaborating graphic technique. But beyond these similarities of image and drawing is Johns' consistently ironic attitude toward such subject matter and technique. As interesting as it may be to note formal connections between artists, the issue is more resolved by the texture of Johns' mind itself. Who but Johns so consistently insinuates, so perversely warps the known?

Johns' relationship to Duchamp is one matter, and widely accepted. It serves to establish a model against which a wider and more contemporary mode of art can be discussed. Three aspects of Duchamp's work found response in the ranging horizontal and emotional climate of California art: 1) personal mythology; 2) a punning focus;

and 3) modeling or casting itself as an irony as well as a method. The absorption of the folksy and homespun pun as typified in the Bay Area work of several artists, particularly Fred Martin, Jeremy Andersen and William Wiley, is the facet from which derives, in the first instance, Bruce Nauman's introduction to the pun. From such a local usage it was but one step further to explore the physically referential aspects of Duchamp's art, aspects that had been corroborated in the prestigious East Coast model afforded by Johns.

A telling motif, say, of Nauman's appreciation of linguistic circularity is the neon spiral, a motif employed by the artist in executing the early *Maxims*. Their shape obviously approximates the cyclical nature of the pun, as Johns' *Targets* duplicates it.

While the very title of Nauman's *Wedge Piece*, 1968, inevitably recalls Duchamp's *Wedge of Chastity*, seemingly the least rewarding of the three erotic objects, its appearance relates strongly to that work. The *Wedge of Chastity* presents a rugged metallic element, the male plug, driven into a matrix of dental plastic, the female receptacle. Nauman's *Wedge Piece* counters a vaginal chamfering (registered during the industrial fabrication of the wedges) against an elongated phallic shape. Moreover, the redness of the wedges corresponds in hue to the pinkness of the dental plastic used in Duchamp's piece. There is, then, a close coloristic and structural relationship between Duchamp's and Nauman's wedge variations.[1]

It is also important to note that the form of the wedge had been awarded credentials within Minimalism—the preeminent abstract-reductivist movement of our time—as a form in itself. Among the few alternatives open to abstract-reductivist form is commonly found the triangle—the wedge, the ramp, the corner, the "L." The icons of Mini-

[1] In Germany, Nauman found two red wedges and inscribed the English word "like" on them. Our word for "like" has the same number of letters and incorporates the same letters but in different sequence as the German word for wedge, *Keil*. On the basis of this "likeness" Nauman formulated the palindromic relationship between the words and shapes of the wedges.

This material was presented in my "Bruce Nauman: Another Kind of Reasoning," *Artforum*, February, 1972. In a recent essay on the artist, this interpretation was rejected. Jane Livingston protested that at the time of the *Wedge Piece*, Nauman had never heard of Duchamp (Jane Livingston and Marcia Tucker, *Bruce Nauman: Work from 1965 to 1972*). Even were this assertion remotely possible, it is unacceptable because no serious art student glancing at the illustrations or reading the commentaries on Duchamp's work—rife in both specialized and popular magazines—could remain unaffected by Duchamp. In addition, Nauman worked in an atmosphere in which a multitude of Duchamp-inspired variations and dilutants were to be encountered in studio conversation, gallery cant, and media dispersal. An artist does not have to "know Duchamp" to know Duchamp's ideas. How many persons familiar in a general way with the notions of Freud or Marx have ever read Freud or Marx?

malism are few—the square, the circle, and the triangle, as well as each of their spatial projections—cube and oblong, sphere and cylinder, pyramid, and wedge. In the many Minimalist pieces executed by Robert Morris and Donald Judd, for example, we find "L" variations, wedge forms, ramps, and architectural elements that negotiate corner and walls. Imagine a situation that combines the circumlocutionary processes stemming from literary conceits, plus a value system primarily supportive of abstract art, then the sources and latitude of post-Minimalism become clearer.

Recent elaborations of this art manifested themselves in the rise of theatricality—the theater of the conceptual. The problem of drawing a mainstream formalist argument with regard to a conceptual theater, one that acknowledges its elements of dance, music, and behaviorism, lies in the difficulty of isolating those elements germane to the histories of dance, music, and behaviorism themselves, and those which have developed within a more contained view of painting and sculpture.

We witnessed, for example, as part of conceptual theater, work by the so-called body artist, Vito Acconci. He extrapolated the mythical type perfected by Duchamp—the androgyne—onto a behaviorist examination of his own psychology, seen in *Seedbed,* a work developed during the period of 1970–72.

Despite scandalized outcries, *Seedbed* presents a bare *mise-en-scène.* Its setting is a ramp or wedge sloping up the corner of a gallery floor.[2] Certainly it was not the external aspect of the work that proved provocative, but that the artist, fed by airholes drilled into the ramp's surface, isolated himself below the slanted floor and engaged in masturbation. The fantasy accompanying this act was faintly audible in the larger gallery space as it was transmitted through a loudspeaker in the corner of the chamber.

Seedbed takes as its metaphor one that Duchamp earlier had attributed to the *Large Glass* [Fig. 17]. *Seedbed,* like Duchamp's subtitle for the *Large Glass,* is "an agricultural machine"—Acconci's seed, so to speak, now being cast upon the floor.

The *Large Glass*—the work must here be referred to by its proper name *The Bride Stripped Bare by Her Bachelors, Even*—records an ongoing series of physical changes, effected through the actions of complex mechanomorphic machinery. Owing to the functions of the mechanomorphs depicted on the glass, physical states are at one point seen as gaseous—the cloud, or liquid—the "love juice" dripped from the Bride in the upper portion of the glass into the realm of the Bachelors below. At length, the love juice falls into the *Nine Malic*

[2] See my "Vito Acconci and the Conceptual Performance," *Artforum,* April, 1972.

Molds and therein presumably solidifies. Among still other possibilities, this altered physical matter may be pulverized by the *Chocolate Grinder,* as it once again may be turned into light energy while passing through the lenses of the *Optical Witnesses.*

In arcane lore, the person capable of enforcing the change of physical matter from one state to another is the alchemist or the androgyne—the latter being a fusion of male and female. He-She corresponds to a notion of God, that is, a coincidence of opposites. Throughout highly disparate cultures, such a person is often assigned the role of shaman or seer, the see-er of the future, like Tiresias of Greek tragedy, or the Seller of Salt, the Salt Merchant of kabbalism and alchemy.

By an exiguous and circumstantial argument the salt merchant appears to correspond to the medieval alchemist, i.e., the person capable of effecting the change of matter from one physical state to another. The "salt" of the salt merchant may well be symbolized by the philosopher's stone of the alchemist—the esoteric catalyst without which such changes in matter cannot be made. The arcane knowledge, the gnosis needed to effect this change—say, for example, the secret name of God—and the actual enactment of these changes constituted for the alchemist, the kabbalist or the magus, *le grand oeuvre,* the great work of magic. Duchamp's *Large Glass* as completed by the *Étant Donnés* is his great work of magic and his life work as well.

In French the Salt Merchant is called "Le Marchand du Sel," a transpositional pun on the four syllables of the name of Marcel Duchamp. Duchamp knew the name of the androgyne—Rose Sélavy (the secret name of God?) as well as the androgyne's appearance—the artist himself in transvestiture. Man Ray photographed Marcel Duchamp in such cross-garb in 1920, when preparing the punning label for the perfume bottle *La Belle Haleine*—beautiful breath, beautiful Helen. The label displays a photograph of Rose Sélavy, a punning name meaning "life is okay." She is the female side of Duchamp's nature.

All of this background is essential to an understanding of *Seedbed.* Acconci's earlier attempts to deal with the projection of an androgynous personality were realized through performances of such actions as the burning away of the artist's body hair, the tugging at his breasts, and the hiding of his penis between his legs. These performances indicate publicly that Acconci projected a notion of the androgyne that had earlier been set by Duchamp within his conception of his mythical alter ego, Rose Sélavy.

It is important to note the difference between the conceptual theater of Acconci's *Seedbed* and Dennis Oppenheim's *Adrenochrome* of 1973. *Adrenochrome,* like *Seedbed,* deals with the emission of

chemicals—in Oppenheim's case, the chemical necessary to reconstitute the normal blood-cell structuré of a schizophrenic—in Acconci's work, human sperm. *Adrenochrome* illuminates a particle of the chemical at the apex of a pyramid, while at the same time, a slide of the microscopic structure of the chemical is projected against a gallery wall. Both *mises-en-scène* are lent credibility owing to a parallel support system for abstract forms, the ramp and the pyramid.

While both the above works were generated by personal crises, *Adrenochrome* remains a pro forma work that insists on a one-to-one relationship to the artist's biography. *Seedbed,* by contrast, is a highly nonformal and secretive work whereby the autobiographical element is transposed to the plane of myth on the basis of Duchamp's lore.

The ontological artist, therefore, as Duchamp had anticipated and indicated, is the one whose work is completed in the public psyche. It must be noted that the psyche is primed by a literature of myth. In the absence of this acculturation nothing appears to happen except the work itself and the viewer's subjective experience of it.[3]

The mythical personage of the androgyne, it seems to me, is the exteriorization of Duchamp himself, expressed through the surrogate adventure that began when the Nude Descended the Staircase [Fig. 8] became the Bride [Figs. 9, 10], was Stripped Bare by the Bachelors [Fig. 17]—female and male personae who ultimately united in the androgyne as impersonated by Duchamp in transvestiture.

An important "proof" for this, apart from the visual evidence, derives from the French name of the *Large Glass: La Mariée mise à nu par ses célibataires, même.*[*] La MARiée mise à nu par les CELibataires—MAR-CEL, the first three letters of the French word for bride and the first three letters of the French word for bachelors comprise the letters of Duchamp's first name.

The by now obvious fact that Marcel Duchamp is both Bride and Bachelor at the same instant allows one to recognize something of a mythical core in, say, Vito Acconci's work, as well as to understand why Bruce Nauman may have used his name as a Readymade— *My Name As If It Were Bounced Off The Surface Of The Moon* or *My Name Enlarged Vertically 14 Times.*

Similarly, as Duchamp had regarded the three sexual objects in terms of morphological transfer—most particularly the *Female Fig Leaf*—so too Nauman casts against his body in unanticipated ways.

[3] The recognition, therefore, of "public psyche" does not take place as a mystical necessity—the overtones of Jungian archetypes—but as a conclusion drawn from a liberal education. Were this not so, then I would be sponsoring an art of mysticism and intuition, qualities, if they exist, that are the paths of madness.

[*] [*The Bride Stripped Bare by Her Bachelors, Even* (Fig. 17)—Ed.]

It was this aspect of Duchamp's work that licenses for us Nauman's move into behavioristic performance, video work, laser stereoptics, and architectural situations. At first, Nauman's attention focused on the external effect made by his body upon some malleable substance, as in the *Template of the Left Hand of My Body at Ten Inch Intervals.* From this, Nauman was able to project an art in which no external object was actually formed but which internalized the process back into his body—intangible substances such as space, light, warmth, acting in time—were now reforming his body.

This shift between the mold and that which is molded has influenced much of the open and often seemingly unpurposeful aspects of the conceptual performance. In such instances the distinction between Acconci and Oppenheim may prevail. Those conceptual performances which allow for the consciousness of the mythic may be of a greater interest than those that are purely behavioristic.

Such a judgment is speculative. To insist on this distinction means that I posit a conceptual theater given value largely through an attachment to myth and legend. The converse may as easily be true. The question is still an open one. Conceptual theater may yet prove interesting precisely to the degree that it detaches itself from a mythological frame of reference.

Since literature of any kind has the effect of diminishing the abstractness of a work, a conceptual theater grounded, say, in myth would necessarily be weakened by this connection. But, in the same degree that myth may devalue abstraction, so too does autobiography. In the absence of myth and autobiography the conceptual performance becomes purely behavioral. This appears to be another reason why, in Conceptual art, the behavioral appears to bridge the ontological and epistemological branches of the movement. Contrary to what I have previously thought, behaviorism is abstract conceptual theater.

When Nauman investigated the artistic possibilities of his body or his name as a Readymade, he drew away from an art based on the pun and simple language toward what has been loosely called "phenomenology"—perhaps an abuse of the term, but one that nonetheless has entered art talk.

"Phenomenology," used this way, indicates a kind of physiological behaviorist activity and self-examination. What is it like to be? To do? To sense? To enact certain kinds of experiences and activities? Many of the experiences thus examined tend to be those attributed to inanimate things—residual Minimalism again—an underpinning derived from abstraction. What is it like to be immobile for long durations? To mechanically repeat physical activities? In such ways, artists as disparate as Nauman, Gilbert and George, recent Keith Sonnier, Rob-

ert Morris, and Lynda Benglis can be bracketed, if only momentarily.

Moreover, Nauman regarded his body as a medium—trying to find in his body the very vehicle of his 'art—in the way that earlier artists had discovered the media of their art in watercolor, gouache, oil paint, etc. This may relate to Johns' connection between seeing and orality in many forms—speaking, masticating, ingesting.

This enlarging episode in recent art tied post-Minimalism into a loss of distinct species-types—painting and sculpture became "pictorial sculpture." Post-Minimalism is marked by a loss of typology— the rejection of stretcher supports, framing edge in painting, of base in sculpture, the loss of facture, and the loss of site. Until post-Minimalism, "Art" was indoors and "Nature" outdoors. In this connection Robert Smithson's Nonsites, Carl Andre's floor pieces and Richard Long's walking tours cannot be over-estimated. Post-Minimalist elasticity meant that work could theoretically be placed anywhere.

With the loss of time-honored conventions of this kind—once art became part of an infinite continuum ranging from interior to exterior and species to species—painting and sculpture could quite naturally evolve toward and encompass theatricality. Nonetheless, the enactment, for example, of mechanical and repetitive actions and gestures still points to a formal continuity from Minimalism, despite the theatrical nature of such activity. To the painter or sculptor theatrically offered itself as an alternative to the loss of belief in facture in species-type, in retinality, and in site that had taken place.

Certainly, the *sine qua non* of art—traces of sensitively stroked surface executed with a paint-loaded brush—has been fundamentally undermined, perhaps irrevocably. While such activity is, can, and does remain art for many, other artists feel impelled to investigate looser modes and media, such as laser beam photography, video and film, behavioral phenomenology, the dance, storywriting and telling. The latter are all being explored as viable in their own right as alternatives to sensibility drawing and sensibility painting, and as an alternative to the structures of thought of the pure Conceptualists.

In part this is why there has been such a resurgence of dance. Not necessarily dance practiced as a classically defined discipline, but rather as an art of rudimentary movement: walking as dance, amateur as dancer, another way of painting and sculpting—an alternative. Painting without painting, sculpture without sculpture.

This may be a polemical generalization. That today we happen to see many dancers performing in ways suggestive of modes of painting and sculpture does not necessarily mean that the dancer is a painter or sculptor. When dance—and music too, for that matter— engages a wide reach in relation to painting and sculpture, it is tacitly

assumed that this kind of dance or music is in some sense an expression *formed* by painting and scultpure rather than one that is *formative* of painting and sculpture. This is by no means a clear question today.

Robert Rauschenberg's connection as a dancer and stage designer to the Merce Cunningham Company is well known. Much of Robert Morris' early career was spent as a dancer working with Yvonne Rainer. Before her desire to become a painter, Dorothea Rockburne trained at length to be a dancer. Certainly, the prestige of Yvonne Rainer among post-Minimalists is high, both as dancer and filmmaker. Similarly, Trisha Brown's "Accumulations" dance of simple abstract movements is suggestive of many of the visual properties of our art. Yet despite such superficial bracketings and circumstantial inferences, the real question remains unanswered: Does recent dance come out of painting and sculpture or does sculpture and painting come out of dance?

In a parallel vein, about which I feel more equipped to speak, I question whether the emergence of "story art" evolves from the Happening, is a surrogate expression of the conceptual performance, or is informed by the abstract qualities of visual art. John Baldessari presents bitter parables, the morals of which ironically underscore the hollowness of art. Lawrence Wiener, like Kienholz before him, presents statements which are themselves projects and works. Vito Acconci and Dennis Oppenheim, among many, present strong performances in the contexts of behavioral phenomenology. Bill Beckley tells shaggy dog stories, while William Wegman opts for a clear, ironical humor. It is possible to see "story art" as a post-conceptual theater.

However, the methods of "story art" use modes still related to abstract form—halting speech, as if something solid and blocky were being formed in the mouth—terse, iconic words, stubby and solid; non sequiturs abound, breaking down the idea of story as narrative; memorization is used as a means of inducing a sense of rotelike immutability; repetition is used to establish a format of constant structure. These are some of the methods by which "story art" announces its connection to an abstract pictorial and sculptural mainstream, rather than to literature or anything literary.

What of the artists who had typified the pure Conceptualists, the epistemological mainstream? Oddly enough one is witnessing a growing tendency toward more traditional conceptions of art typology. Even those artists who in the past exemplified research into the quantifying elements of art, who questioned the actual physical species of art through borrowed structural systems of knowledge—such artists now appear to be opting for an art of more familiar typologies. Ratification which once came from systems of mathematics or philosophy,

is now deriving from nonverbal theories of structure, in which credibility becomes an act of faith in taste and sensibility rather than in cerebral verification systems.

The reintroduction of material processes in the work of Bochner and Rockburne, for example, may indicate a return, but to what? To the conception that art is not necessarily made with notions, but with materials—a position that parallels Richard Serra's notion of sculpture as a distinct species type. This has always been true, but the shift is one of emphasis and context. It may be that such a return to the investigation of material may have been spurred by the open-endedness of theatricality itself, thus ratifying the cerebral radicality of this position.

Most important, this change or alteration may mean that the most forward and intellectually grounded choice in art may now opt for "granted," tangible aspects of painting and sculpture, choices made within typologically defined species. This, in turn, surely indicates that post-Minimalism as a movement has come full cycle—from species, to loss of species, to species regained—and in so doing, that a certain period notion style in American art may have ended.

Chronology

For a more extensive chronology, see Walter Hopps, "Chronological Notes," *Art in America*, LVII, No. 4 (July–August 1969), 28–30.

1887 Born, July 28th.

1904 To Paris; studies painting at the Académie Julian (until July 1905), playing billiards half the day.

1905 Cartooning (until 1910); works for a printer in Rouen to qualify as "art worker" for short military service.

1906 Painting in Paris.

1908 Moves to suburb of Neuilly (until 1913).

1909 First exhibition, *Salon des Indépendents*; joins in Section d'Or meetings.

1911 First works dealing with figure in arrested motion; beginning of *Nude Descending a Staircase* project.

1912 Visits Munich, where he paints and admires the work of Kandinsky and Klee; *Nude Descending a Staircase, No. 2* withdrawn from *Salon des Indépendents*.

1913 Turns away from conventional painting and drawing; investigates chance: *Three Standard Stoppages* (completed 1914); librarian at Bibliothèque Sainte-Geneviève; first studies toward *Large Glass*; first ready-made: *Bicycle Wheel*; first glass piece: *Glider Containing a Water Mill* (*in Neighboring Metals*) (completed 1915); *Nude Descending a Staircase, No. 2* shown in New York.

1914 *Bottle Rack*, the most famous ready-made.

1915 To New York (until 1918); begins the *Large Glass* (stopped work 1923).

1917 Assists with first New York Independents exhibition; resigns when

173

ready-made urinal *Fountain*, is rejected; helps publish *The Blind Man* and *Rongwrong*, New York Dada magazines.

1918　Last canvas: *Tu m'*; to Buenos Aires for 9 months: *To be Looked at with One Eye, Close to, for Almost an Hour.*

1919　*Unhappy Ready-made* (executed in Paris by sister Suzanne, on orders from Buenos Aires); returns to Picabia and Paris Dadas.

1920　Shows *L. H. O. O. Q.* in Paris Dada exhibition; to New York; assumes pseudonym Rose (by 1921, Rrose) Sélavy; first motorized work: *Rotary Glass Plate (Precision Optics).*

1921　Edits and publishes *New York Dada* with Man Ray (Rube Goldberg contributes); six-month visit to Paris.

1922　Returns to New York; serious involvement with chess.

1923　Brings *Large Glass* to "incompletion"; to Paris (except for visits, until 1942); beginning of the legend that he has abandoned art.

1926　Makes film *Anemic Cinema* with Man Ray and Marc Allegret; visits New York to arrange Brancusi show; *Large Glass* first shown at Brooklyn Museum in New York (breaks afterward).

1927　*Door: 11 rue Larrey, Paris.*

1933　Visits New York arranging second Brancusi show.

1934　*The Green Box.*

1935　André Breton's insightful essay "Phare de la Mariée" (Lighthouse of the Bride; reprinted in Lebel, *Duchamp*) appears in *Minotaure* (Paris), No. 6, a magazine also being read by New York artists.

1936　Visits New York to restore *Large Glass.*

1937　First one-man show, Arts Club of Chicago; "generator-arbitrator" of international Surrealist exhibition, Paris, himself hanging 1,200 coal bags from ceiling; begins *Box in a Valise* (portable auto-museum completed 1941–42, Paris–NewYork).

1942　Settles in New York (except for vacations).

1946　Visits Paris to work with Breton on 1947 Surrealist exhibition; in New York, begins secret work on *Étants Donnés: 1° la Chute d'eau, 2° le Gaz d'éclairage* (completed 1966).

1951　"Three Erotic Sculptures," made in connection with *Étant Donnés: Female Fig Leaf, Objet-Dard,* and *Wedge of Chastity* (the last completed 1952).

1959　One-man show, Sidney Janis Gallery, New York.

1960　*"The Bride Stripped Bare by Her Bachelors, Even;" a Typographic Version,* by Richard Hamilton, published at London.

1961　Ulf Linde's replica of the *Large Glass,* Stockholm.

1963　Major retrospective, *By or of Marcel Duchamp or Rrose Sélavy,* organized by Walter Hopps, Pasadena Art Museum.

1964　Galleria Schwarz, Milan, produces 13 signed and numbered ready-made copies in editions of eight.

1966 Richard Hamilton exhibits his reconstruction of the *Large Glass* as *The Bride Stripped Bare by Her Bachelors, Even, Again* at the University of Newcastle-upon-Tyne, England, and mounts large exhibition at the Tate Gallery, *The Almost Complete Works of Marcel Duchamp*. *Étants Donnés* completed (not revealed until 1969).

1968 Dies, October 1st, in Paris.

Notes on the Contributors

Guillaume Apollinaire. Poet and advocate of Cubism, Apollinaire is one of the heroes of modernity.

John Cage. Cage, an avant-garde composer and aesthetician closely involved with chance and concreteness, is the author of *Silence* (1961).

Georges Charbonnier. Charbonnier is a critic of contemporary art in France.

William Copley. Copley paints under the abbreviated name Cply; examples of his work can be found in the Museum of Modern Art, New York, and the Tate Gallery, London.

Katherine S. Dreier. Together with Duchamp, Man Ray, and Kandinsky, she founded the great corpus of contemporary art called the Société Anonyme collection (now at Yale) in 1920.

Clement Greenberg. Greenberg, perhaps the most important and problematic art critic since Roger Fry, is the author of a classic collection of essays entitled *Art and Culture* (1961).

George Heard Hamilton. Hamilton, who taught the history of art for many years at Yale and was Slade Professor of Fine Art in the University of Cambridge in 1971–72, directs the Stirling and Francine Clark Art Institute at Williamstown, Mass.

Thomas B. Hess. Associated with *Art News* since 1946, Hess helped make that journal a flagship for the New York School.

Werner Hofmann. Hofmann is a German historian of modern art.

Harriet and *Sidney Janis.* The Janis Gallery took an active role in the encouragement of New York painting, especially Abstract Expressionism and Pop Art. Harriet Janis was an expert on ragtime.

Jasper Johns. One of the most accomplished of all contemporary

artists, his conceptual and ironic preoccupations relate back to Duchamp and forward to Conceptualism.

Donald Judd. Judd, who made terse critical contributions to *Arts Magazine* from the late '50s to 1965, became an important Minimalist sculptor in his own right.

Leon Kochnitzky. Kochnitzky wrote on such varied subjects as African art and Adolphe Sax and his saxaphone, for the Belgian Government Information Center, New York, in the 1940s.

Max Kozloff. An associate editor of *Artforum*, Kozloff's monograph on *Jasper Johns* (1967) relates to the essay reprinted here.

Claude Lévi-Strauss. The most famous and controversial of contemporary anthropologists, Lévi-Strauss has from time to time commented on modern art.

Matta Echaurren (R. A. S. Matta-Echaurren). Matta Echaurren, the Chilean-born painter and architect, studied under Le Corbusier. He has worked in New York and in France.

Louise Norton. A poet, Louise Norton is also Mrs. Edgar Varèse.

Octavio Paz. A celebrated Mexican poet, Paz has also written a book on Duchamp and Claude Lévi-Strauss, which has been translated into French as *Deux Transparents*.

Robert Pincus-Witten. With a Ph.D. from the University of Chicago, Pincus-Witten, a critic of contemporary art and senior editor of *Artforum*, teaches at Queens College, City University of New York.

Hans Richter. A Berlin-born painter, Dada, film maker, and teacher, who has been active in America ever since he left Nazi Germany, Richter is the author of *Dada: Art and Anti-Art* (1965).

Moira Roth. Roth, a student of contemporary art, has worked with William Roth on an oral archive of recent artists.

William Rubin. Formerly curator of painting and sculpture at the Museum of Modern Art, Rubin produced distinguished exhibitions and such catalogues as *Dada, Surrealism, and Their Heritage* (1968).

Robert Smithson. Smithson, whose earthwork *Spiral Jetty* (1970) at Great Salt Lake is a masterwork of contemporary sculpture, died in the summer of 1973.

Lawrence D. Steefel, Jr. Steefel, who took his doctorate at Princeton, teaches art history at Washington University, St. Louis.

Selected Bibliography

A. *Bibliographies*

KARPEL, BERNARD. "Selected Bibliography." In Pierre Cabanne, *Dialogues with Marcel Duchamp*. Trans. Ron Padgett (The Documents of 20th Century Art). New York: The Viking Press, 1971. Pp. 121–32.

LEBEL, ROBERT. *Marcel Duchamp*. Trans. George Heard Hamilton. New York: Grossman Publishers, 1967. Pp. 177–88, 196–201.

SCHWARZ, ARTURO. "Elements of a Descriptive Bibliography of Marcel Duchamp's Writings, Lectures, Translations, and Interviews." In his *The Complete Works of Marcel Duchamp*. New York: Abrams, 1969. Pp. 583–617.

B. *Writings by Duchamp*

DUCHAMP, MARCEL. *Salt Seller; the Writings of Marcel Duchamp (Marchand du Sel)*, eds. Michel Sanouillet and Elmer Peterson. New York: Oxford University Press, 1973.

DUCHAMP, MARCEL, and V. HALBERSTADT. *L'Opposition et les cases conjuguées sont réconciliées*. Paris and Brussels, 1932. (See also Pierre de Massot, " 'L'Opposition et les cases conjuguées sont réconciliées;' une étude." *Orbes* [Paris], Ser. 2, No. 2 [Summer 1933].)

HAMILTON, RICHARD, ed. *The Bride Stripped Bare by Her Bachelors, Even; a Typographic Version*. Trans. George Heard Hamilton. London: Lund Humphries; New York: Wittenborn, 1960.

SCHWARZ, ARTURO, ed. *Notes and Projects for the Large Glass*. New York: Abrams, 1969.

C. *Statements and Interviews*

ASHTON, DORE. "An Interview with Marcel Duchamp." *Studio International*, CLXXI,/878 (June, 1966).

BRETON, ANDRÉ. "Entretien avec Marcel Duchamp." In André Parinaud, *Omaggio a André Breton*. Milan: Galleria Schwarz, 1967.

CABANNE, PIERRE. *Dialogues with Marcel Duchamp.* Trans. Ron Padgett (The Documents of 20th Century Art). New York: The Viking Press, 1971.

DUCHAMP, MARCEL. "A Complete Reversal of Art Opinions by Marcel Duchamp, Iconoclast." *Arts and Decoration* (September, 1915), pp. 427–28, 442.

———. "The Creative Act." Paper read to American Federation of Arts convention, Houston, April, 1957. Reprinted in Gregory Battcock, ed., *The New Art: A Critical Anthology.* New York: Dutton, 1966.

HAHN, OTTO, interviewer. "Passport No. G 255300." *Art and Artists* (July, 1966), pp. 7–11.

KUH, KATHERINE. Interview with Duchamp in her *The Artist's Voice.* New York: Harper & Row, Publishers, 1962.

ROBERTS, FRANCIS, interviewer. "I Propose to Strain the Laws of Physics." *Art News* (December, 1968), pp. 46–47, 62–64.

SEITZ, WILLIAM, interviewer. "What's Happened to Art?" *Vogue* (New York), March 1, 1963, pp. 110–13, 129–31.

D. Exhibition Catalogues

Chicago. ART INSTITUTE OF CHICAGO. *20th Century Art from the Louise and Walter Arensberg Collection,* 1949.

London. TATE GALLERY. *The Almost Complete Works of Marcel Duchamp.* London: Arts Council of Great Britain, 1966.

Milan. GALLERIA SCHWARZ. *Duchamp Ready-Mades, etc. (1913–1964),* 1964.

New York. CORDIER & EKSTROM, INC. *Not Seen and/or Less Seen of/by Marcel Duchamp/Rrose Sélavy 1904–1964.* Mary Sisler Collection, 1965.

New York. SIDNEY JANIS GALLERY. Dada Exhibition, 1953.

New York. SOLOMON R. GUGGENHEIM MUSEUM. *Jacques Villon, Raymond Duchamp-Villon, Marcel Duchamp,* 1957.

Pasadena, Calif. PASADENA ART MUSEUM. *Marcel Duchamp, a Retrospective Exhibition,* 1963.

Philadelphia and New York. PHILADELPHIA MUSEUM OF ART AND THE MUSEUM OF MODERN ART. *Marcel Duchamp,* 1973.

Zurich. KUNSTGEWERBE MUSEUM. *Dokumentation Über Marcel Duchamp,* 1960.

E. Books

BARR, ALFRED H., JR. *Fantastic Art, Dada, Surrealism.* 4th ed. New York: Museum of Modern Art and Arno Press, 1969.

CARROUGES, MICHEL. *Les Machines Célibataires.* Paris, 1954.

CHARBONNIER, GEORGES. *Conversations with Claude Lévi-Strauss,* trans. John and Doreen Weightman. London: Jonathan Cape, 1969.

DREIER, KATHERINE S., and MATTA ECHAURREN. *Duchamp's Glass "La*

mariée mise à nu par ses célibataires, même," an *Analytical Reflection.* New York: Société Anonyme, Inc., 1944.

GOLDING, JOHN. *The Bride Stripped Bare by Her Bachelors, Even* (Art in Context). New York: The Viking Press, 1973.

HULTEN, K. G. PONTUS. *The Machine as Seen at the End of the Mechanical Age.* New York: Museum of Modern Art, 1968.

HOPPS, WALTER, ULF LINDE, and ARTURO SCHWARZ. *Marcel Duchamp: Ready-Mades, etc.* (*1913–1964*). Milan: Galleria Schwarz, 1964.

LEBEL, ROBERT, with chapters by MARCEL DUCHAMP, ANDRÉ BRETON, and H. P. ROCHÉ. *Marcel Duchamp.* Trans. George Heard Hamilton. New York: Grossman Publishers, 1967.

PAZ, OCTAVIO. *Marcel Duchamp; Or the Castle of Purity,* trans. Donald Gardner. London: Cape Goliard Press Ltd., 1970.

RUBIN, WILLIAM. *Dada and Surrealist Art.* New York: Abrams, 1968.

SCHWARZ, ARTURO. *The Complete Works of Marcel Duchamp.* New York: Abrams, 1969.

STEEFEL, LAWRENCE D., JR. "The Position of *La Mariée mise à nu par ses célibataires, même* (1915–1923) in the Stylistic and Iconographic Development of Marcel Duchamp." Ph.D. dissertation, Princeton University, 1960 (Ann Arbor, Mich.: University Microfilms).

TOMKINS, CALVIN. *The Bride and the Bachelors; the Heretical Courtship in Modern Art,* rev. ed. New York: Viking, 1968.

—— and the Editors of Time-Life Books, *The World of Marcel Duchamp, 1887–* . New York: Time, Inc., 1966.

WENDT, WOLF RAINER. *Ready-Made; das Problem und der philosophische Begriff des äesthetischen Verhaltens, dargestellt an Marcel Duchamp.* Meisenheim am Glan: Verlag Anton Hain, 1970.

F. Articles

APOLLINAIRE, GUILLAUME. "Duchamp," in his *The Cubist Painters; Aesthetic Meditations.* Trans. Lionel Abel (The Documents of Modern Art), 2nd ed. New York: Wittenborn, Schultz, Inc., 1949, pp. 47–48.

BRADY, FRANK R. "Duchamp, Art, and Chess." *Chess Life,* XVI, No. 6 (June, 1961), 168–69.

BRETON, ANDRÉ. "The Lighthouse of the Bride." From *Minotaure* (Paris), No. 6 (1935). Trans. in *View,* V, No. 1 (March, 1945); repr. in Lebel, *Duchamp,* pp. 88–94.

BUFFET[-PICABIA], GABRIELLE. "Magic Circles." From *Cahiers d'Art* (Paris), Nos. 1–2 (1936). Trans. in *View,* V, No. 1 (March, 1945).

CAGE, JOHN. "26 Statements re Duchamp," *Art and Literature* (Lausanne), No. 3 (1964), pp. 9–10.

CALAS, NICOLAS. "Cheat to Cheat." *View,* V, No. 1 (March, 1945), 20–21.

——. "The Large Glass." *Art in America,* LVII, No. 4 (July–August, 1969), 34–35.

COPLEY, WILLIAM. "The New Piece." *Art in America*, LVII, No. 4 (July–August, 1969), p. 36.

D'HARNONCOURT, ANNE, and WALTER HOPPS. "*Étant donnés: 1° la chute d'eau, 2° le gaz d'éclairage;* Reflections on a New Work by Marcel Duchamp." *Bulletin of the Philadelphia Museum of Art*, LXIV, No. 299–300 (April–June/July–September, 1969), 1–58.

GREENBERG, CLEMENT. "Counter-Avant-Garde." *Art International*, XV, No. 5 (May 20, 1971), 16–19.

HAMILTON, GEORGE HEARD. "In Advance of Whose Broken Arm?" *Art and Artists*, I, No. 4 (July 1966).

HAMILTON, RICHARD. "Duchamp." *Art International* (January, 1964).

———. "Son of the Bride Stripped Bare." *Art and Artists*, I, No. 4 (July, 1966).

HARTLEY, MARSDEN. "And the Nude Has Descended the Staircase," in his *The Spangle of Existence*, typescript, New York, 1942.

HEECKEREN, JEAN VAN. "La Porte de Duchamp." *Orbes* (Paris), II, No. 2 (Summer 1933), xiv–xv.

HESS, THOMAS B. "J'accuse Marcel Duchamp." *Art News*, LXIII, No. 10 (February, 1965), 44–45, 52–54.

HOFMANN, WERNER. "Marcel Duchamp und der emblematische Realismus," *Merkur; Deutsche Zeitschrift für europäisches Denken*, XIX, No. 10 (October, 1965), 941–55.

HOLLÄNDER, HANS. "Ars inveniendi et investigandi; zur surrealistischen Methode." *Wallraf-Richartz-Jahrbuch; Westdeutsches Jahrbuch für Kunstgeschichte*, XXXII (1970), pp. 193–234.

JANIS, HARRIET and SIDNEY. "Marcel Duchamp, Anti-Artist." From *Horizon* (London), October, 1945; repr. in *View*, V, No. 1 (March, 1945); repr. in Robert Motherwell, ed., *The Dada Painters and Poets* (New York: Wittenborn, 1951; repr. 1967).

JOHNS, JASPER. Review of *"The Bride Stripped Bare by Her Bachelors, Even;" a Typographic Version*, by Richard Hamilton, *Scrap* (New York), December 23, 1960, p. 4.

———. "Marcel Duchamp (1887–1968)." *Artforum*, VII, No. 3 (November, 1968), 6.

———. "Thoughts on Duchamp." *Art in America*, LVII, No. 4 (July–August, 1969), 31.

JUDD, DONALD. "Marcel Duchamp and/or Rrose Sélavy" (Review of exhibition at Cordier and Ekstrom Gallery, New York). *Arts Magazine*, XXXIX, No. 6 (March, 1965), 53–54.

KOCHNITZKY, LEON. "Marcel Duchamp and the Futurists." *View; the Modern Magazine*, Series V, No. 1 (March, 1945), 41–42.

KOZLOFF, MAX. "Johns and Duchamp." *Art International*, VIII, No. 2 (March 20, 1964), 42–45.

KUH, KATHERINE. "Walter Arensberg and Marcel Duchamp," in her *The Open Eye* (New York, 1971), pp. 56–64.

LEBEL, ROBERT. "The Ethic of the Object." *Art and Artists*, I, No. 4 (July, 1966).

———. "L'Humour absurde de Marcel Duchamp." Repr. from *XXᵉ Siècle* (Paris), No. 8 (January 1957) as "Whiskers and Kicks of All Kinds" in Lebel, *Duchamp*, pp. 95–97.

LEIRIS, MICHEL. "Arts et méters de Marcel Duchamp." *Fontaine* (Paris), No. 54 (Summer, 1946), 188–93.

MICHELSON, ANNETTE. "'Anemic Cinema;' Reflections on an Emblematic Work." *Artforum*, XII, No. 2 (October, 1973), 64–69.

NORTON, LOUISE. "Buddha of the Bathroom." *The Blind Man* (New York), No. 2 (1917), pp. 5–6.

O'DOHERTY, BRIAN. "Duchamp's Cardiogram." *Art and Artists*, I, No. 4 (July, 1966).

PINCUS-WITTEN, ROBERT. "Theater of the Conceptual: Autobiography and Myth." *Artforum*, XII, No. 2 (October, 1973), 40–46.

RICHTER, HANS. "In Memory of a Friend." *Art in America*, LVII, No. 4 (July–August, 1969), 40–41.

———. "In Memory of Marcel Duchamp." *Form* (Cambridge, England), No. 9 (April, 1969), pp. 4–5.

ROSENBLUM, ROBERT. "The Duchamp Family." *Arts Magazine* (April, 1957).

ROTH, MOIRA. "Robert Smithson on Duchamp; An Interview." *Artforum*, XII/2 (October, 1973), p. 47.

ROTH, MOIRA and WILLIAM. "John Cage on Marcel Duchamp; An Interview." *Art in America* (November–December, 1973), pp. 72–79.

ROUGEMONT, DENIS DE. "Marcel Duchamp mien de rien." *Preuves* (Paris), XVIII, No. 204 (February, 1968), 43–47.

RUBIN, WILLIAM. "Reflexions on Marcel Duchamp." *Art International*, IV, No. 9 (December 1, 1960), 49–53.

SARGEANT, WINTHROP. "Dada's Daddy; a New Tribute Paid to Duchamp, Pioneer of Nonsense and Nihilism." *Life*, April 28, 1952.

SCHWARZ, ARTURO. "Contributions to a Poetic of the Ready-Made," in Hopps, *et al.*, *Marcel Duchamp*.

———. "The Mechanics of 'The Large Glass.'" *Cahiers Dada, Surréalisme* (Paris), No. 1, 1966.

SOBY, JAMES THRALL. "Marcel Duchamp in the Arensberg Collection." *View*, V, No. 1 (March, 1945), 11–12.

SPECTOR, JACK. "Freud and Duchamp; the Mona Lisa 'Exposed.'" *Artforum*, VI, No. 8 (April, 1968), 54–56.

STEEFEL, LAWRENCE D., JR. "The Art of Marcel Duchamp: Dimension and Development in *Le Passage de la Vierge à la Mariée*," *The Art Journal*, XXII, No. 2 (Winter, 1962–63), 72–79.

STEIN, GERTRUDE. "Next; Life and Letters of Marcel Duchamp," in her *Geography and Plays* (1922; reprinted, New York: Something Else Press, Inc., 1968), pp. 405–06.

G. Film and Television

Entr'Acte, 1924. Film by René Clair with Picabia scenario and music by Satie. Duchamp acted, among others.

Anemic Cinema, 1926. Film made in Paris by Duchamp, with Man Ray and Marc Allégret. See now Annette Michelson, " 'Anemic Cinema,' Reflections on an Emblematic Work." *Artforum*, XII, No. 2 (October, 1973), 64–69.

Interview with James Johnson Sweeney at the Philadelphia Museum of Art. N. B. C. (New York), 1955; televised 1956.

Interview with Richard Hamilton for "Monitor" program. B. B. C. (London), 1961.

Dadascope, 1961. Film by Hans Richter. Duchamp plays chess with Larry Evans, chess expert, both sitting under water.

Interview with Jean-Marie Drot. R. T. F. (Paris), 1964.

Rebel Ready-Made, 1966. Film by Tristan Powell for B. B. C. (London).